MUSEUM COMPANION

A
Dictionary of
Art Terms and Subjects

MUSEUM COMPANION

A
Dictionary of
Art Terms and Subjects

Antje *Ruth*
Lemke *Fleiss*

HIPPOCRENE

Library of Congress Catalog Number: 73-76577

Hardcover edition ISBN: 0-88254-043-2

Grateful acknowledgment is made to the following for copyright material:

The chart in definition of TITANS from *Dictionary of Classical Mythology* (p. 275) by J. E. Zimmerman is reprinted by permission of Harper & Row.

The poem quoted in definition of JUNK SCULPTURE from *David Smith by David Smith* (p. 152) edited by Cleve Gray is reprinted by permission of Holt, Rinehart and Winston, Inc.

Printed in the United States of America

to Arthur

Contents

Introduction

"Art is the affirmation of being"
Friedrich Nietzsche

This book has been written to meet the need of museum visitors and art students for a convenient reference source with concise explanations of art terms and subjects. It includes art movements, schools, styles, media, techniques, and subjects, especially in mythology and religion, relating to Western art. Terms from the fields of architecture and crafts are listed only if the object appears frequently in paintings or graphic works. *Frieze*, and *molding*, for example, are among the entries. Printing techniques and terminology have been included if they relate to art. Thus terms like *lithography* or *expulsit* are explained.

A selective list of museums in North America (Canada and all states of the U.S.A. are represented) and abroad, with an indication of major collections follows the dictionary section.

A selective reading list of books by and about artists, reference works, and journals has been added for those who are interested in additional information, concludes the museum companion.

In addition to museum visitors and students this reference volume should be helpful to the general reader of art history, the art buyer and dealer, and — for quick reference — the scholar, artist, curator and librarian.

The dictionary entries have been selected on the basis of their occurrence in museum collections (labels on paintings or sculptures), in art books, reviews of art shows, and various publications of museums and galleries. As we wrote the text, we envisioned people wandering through museums, trying to find out why painters had selected the Fall of *Icarus* as a theme, what *Hard-Edge Painting* means, or when *Kinetic Art* appeared. We especially thought of the person who

1

likes to encounter works of art directly and without elaborate commentary; who, like the traveler in a foreign country, is looking for basic information and wants to discover the new territory by himself, rather than with a guided tour.

Works of art — although they can be genuinely enjoyed without any knowledge of their creator or their country or period of origin — are not isolated entities. They have their history, their social and geographical context. They are created of certain materials, and they may depict unique and at the same time eternal events or impressions. Thus in addition to their visual impact they have a manifold life that includes anything from symbolism and mythology to direct social messages. Medieval or Baroque art, so different in style from Pop art or New Realism, wrestles with similar issues. We may ask with Carl Jung whether the demons that descended on St. Anthony are different from the specters that are haunting us in our dreams today.

Cezanne considered painting as a means of understanding the underlying structure of life. "I feel myself illuminated by all the implications of the infinite. At that moment I am one with my painting. . . Yes, I want to know, to know in order to feel more deeply, to feel more deeply in order to know more . . ."

To provide some of the essential background to see and experience works of art in their broader context, to gain new insights in and through art, is the intention of the *Museum Companion*.

Antje Lemke, Ruth Fleiss

Syracuse, N. Y.
January 1973

Acknowledgements

The introduction to this volume would not be complete without an expression of gratitude to Barbara A. Brown, who contributed some of the line drawings, and to Helen Romano, superb typist.

How to Use Museum Companion

The alphabetical arrangement of the definitions provides easy access to the information. The visitor to a show on realism, who looks, for example, at Daumier's lithograph "Odysseus and Penelope" will find under *Odysseus* a brief account of Odysseus' adventures, ending with his return to his wife Penelope. Under *Lithography*, an explanation of the term is followed by a brief description of how lithographs are made. Finally under *Realism*, the origins, meanings, specific characteristics and versions of realism are described. In addition, the names of representative artists and cross references to related art movements are included. Through these cross references, which are printed in capital letters, the information in the original entry is expanded, and related movements or styles are linked with each other.

Illustrations have been added to some entries, for example: *Cartouche* or *Tryptich*. Simplified phonetic spelling has been indicated where it seemed helpful, for example: Chiaroscuro – key AH ro SKOO ro.

The selective list of museums gives the names, addresses, and an indication of major holdings for museums in the United States, Canada, Europe and other areas.

A Reading List concludes the volume. It is highly selective, designed as a first step to further information on the subjects in *Museum Companion*.

Dictionary of Art Terms and Subjects

A and W: Alpha and Omega. See: MONOGRAMS.

ABC Art. See: MINIMAL ART.

Abraham. Father of Judaism and Mohammedanism, who led the Hebrews into Canaan. Popular themes: 1. *Abraham and Melchizedek*. Abraham, in Canaan, learned that his nephew Lot had been imprisoned and deprived of his belongings by the kings who had sacked Sodom. A group of armed men joined Abraham in pursuing and defeating the raiders. Upon the triumphant return of Abraham, Melchizedek, king of Salem, brought forth bread and wine and blessed him. (Genesis 14:18) (Hebrews 7:1ff) 2. *The Sacrifice of Isaac*. Testing the faith of Abraham, the Lord ordered him to sacrifice his son Isaac. As Abraham was about to comply, the Lord, convinced of Abraham's faithfulness, stopped the slaying. (Genesis 22).

Abstract Art. Art concerned with geometric or imaginative shapes that may or may not be derived from real objects. Abstract elements appear from the beginning of painting and sculpture, any time an artist departs from nature. Today, we usually speak of Abstract Art referring to the movement that began early in the 20th century when artists sought pure art by eliminating the traditional subject and creating a visual experience by means of form, line or color and their spatial relationship. The "abstractionist," even if he starts with an object, attempts to remove all traces of reality. Abstract Art embraces many movements and artistic intentions from the mystic and most sensitive individual expression to

5

revolutionary social statements. Painters: Wassily Kandinsky, Paul Klee, Laszlo Moholy-Nagy. Sculptors: Hans Arp, Constantin Brancusi, Alexander Calder. See also: NON-OBJECTIVE ART.

Abstract Calligraphy. See: CALLIGRAPHY.

Abstract Classicism. Twentieth century style in which straight lines and methodical execution are emphasized to achieve certainty and order in art. Typical of Abstract Classicism is HARD EDGE painting with its firm edges. Painters: Piet Mondrian, Burgoyne Diller. Sculptors: Barbara Hepworth, Henry Moore, Ben Nicholson.

Abstract Concrete. See: CONCRETE ART.

Abstract Expressionism. First used in 1919 to describe paintings of Kandinsky, Abstract Expressionism developed as a significant movement of American abstract painting in the 1940s and 1950s in New York City. Also called the NEW YORK SCHOOL, Abstract Expressionism is considered the first important school in American painting that was independent of European styles. A major impetus to Abstract Expressionism was Arshile Gorky who derived from the art of Picasso, Miró and SURREALISM and became more personally expressive in his painting. Brush action, texture of paint, huge canvases, spontaneous outburst of emotion by the artist, importance of the act of painting characterize Abstract Expressionism. Painters: Willem de Kooning, Jackson Pollock, Hans Hofmann. Related to: ACTION PAINTING, TACHISME. See also: NEW YORK SCHOOL.

Abstract Image Painting. See: COLOR-FIELD PAINTING.

Abstract Lyricism. In his search for a symbolic visual language for the spiritual in art, Wassily Kandinsky (1866-1944) refers to Abstract Lyricism. This lyricism becomes pure expression, corresponding to the development of music in the 17th century when composers began to create works without any association to a text or action as in liturgy, opera or songs.

Abstraction - Création. A group of abstract painters and sculptors founded in Paris in the 1930s by Antoine Pevsner and Naum Gabo. Its purpose was to advance the principles of pure abstraction and of Mondrian's NEO-PLASTICISM. It issued an annual publication and was supported by 400 members including Josef Albers, Piet Mondrian and Wassily Kandinsky. See also: AMERICAN ABSTRACT ARTISTS.

Academic. A term indicating the adherence to traditional art concepts, or to standards set by an ACADEMY. Today the term usually refers to noncreative, conventional art.

6

Academy. The term is derived from Plato's 'Academy'. During the Italian RENAISSANCE, an academy was a place used by groups of humanists meeting for discussion. From that time on the concept of an academy has been widely used for official and semi-official groups engaged in scientific, artistic and scholarly endeavors. Today, an academy of art is a school where art courses are given or an institution concerned with the support of art through various programs, including publications and fellowships.

Achilles. In Greek mythology, he was the son of PELEUS and THETIS. The greatest Greek hero in the Trojan War, Achilles was killed by PARIS, who wounded him in his heel; his only vulnerable spot.

Acis. In Greek mythology, he was the lover of the beautiful sea-nymph GALATEA. He was crushed by a huge boulder hurled by his jealous rival, the giant POLYPHEMUS. Hearing his cries of pain, GALATEA changed Acis into a river.

Acropolis. The elevated part of a Greek city. The most famous Acropolis is at ATHENS, on which the PARTHENON, the Propylea and the Erectheum were built.

Acrylic Paint. A synthetic paint made of plastic RESINS, PIGMENT and water; it dries quickly, is durable, resistant to atmospheric changes, easy to handle and apply. Some Acrylic Paints can be mixed with oils and turpentine to form a faster drying, more durable oil paint. For these reasons, many artists today use Acrylic Paints.

ACT. *A*esthetically *C*laimed *T*hings. In the late 1960s, artist Ian Baxter of Canada set up a method of evaluating objects from nature and from our man-made environment. Selecting a supermarket sign or a Donald Judd box, Baxter photographs and enlarges it. If he considers this "visual sensitivity information" pleasing, he stamps it with a seal of approval. It is ACT; an Aesthetically Claimed Thing. If he dislikes it, he calls it ART; an Aesthetically Rejected Thing. Opposed to the artist-gallery convention, Baxter and a group of poets, artists, engineers and film-makers formed the N. E. Thing Co. through which they provide their consultation and evaluation service with respect to things. Related to: FOUND OBJECT.

Acteon. Hunter in Greek mythology who watched the naked DIANA bathing. Angered by this, DIANA changed him into a stag and he was torn apart by his own dogs.

Action Art. See: ACTION PAINTING.

Action Painting. Throughout history many artists, for example Cezanne, were more interested in the activity of painting than in the completion of their pictures. Contemporary Action Painting, emerging in the 1950s, is an aggressive controlled attack by splashing, slapping, dragging, dripping the loaded brush across the canvas. The canvas, usually of large size, becomes a partner in the encounter, not an object to receive a preconceived image. What matters is the action; the final product is accidental, a surprise, which often looks like a monumental exercise in CALLIGRAPHY, albeit indecipherable. Painters: Jackson Pollock, Willem de Kooning, Franz Kline. Related to: ABSTRACT EXPRESSIONISM.

Adam and Eve. According to Judeo-Christian tradition, the first man and woman. (Genesis 2:7). Popular subjects: *Creation of Adam* out of dirt. (Genesis 2:7). *Creation of Eve* out of Adam's rib. (Genesis 2:21). *Temptation of Eve* by the serpent (devil) to eat the forbidden fruit. (Genesis 3:7). *Expulsion of Adam and Eve* from the Garden of EDEN for disobeying the Lord and eating the fruit. (Genesis 3:19). *Adam and Eve Toiling on Earth.* After their expulsion from the Garden of EDEN, Adam and Eve must work for their food. (Genesis 3:23).

Adonis. A beautiful youth in Greek mythology loved by APHRODITE and PERSEPHONE. Both claimed Adonis when he was gored to death by a wild boar. ZEUS settled the argument by permitting Adonis to spend half the year (the summer months, for example the vegetation period) above the ground with APHRODITE and the other half in the underworld with PERSEPHONE.

Adoration of the Lamb. See: LAMB.

Adoration of the Magi. Three wise men from the East who follow a star to Bethlehem in search of the newborn King of the Jews, find him and pay homage to Jesus. The Magi are represented as kings offering gifts of gold, frankincense and myrrh. Gold symbolizes the royalty of CHRIST; frankincense his divinity; and myrrh, a symbol of death, foreshadows his suffering during the PASSION. On their way to Bethlehem, the Magi passed through Jerusalem where King HEROD asked them to "search diligently for the child" and, on their return, let him know the place so he may worship it. As they departed from Bethlehem an ANGEL appeared in their dream, telling them not to return to HEROD. Both, the Adoration, and the appearance of the ANGEL are frequently represented

in BYZANTINE, Medieval and RENAISSANCE art. (Psalm 72:10, 11, Matthew 2:1-12). See also: MASSACRE OF THE INNOCENTS.

Adoration of the Shepherds. Following the angel's ANNUNCIATION of the birth of CHRIST, the shepherds go to Bethlehem to find Jesus, MARY and JOSEPH in the stable. The adoration of the Shepherds depicting the shepherds worshipping the CHRIST child is a popular subject chosen by artists from the Middle Ages through the 18th century. (Luke 2:15-20).

Adultress Before CHRIST (The Woman Taken into Adultery). The scribes and the Pharisees, rigid observers of ancient Jewish law, brought an adultress before CHRIST. They interpreted the law of MOSES to punish adultery by stoning. When they asked Jesus his opinion, he said, "He that is without sin among you, let him first cast a stone at her." (John 8:7-11).

Ad Vivum. (Latin — "from life") A term found on art PRINTS to indicate that a portrait was not made from a painting, but from the person directly.

Aegean Art. Pre-Greek art of the Northeastern Mediterranean area. Its highest form developed probably in the MINOAN and MYCENAEAN civilizations.

Aeneas. Trojan hero in classical legend. He was the son of the Trojan prince Anchises and the goddess APHRODITE. Forewarned of the fall of TROY by LAOCOÖN, Aeneas escaped, carrying his father on his back. On his way to Italy, he fell in love with DIDO, the queen of CARTHAGE. Fulfilling the wish of the oracle, he left DIDO for Latium, which was to become Rome.

Aerial Perspective. See: PERSPECTIVE.

Aesculapius. Roman name for ASCLEPIUS. See: ASCLEPIUS.

Afro-American Art. See: BLACK ART.

Agamemnon. In Greek mythology, he was king of Mycenae; commander-in-chief of the Greek forces in the Trojan War; husband of Clytemnestra; father of Orestes, Electra, and IPHIGENIA. Because Agamemnon sacrificed his daughter IPHIGENIA to ARTEMIS to obtain favorable sailing winds, his wife Clytemnestra despised him. When Agamemnon returned from Troy, Clytemnestra, and her lover Aegisthus, murdered him. To avenge his death, Orestes and Electra killed their mother, Clytemnestra.

9

Agnes, St. (3rd century). Virgin and martyr. At the age of thirteen, she committed her life to Jesus and refused to marry the son of the prefect of Rome. Stripped of her clothing, by order of the prefect, and threatened with rape, she was saved by a miracle. Her hair grew long and covered her. She was then either burned, decapitated or stabbed. Agnes is patroness of maidens. Attributes: a lamb (agnus — a pun on her name); a sword, fire, long hair.

Agnus Dei. See: LAMB.

Agony in the Garden. After the LAST SUPPER, Jesus and his disciples went to a garden called Gethsemane (Hebrew Olive Press). Taking Peter, James and John aside with him, Jesus asked them to wait and watch while he prayed and prepared himself for death. He returned to find his disciples asleep. Paintings of "The Agony in the Garden" almost always show the three disciples sleeping. (Matthew 26:36-46; Mark 14:32-42; Luke 22:39-46).

Agora. In ancient Greece, the agora was the market place. Usually an open, rectangular square, the agora was the political, social and religious center of the city.

Ahasuerus. See: ESTHER.

Air Sculpture. See: SOFT SCULPTURE and INFLATABLE SCULPTURE.

Allegory. Representation of a concept, or ideal through the use of symbols; a message in disguise. Figures or objects are used to represent something other than themselves. Examples: Botticelli's "Spring" and "Birth of Venus"; in "Peaceable Kingdom" by Edward Hicks, while William Penn signs his treaty with the Indians, the lion and the lamb sit side by side peacefully.

All-over painting. A method in which the canvas is filled from end to end with self repeating MOTIFS. Painters: Jackson Pollock, Mark Tobey.

Altar. A structure for religious ceremonies which can consist of a simple table, and any of the following parts:

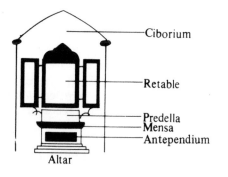

Altar

 Ciborium — Superstructure (the term is also used for liturgical vessels)
 Retable — Altar-piece
 Predella — Base for the Altar-piece
 Mensa — Altar table
 Antependium — Base for the table

10

The altar-piece is usually either a single slab or a TRIPTYCH. In some churches, reredos — decorated screens, are erected behind the altar. Because of their central significance in worship, altars have been decorated with some of the greatest masterpieces, for example the Ghent altar by van Eyck, or the Isenheim altar by Grünewald. Since the Middle Ages, small portable altars have been produced as fine wood or metal art works.

Alto-Relievo. See: HIGH RELIEF.

Amazons. In Greek legend, they were a tribe of female warriors who lived in Asia Minor. In their matriarchal society the women fought and governed. It was believed that Amazons cut off their right breasts in order to shoot or throw spears more effectively.

Ambrose, St. (4th century). One of the four LATIN FATHERS of the Church and bishop of Milan. In the struggle between the Arians and the Christians, he proved eloquent and courageous. St. Ambrose is represented wearing the dress of a bishop with headdress and staff. Attributes: A whip and a beehive, referring to his eloquence. Legends vary from the story that in his infancy a swarm of bees settled on his mouth, without harming him, to his mother's dream before his birth, that she swallowed a bee which made her son honey-mouthed.

Ambrosia. The food of the Gods in Greek mythology, which granted immortality. According to Homer, it was brought to Zeus from the West by doves. Together with NECTAR, the drink of the Gods, it appears in works of CLASSICAL and RENAISSANCE art.

American Abstract Artists. A group formed in the late 1930s by Ilya Bolotowsky for the purpose of promoting every form of abstraction, particularly geometric abstraction. Continuing the international abstract movement that was dispersed during the rule of National Socialism in Europe, they held annual exhibitions. This group made New York an important center of ABSTRACT ART and greatly influenced the subsequent course of modern American Art. In AAA were Josef Albers, John Ferren, Ilya Bolotowsky. See also: ABSTRACTION — CRÉATION.

Amor. Roman god of love. See: EROS.

Amphora. A two-handled vessel of oblong shape first used by the ancient Greeks for holding wine or other liquids.

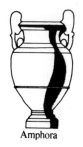
Amphora

Analytical Cubism. See: CUBISM.

Andromeda. In Greek mythology, an Ethiopian princess who was rescued from a sea serpent by PERSEUS. Her mother, Queen Cassiopeia declared that Andromeda was more beautiful than the NEREIDS, attendants of POSEIDON. Angered by this, POSEIDON sent a sea monster to prey on the country. To appease POSEIDON, Andromeda was sacrificed, chained to a rock by the sea. Returning from the land of the GORGONS, PERSEUS killed the monster, rescued Andromeda and married her. After her death, Andromeda was made a constellation by ATHENA.

Anecdotal Art. See: NARRATIVE PAINTING.

Angels. According to the traditional belief of Judaism, Christianity, Islam and other religions, angels are messengers of God, guardians of the innocent and the just, and the choristers in heaven. Human in form and winged, they are often depicted with musical instruments. In the early Christian era, angels are usually divided into three tiers and each tier is divided into three groups.

First Hierarchy: SERAPHIM, CHERUBIM, Thrones.

Second Hierarchy: Dominations, VIRTUES, Powers.

Third Hierarchy: Princedoms, ARCHANGELS, ANGELS.

Constantly represented in devotional art from the earliest period on. In Christian architecture, angels often fill spaces on FRIEZES and in arches. Attributes: trumpets, flaming swords, sceptres, censers and musical instruments.

Anne, St. Mother of the Virgin MARY. She is frequently represented in RENAISSANCE Art in scenes of the life of the VIRGIN and in pictures of the HOLY FAMILY. Attributes: green mantle and red dress, book.

Annunciation. Depicts the ARCHANGEL GABRIEL coming to the Virgin MARY to announce to her that she will give birth to CHRIST, the son of God. GABRIEL carries the wand, or sceptre as the herald of God; or the lily, as the symbol of the purity of the Virgin. The dove is the symbol of the presence of God, the Holy Ghost. (Luke 1:26-38).

Annunciation to the Shepherds. On the night CHRIST was born, an ANGEL appeared to the shepherds tending the flock and told them of the birth of the Saviour. "For to you is born this day in the city of DAVID a Saviour who is CHRIST the Lord." (Luke 2:8-14).

Antependium. See: ALTAR.

Anthony Abbot, St. or Anthony the Great. (4th century). Early Egyptian hermit. Born of wealthy parents in Egypt, Anthony distributed his inheritance among the poor at the age of eighteen and became a hermit. The tortures and temptations of St. Anthony is one of the most popular subjects in art. In early pictures he is confronted by a beautiful woman; in later works he is surrounded by foul demons. St. Anthony is usually represented as an old man in a long white beard in the hood and robe of a monk, marked with the blue letter T (for "Theos" God). Attributes: A crutch for old age; a bell for exorcising demons and evil spirits; a pig for sensuality symbolizes the saint's triumph over sin; and flames under his feet, as a reminder that a vision of the flames of hell killed in St. Anthony the desire for flesh.

Anthony of Padua, St., (13th century). Doctor of the church. Born in Lisbon, he joined the Franciscans in Assisi. Famous for his preaching and various miracles, he became the apostle of charity, patron saint of lovers, marriage, women and people in confinement. He is also considered a retriever of lost belongings. Generally he is painted in the robe of the Franciscan Order holding the CHRIST Child, a lily and a book.

Anti-Art, non-Art. Works of art that negate traditional art concepts. Duchamp's theory of Anti-Art involved taking a commonplace object and giving it new significance. He took a bicycle wheel, mounted it on a kitchen stool and exhibited it as a work of art. Duchamp and his friends contributed significantly to the development of DADA, SURREALISM, KINETIC SCULPTURE, JUNK SCULPTURE and POP ART.

Anti-Illusion Art. See: CONCEPTUAL ART.

Aphrodite. Greek goddess of love, beauty and fertility; also war goddess, sea goddess and patroness of sailors. In some myths she was the child of ZEUS and Dione; in most, she rose from the foam of the sea, near Cyprus or Cythera. Because she refused ZEUS, he gave her in marriage to his ugly and deformed son HEPHAESTUS (Vulcan). Aphrodite, however, gave her love to others (Ares, HERMES, DIONYSUS, POSEIDON) and bore many children.

PARIS awarded her the apple of discord for which she helped him win HELEN. The dispute which ensued led eventually to the Trojan War. Roman counterpart: VENUS

Apocalypse. Ancient Hebrew and Christian writings dealing with predictions of the end of the world. Revelation of St. John the Divine, the last book of the New Testament, is often called the Apocalypse. Four Horsemen of the Apocalypse ALLEGORICALLY symbolize the future of the world.

Four riders on:

Horses	*Symbolize*
white	pestilence
red	war
black	famine
pale	death

Apollo. Greek and Roman God of the sun, fine arts, music, poetry, healing, prophecy, care of flocks and herds, and manly beauty. One of the twelve OLYMPIAN gods, he was also known as Phoebus Apollo — Radiant Apollo. Son of ZEUS and Leto, his twin sister was ARTEMIS (Diana).

Attributes:

Python (this serpent guarded the shrine at DELPHI. As an infant, Apollo is said to have killed the serpent and seized the shrine);
wreath of laurel leaves or a laurel tree (to escape the embraces of Apollo, the chaste nymph DAPHNE turned into a laurel tree);
bow and arrows (with which he sent plagues and slew Python);
lyre (which he played as god of music and poetry);
tripod (seat of the oracle at DELPHI).

Apostles, The Twelve. The traditional list of twelve disciples of CHRIST is composed of PETER, Andrew, James, JOHN, Philip, Bartholomew, MATTHEW, THOMAS, James (son of Alphaeus), JUDE (or Thaddeus), Simon Zelotes, and Judas Iscariot. These disciples, with the exception of Judas, who betrayed CHRIST and hanged himself, became the Apostles who preached the gospel throughout the world. St. Matthias was chosen by lot to replace Judas and bring the number of Apostles to twelve. In pictures the number of Apostles is kept at twelve, but it is not always the same twelve who are represented, because more than twelve men came to be called Apostles.

Apparition of the Three Angels. See: SARAH.
Apples of Hesperides. See: HESPERIDES.

Applied Art. Art to which the principles of design are put to use, primarily in industrial and decorative arts and crafts. For example: the design of pottery, glass, hardware, posters, furniture, cars.

Apud. (Latin — "by or from") Attached to a name in a work of art, the term indicates by whom the work has been sold.

Aquarelle. French term for a WATER COLOR done in transparent colors. Especially popular in England and France in the 18th and 19th centuries.

Aquarius. See: ZODIAC.

Aqua Fortis, aq., aquaf. Latin for "Nitric acid" which is used in ETCHING. The term, or its abbreviation, sometimes appears with the name of the etcher on prints.

Aquatint. An ETCHING technique invented in the 18th century and used with the greatest mastery by Goya. To produce a TONAL effect of WATER COLOR drawings, the metal plate is covered with a porous coating through which the acid bites tiny pockmarks into the metal.

Arabesque. Surface decoration composed of running patterns of flowers, leaves, branches and scroll-work delicately interlaced.

Arcadia. An isolated mountainous region of ancient Greece known for the simple pastoral life of its people.

Archaic. Early styles of classical antiquity, especially Greek art from about 600 to 450 B.C. Highly STYLIZED costumes of simple elegance, and a human, yet not personal expression, the famous "Archaic smile" characterize the figures of that period. The term is also used to describe the earliest phases of other civilizations.

Archangels. Angels in important positions in heaven, acting as heavenly messengers, guides and protectors of the church; renowned for beauty, divine prowess and lofty relations with mortal man. Archangels most frequently represented in Christian Art and their attributes are:
Michael: the sword and scales
Gabriel: the lily
Raphael: the pilgrim's staff and gourd
Uriel: a roll and a book

Ares. In Greek mythology, god of war. Son of ZEUS and HERA. Disliked by the gods because of his quarrelsome temper. Friend and lover of APHRODITE, they were the parents of EROS. Not as important as his Roman counterpart: MARS.

Arethusa. In Greek mythology, a beautiful wood nymph, attendant of Artemis (Diana). When the passionate river god Alpheus

pursued Arethusa, she was saved from him by Artemis who changed her into a fountain. She became the patron of the Ancient Greek City of Syracuse, Sicily, where the Fountain of Arethusa still exists.

Argonauts. See: JASON.

Ariadne. In Greek mythology, daughter of King MINOS of Crete and Pasiphae. Ariadne fell in love with THESEUS, the Athenian hero who was confined in the LABYRINTH to be devoured by the MINOTAUR. Providing him with a ball of thread, she helped THESEUS find his way out of the maze after killing the monster. Together they left CRETE, but before they reached Greece, THESEUS abandoned Ariadne on the Island of Naxos. There, DIONYSUS (Bacchus) consoled her, then married her and they had several children.

Aries. See: ZODIAC.

Armature. A rigid metal framework, constructed by a sculptor, to support the forms modeled upon it.

Armory Show, The. In 1913, the Armory Show was held at the 69th Regiment Armory in N.Y.C. It introduced POST-IMPRESSIONIST art to the U.S. Matisse, Picasso, Braque, Legér, Vlaminck, Kandinsky and Duchamp were some of the artists exhibited. "Nude Descending a Staircase" by Duchamp created the greatest furor in the show which paved the way for a change in American Art.

Armature

Ars Phantastica. See: FANTASTIC ART.

Art Brut. A rough, raw, unpolished and "anti-cultural" style that leans on the art of the insane, the PRIMITIVE and the naive (i.e. children). GRAFFITI-like drawing on crude materials express the anguish of the artist in simple, direct appeal. Artist: Jean Dubuffet.

Art Deco. Style derived from and closely related to ART NOUVEAU. Beginning early in the 20th century, Art Deco reached its height in the 1920s and 1930s. Incorporating technological development, it created decorative items that were suave, sleek and shiny; sometimes regarded as KITSCH. The Art Deco style affected architecture, furniture, fabric, CERAMICS, glassware, rugs, bookbinding, GRAPHICS, fashion, theatre and industrial design.

Art Informel. See: TACHISME.

Art Nouveau, Jugendstil. ("Jugendstil" after the magazine Jugend, meaning youth, which was published in Art Nouveau style in 1896 in Munich.) Both a style and a movement, Art Nouveau is charac-

terized by decorative highly STYLIZED MOTIFS from nature (flowers, leaves, branches). Spear-headed by the Arts and Crafts Movement of William Morris, and strongly influenced by the British magazine "Studio", Art Nouveau spread to the continent in the 1890s and early 1900s. It signaled the end of the symbolic romantic past and the beginning of APPLIED ART. Artists consciously set out to revolutionize design in interiors, architecture, household objects, posters and book illustrations, affecting almost all art forms. Because of the interest in objects of use rather than objets d'art, and because of its LINEAR style, some art historians trace the roots of Art Nouveau to Far Eastern and Pre-Greek MINOAN Art. Interest in Art Nouveau revived in the 1960s when some artists returned to its style and themes.

Artists: In England: William Morris, Aubrey Beardsley.

In Holland: Henri Van de Velde, Victor Horta.

In France: Hector Guimard.

Art Nouveau is also known as Le Style Moderne and Style Metro.

Arte Povera. See: CONCEPTUAL ART.

Artemis. In Greek mythology, the daughter of ZEUS and Leto, she was the virgin goddess of the hunt, goddess of wildlife, chastity and childbirth. Counterpart to her twin brother APOLLO, the sun god, she was the moon goddess. Artemis was known by many names: Cynthia, Luna, Phoebe and others. Attributes: Crescent moon, bow and arrows. Roman counterpart: DIANA.

Ascension. Portrays Jesus being lifted to heaven forty days after the CRUCIFIXION as his disciples watch on the Mount of Olives. Popular subject, especially with RENAISSANCE artists. (Luke 24:50-53)

Asclepius. Greek god of medicine and healing, son of Apollo and Coronis. By his wife Epione, he had two sons famous in medicine, Machaon and Podalirius and one daughter, Hygeia, goddess of health. The serpent and the cock were sacred to Asclepius. He is usually represented with staff and serpent, the symbol of the medical profession. Originally it was staff and one serpent, but in the 16th century the caduceus of HERMES with its two serpents replaced the symbol of Asclepius.

Ashcan School. Originally known as THE EIGHT, this group of American realist painters, at the beginning of the 20th century tried to free American painting from academic domination. Their work focuses on various aspects of urban life, especially of New York City. Painters: George Bellows, Robert Henri, George B. Luks.

Assemblage. Art work in which diverse materials, Ready-Made objects (FOUND OBJECT) or fragments, are joined together to form one three-dimensional composition. An assemblage can be constructed like a COLLAGE, like JUNK SCULPTURE, and like ENVIRON-MENTAL ART. Rauschenberg coined the term 'combine' for his combination of paintings and objects, which are either loosely connected, or glued to the picture.

Painters: Robert Rauschenberg, Jean Tinguely.

Sculptors: Louise Nevelson, H.C. Westerman, Alexander Archipenko.

Assumption of the Virgin. An early Christian legend which tells that after the soul of MARY had been taken to heaven by CHRIST, her body was later lifted from earth by ANGELS. The assumption of MARY is often depicted with St. THOMAS near the open tomb.

Atelier. (ah tel YAY) French term meaning painter's or sculptor's workshop or studio.

Athena. Greek goddess of wisdom, prudent warfare, the arts and crafts. She sprang fully grown and fully armed out of the head of ZEUS. In art, Athena is usually represented as a draped figure, wearing a helmet and holding a spear and shield. Sometimes a breastplate adorned with the head of a monster (GORGON) covers her chest. Roman counterpart: MINERVA.

Athens. Named after its patron goddess ATHENA, Athens was the center of ancient Greek culture. In the Age of Pericles, 5th century B.C., Athens reached its height. The PARTHENON was erected, sculpture and painting flourished and eminent Greeks came to Athens.

Atlas. In Greek mythology, a TITAN who joined CRONUS in defend-ing the TITANS against the OLYMPIANS. ZEUS, son of CRONUS, and the victorious OLYMPIANS, condemned Atlas to hold the sky on his shoulders forever (thus preventing the sky from falling).

Augustine, St. (5th century). Theologian, one of the four LATIN FATHERS of the church. Resisting Christianity in his youth, he was later converted and baptized by St. AMBROSE, then bishop of Milan. Returning to his native Africa, St. AMBROSE, then bishop of Hippo. Through his brilliant writings and spiritual example, he greatly influenced Christian religion. In paintings, he usually wears the mitre and vestments of a bishop and often holds one of his books. Attributes: Heart pierced by arrow or by flames, and a child.

Aureole. Radiance that encircles the head or the whole figure of deities or saints. See also: HALO.

Automatism. Action without conscious direction, like doodling. One of the techniques used by the SURREALISTS to express unconscious thoughts. This concept accentuates the intuitive, the irrational and the accidental in the creation of a work of art. Painters: Max Ernst, Robert Motherwell, Jackson Pollock.

Avant-Garde Art. Experimental art ahead of the general trends of a period.

B

Babel. The story of the tower of Babel tells of the descendants of NOAH who set out to "build a tower with its top in heaven . . . to make a name for themselves." God, angered at their pretentiousness, scattered the people over the face of the earth, and the tower was never finished. Artists have chosen this subject, especially in times of social crisis, to symbolize man's overestimation of his own powers. (Genesis 11:91-9).

Bacchae, Bacchantes. Female followers of BACCHUS. See: MAENADS.

Bacchus. Roman god of wine. See: DIONYSUS.

Baptism of CHRIST. In the Jordan River CHRIST was baptized by St. JOHN THE BAPTIST. In paintings, CHRIST stands in the river as St. JOHN pours the water over his head and the dove of the Holy Ghost descends from God the Father. Two angels stand on the bank ready to clothe the naked CHRIST when he steps from the river. (Matthew 3:13-17).

Barbara, St. (3rd century). Virgin and martyr. Contradictory legends surround her life. It is said that her pagan father imprisoned her in a two-windowed tower to prevent her conversion to Christianity. To pursue her religious passion, in spite of the imprisonment, St. Barbara arranged for a priest, disguised as a physician, to instruct and baptize her. She then ordered a third window to be cut into her tower as a symbol of the TRINITY. When her father learned of her conversion, he cut off her head in rage. On his return home he was killed by a crash of thunder and lightning. Thus St. Barbara became patroness of artillery, soldiers, fire fighters and all exposed to sudden death. Attributes: a tower with three

windows which appears behind her or in her hand, the sacramental cup and wafer, a peacock's feather.

Barbizon School. Group of French realistic landscape painters active in the mid-19th century. They executed profound paintings of simple and common themes of nature, like the field and the forest. In reproducing the effects of light, they paved the way for the subsequent movement of IMPRESSIONISM. Painters: Charles-Francois Daubigny, Pierre-Etienne-Theodore Rousseau, Jean-Francois Millet.

Baroque. (Portuguese barocco: bent-round). 17th and 18th century period in Western Civilization that is characterized by a reaction to the restraint of the classical ideals of the RENAISSANCE. In art it is an exuberant, often fantastic style which emphasizes light and shade, rather than form, and which prefers curves and spirals to the straight line. All arts join: painting, sculpture, architecture; all media are used together: marble, bronze, STUCCO, FRESCO. Christian and pagan MOTIFS coexist happily, and the artists break the barriers between reality and illusion, reason and faith. It is characteristic of Baroque art that, in spite of involved, irregular detail, the whole composition is harmonious. Painters: Rembrandt Harmensz Van Rijn, Peter Paul Rubens, Michelangelo da Caraveggio. Sculptors: Giovanni Lorenzo Bernini, Egid Quirin Asam, Georg Raphael Donner.

Basilica. Originally, a Roman public hall for administering justice, or transacting business. In the 4th century, Christian churches adopted the term and the plan (a wide central area flanked by aisles, separated by columns). Today the term denotes very large Catholic cathedrals.

Bas-Relief. See: LOW RELIEF.

Basso-Relievo. See: LOW RELIEF.

Bauhaus. (BOUGH house) German school of design founded by Walter Gropius at Weimar in 1919 with the aim of restructuring society by reshaping the environment. In 1926 it was moved to Dessau and in 1933 it was closed by Hitler. Architects, artists and industrial designers were trained by "masters" in their fields to design functionally everything from soup plates to skyscrapers. In creating products appropriate to modern industrial media and environment, the Bauhaus attempted to integrate art, science and technology, and thus to bridge the gap between pure and applied art. Painters: Lyonel Feininger, Paul Klee, Wassily Kandinsky. Related to: INTERNATIONAL STYLE and FUNCTIONAL ART.

Benedict, St. (6th century) Founder of the Benedictine Order of monks. Established the monastery at Monte Cassino where he wrote the basic rules of Western monasticism. In paintings he is shown with flowing beard, wearing the black robe of the original order or the later white robe. Attributes: dove, raven with a loaf, broken wine cup, sieve. Each attribute refers to an episode in his life.

Bernard, St. (12th century). Established monastery at Clairvaux at 25. As great spiritual leader of all Europe, he influenced the kings of England and France. Usually, he is represented in a white habit with book and pen in hand. Attributes: demon in chains (his defeat of heresy); three mitres at his feet (three bishoprics he refused); beehive (his eloquence); Cross and instruments of the PASSION (his main mystic writing, "The Meditations").

Bernard of Siena, St. (15th century). Franciscan missionary. Major influence in religious and public affairs. Accused of heresy because in his preaching, he used a tablet inscribed with the letters IHS (Greek letters symbolizing the name of Jesus). Following the trial, at which Bernard was acquitted, public display of the name Jesus was permitted. Bernard is usually represented in art with a thin and clean-shaven chin, wearing the Franciscan habit. Attributes: Monogram of IHS inscribed on a book or the sun; mitres (symbolic of three bishoprics he refused).

Betrayal. Usually refers to Judas Iscariot's betrayal of CHRIST to the high priests. As CHRIST and his disciples were leaving the garden of Gethsemane, Judas identified CHRIST for the soldiers by kissing him. The Kiss of Judas is a frequent subject in painting. (Matthew 26:47-50; Mark 14:43-52; Luke 22:47-54; John 18:1-13).

Biedermeier. A version of German ROMANTICISM reflecting 19th century petit-bourgeois values of comfort, quality, and security. Painting and sculpture of this movement can be described as decorative REALISM. Extremes in form or color were avoided, and the world was obviously a place to be enjoyed. Painters: Carl Spitzweg, Ferdinand Waldmüller.

Binder. Substance that is mixed with the PIGMENT to make them stick to each other and to the surface. For example: oil, egg, glue, wax.

Biomorphic Forms. Organic free shapes, similar to biological forms such as amoeba, first used in art by Arp and Miró and adopted

by the SURREALISTS. Painters: Jean Hans Arp, Joan Miró, Arshile Gorky.

Black Art, Afro-American Art. Art of any style or movement, ABSTRACT or realistic, produced by black Americans. Black art is often created in response to pressures growing out of social and political problems and racial stresses in the United States. Therefore, as a social, communicative or "soul" art, it is frequently expressed in terms of REALISM. Painters: Benny Andrews, Dana Chandler, Romare Bearden.

Black-Figured. Technique of Greek vase painting practiced primarily in the 7th and 6th centuries B.C. in which figures were painted in black on a reddish-brown or yellow-beige background. Painter: Exekias.

Blau Reiter, (BLOU uh WRITER) Der. See BLUE RIDER.

Blessing of Jacob. See: JACOB.

"Blow-Up" Art. See: INFLATABLE SCULPTURE.

Blue Rider (Der Blaue Reiter). Group of EXPRESSIONIST painters organized in Munich in 1911 by Wassily Kandinsky and Franz Marc. Unlike the BRIDGE, this group did not want to promote one style, but to encourage contemporary trends of various nations. The only common denominators of their work are their reliance on FAUVISM and the use of abstract form. The group broke up when Franz Marc and August Macke died in World War I; later some members went on to BAUHAUS. Other painters: Paul Klee, Alexey von Jawlensky.

Book of Hours. Devotional manual containing prayers for the seven canonical hours (times set for prayer). In the Middle Ages, Books of Hours were richly decorated manuscripts which reflected the special interest of their owners. In the 15th and 16th centuries these books were also printed. For example: Duc de Berry, Maestricht Book of Hours, The Hours of Jeanne D'Evreux.

Bridge, The. (Die Brücke). First German EXPRESSIONIST group founded in 1905 to "bridge" traditional art with new forms of PAINTERLY expression. Influenced by Van Gogh, Gauguin, and the FAUVES, the paintings are characterized by bold color and exaggeration of form. Members of the Bridge shared the contemporary interest in PRIMITIVE art and revived WOODCUT and other GRAPHIC ARTS to give these techniques new dimensions. Painters: Ludwig Kirchner, Karl Schmidt-Rottluf, Erich Heckel.

Brücke, Die. (BRI ke, dee) See: BRIDGE, THE.

Buon Fresco. See: FRESCO.

Burin (Graver). Hand tool used to cut the lines into metal or wood in ENGRAVING.

Burr. Ridge of metal ploughed up on either side of a line by a BURIN cutting into metal in engraving. In line ENGRAVING the burr is carefully removed to leave a clean line. In DRY POINT the burr is left on the plate to give the print a soft, velvety quality.

Byzantine Art. Art of the Christian East Roman Empire from the 4th to the 15th centuries. Amalgamating HELLENISTIC and Oriental influences, a style characterized by formal design and luminous colors developed. Artists had relatively little freedom because church and emperor prescribed the content and even regulated the form. For example, in order to avoid sensuousness, paintings had to omit any indication of dimensions or PERSPECTIVE. Numerous ICONS, lavish MOSAICS as in Ravenna and Constantinople, and highly decorative ILLUMINATIONS in dyed parchment manuscripts were produced and influenced artists of many countries. Broadly applied the term Byzantine may refer to luxurious or ostentatious styles.

Caiaphas, CHRIST before. After the BETRAYAL in the Garden of Gethsemane by Judas Iscariot, Jesus was arrested and brought before Caiaphas, high priest of the Jews and accused of blasphemy. Mark (14: 53-65).

Calligrammes. Poems in which the words or letters are arranged to make a work of art (i.e. a visual image of a heart, a lamb, a fish) to reflect the meaning of the text. Calligrammes were popular in the Roman Empire, during the Middle Ages and again with 20th century artists. Artists: Guillame Apollinaire, Saul Steinberg, Johannes Itten.

Calligraphy. The art of writing, especially fine or decorative penmanship, as compared with casual writing.
Abstract Calligraphy, Lettrisme. A method of combining letters, syllables or words in order to create a visual effect. For example: Ferdinand Knivet, Isidor Isou, Dieter Rot. See also: CALLI-GRAMMES.

Calliope. See: MUSES.

Calvary, Bearing of the Cross. Calvary, or Golgotha (Heb. 'place of the skull' – the place reserved for capital punishment) or Via Cruces is the place where Jesus was crucified. Most paintings, following the version of St. John (19:17), depict CHRIST himself carrying the cross. The other EVANGELISTS record that Simon of Cyrene carried the cross for Jesus. (Matthew 27:32; Mark 15:21; Luke 23:27).

Calypso. A nymph in Greek mythology. She lived on the island of Ogygia where ODYSSEUS spent seven years with her after being shipwrecked. She offered him immortality if he would remain, but he refused and moved on.

25

Campanile. Italian term for a tower with bells usually built near but not attached to a church. For example: Leaning Tower of Pisa.

Cancer. See: ZODIAC.

Capital. Top or head of a column often decorated in the style of the period. For example:

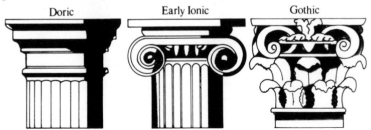

Doric Early Ionic Gothic

Capitol. The ancient temple of JUPITER at Rome.

Capricorn. See: ZODIAC.

Carolingian Art. Art of the Frankish dynasty (8th-10th centuries) that reached its height under the rule of Charlemagne. Determined to build a civilization that combined classical and Christian ideals, Charlemagne invited scholars, artists and craftsmen to his court and supported centers of learning and creativity throughout his empire. Manuscripts produced in monastaries of the "Carolingian Renaissance" belong to the most coveted art objects. The ILLUMINATIONS and the Carolingian writing are influenced by BYZANTINE, CELTIC and Roman art.

Carthage. Famous ancient city on the northern shore of Africa, near modern Tunis. Founded by DIDO (a Phoenician) in the 9th century B.C., it was destroyed in the Punic Wars in 146 B.C.

Cartoon. Originally a full-size drawing for a painting made to be transferred to a wall, canvas or panel. Today it means a humorous drawing.

Cartouche. (Fr. = round case). A frame designed to set a picture or message apart from its background. In Egyptian hieroglyphic writing, the names of gods or kings were written in oblong cartouches. In BAROQUE art, elaborately designed cartouches framed coats of arms or served as general decoration.

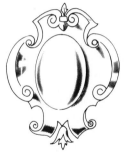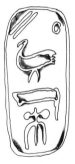

Caryatid. Draped female figure used as a column to support a building. For example: Caryatids of the Erechtheum on the ACROPOLIS at ATHENS.

Cassandra, the prophetess of gloom. In classical mythology, a Trojan princess, the most beautiful of the twelve daughters of Priam and Hecuba. To win her love, APOLLO granted her the power of prophecy. As soon as Cassandra had this gift, she reneged on her promise to satisfy APOLLO'S passion, who then caused her fateful prophecies never to be believed. Cassandra, also known as Alexandra, appears on Greek vase paintings and in later illustrations of the Trojan War.

Cassone. Italian marriage chest. During the RENAISSANCE, these chests were richly decorated on the front and sides with mythological, scriptural, chivalric and other subjects.

Casting. Process of duplicating a three-dimensional object in metal (usually bronze) by pouring a hardening liquid or molten metal into a mold. See also: LOST WAX PROCESS.

Castor and Pollux. See: DIOSCURI.

Catacomb. Underground burial place used by the Romans and Early Christians. MURALS, paintings, sculptured monuments and holy relics decorated the catacombs. Earliest examples of Christian art have survived in catacombs.

Cave Painting. MURAL painting, usually of animals, on walls of caves dating from about 40,000 B.C.-3,000 B.C. For example: Altamira in Spain and Lascaux in France.

Cecilia, St. (3rd century). Virgin and martyr. She married Valerian and converted him to Christianity. When Valerian and his brother Tiburtius (who was also baptized) went out to preach the gospel of CHRIST, the governor of Rome had them and Cecilia executed.

Supposed to be the inventor of the organ, Cecilia could play any musical instrument. She is patron saint of music and musicians. Usually, Cecilia is portrayed listening to music; singing or playing musical instruments. Attributes: organ, harp, lute, viol; crown of roses or lilies.

Celtic Art. Art of the Celts, Indo-European people who became powerful in the 1st century B.C. and settled in Northern France and the British Isles. Influenced by eastern Mediterranean sources, Celtic tribes skilled in bronze and iron working, made stone carvings, bronze and silver objects, gold jewelry and coins. Fantastic animals, stylized human form and designs from daily used objects like baskets and clasps, formed the basis of their highly ornamental, curvi-linear art. ILLUMINATED manuscripts produced in Ireland and Northumbria from 7th to 10th centuries were based on Celtic Art. For example: Book of Kells, Lindesfarne Gospels.

Centaurs. In Greek mythology, a race of monsters living in Thessaly in northern Greece. Centaurs had the head, trunk and arms of a man and the body and legs of a horse. After attending the wedding of the king of the Lapiths, the intoxicated centaurs attacked the bride and guests. The battle between the centaurs and the Lapiths is a frequent subject of Greek art.

Ceramics. Collective term for objects made of baked clay, including various forms of pottery, bricks, and tiles.
Ceramic techniques include:
1. *Earthenware.* Baked clay which is neither painted nor glazed, and shows its original color.
2. TERRA COTTA. Unglazed and unpainted clay which is fired longer, and therefore harder than earthenware.
3. *Faience and Majolica.* Baked clay with colorful designs which are covered with a highly glossy glaze. Named after the famous pottery towns Faensa (Italy) and Majorca (Spain).

Ceres. Roman goddess of agriculture. See: DEMETER.

Chalice. Cup, in art especially; precious vessels used for the wine in religious ceremonies.

Champlevé. See: ENAMEL.

Charon. In Greek mythology, the ferryman who transferred the souls of the dead across the river Styx. The fee for such service was a coin placed in the mouth of the dead at the time of burial.

Cherubim. ANGELS of the First Order representing 'Divine Wisdom' and often depicted holding books. They are often por-

trayed in golden yellow or blue and frequently found in representations of the MADONNA and Child. See also: ANGELS.

Chiaroscuro. (key AH ro SKOO ro) (It. chiaro = bright; oscuro = dark) Emphasis on light and shade in a picture. For example: Paintings of Rembrandt, Caravaggio.

Chimera. A mythological fire-breathing monster with the head of a lion, the body of a goat, and the tail of a serpent. This grotesque creature is often depicted in decorative arts.

CHRIST At The Column. See: FLAGELLATION.

CHRIST Blessing the Little Children. As the children were brought to CHRIST, the disciples scolded them, but Jesus called them to him and blessed them. Paintings on this subject are usually entitled "Suffer Little Children to Come unto Me." (Matthew 19:13-15).

CHRIST Calling APOSTLES PETER and Andrew. When Jesus began to preach, he came to the Sea of Galilee and saw two brothers casting a net into the sea. He said to them, "Follow me, and I will make you fishers of men." PETER and Andrew became his first disciples. This scene is frequently depicted in RENAISSANCE paintings. (Matthew 4:18-19).

CHRIST Cleansing the Temple. It was Passover time and Jesus went to the temple and found people dealing in money and buying and selling food. Enraged at seeing the temple used as a marketplace, he overturned the tables covered with coins and drove the traders from the temple. Paintings on this subject are also called "CHRIST Driving the Moneychangers from the Temple." (John 2:13-16).

CHRIST Crowned With Thorns. See: MOCKING OF CHRIST.

CHRIST's Entry into Jerusalem. This first scene of CHRIST's PASSION depicts his triumphal entry into Jerusalem. Just outside one of the gates to Jerusalem, CHRIST sends two of his disciples for an ass. They bring it, cover it with their clothing and CHRIST rides on it. Spreading palm branches and clothing along the way, the people wildly cheer the arrival of Jesus. (Matthew 21:1-11) (Mark 11:1-11) (Luke 19:28-44) (John 12:12-19).

CHRIST in Limbo, Descent into Hell, Descent into Limbo, Harrowing of Hell. According to Christian doctrine, between the ENTOMBMENT and the RESURRECTION, CHRIST descended into Hell. Hell or Limbo was a special place for the souls of good people who were awaiting the redemption of men's souls through CHRIST'S sacrifice on the cross before they could be admitted into heaven. Among those freed by CHRIST were ADAM and EVE. (Apocryphal "Gospel of Nicodemus, or the Acts of Pilate.")

29

Christ, Jesus. (ca 4 B.C. to 29 A.D.). Founder and chief object of worship of Christianity; regarded by the Christians as the Messiah, prophesied in the Old Testament.

Popular Themes:

ADORATION OF THE MAGI
ADORATION OF THE SHEPHERDS
AGONY IN THE GARDEN
ANNUNCIATION TO THE SHEPHERDS
ASCENSION
BAPTISM OF CHRIST
BETRAYAL
CAIAPHUS, CHRIST BEFORE
CALVARY, THE ROAD TO
CHRIST CALLING THE APOSTLES PETER AND ANDREW
CHRIST IN LIMBO or DESCENT INTO HELL
CHRIST WALKING ON THE WATER
CRUCIFIXION
DESCENT FROM THE CROSS; DEPOSITION
ECCE HOMO
EMMAUS
ENTOMBMENT
FLAGELLATION; CHRIST AT THE COLUMN
FLIGHT INTO EGYPT
GOOD SAMARITAN
INCREDULITY OF THOMAS. SEE: THOMAS, St.
LAST JUDGMENT
LAST SUPPER
LAZARUS, THE RAISING OF
MARRIAGE AT CANA
MASSACRE OF THE INNOCENTS
MOCKING OF CHRIST; CROWNING WITH THORNS
NATIVITY
NOLI ME TANGERE
PASSION, CHRIST'S
PETER, DENIAL OF
PIETÀ
PILATE, CHRIST BEFORE
PRESENTATION IN THE TEMPLE
PRODIGAL SON
RESSURECTION
SERMON ON THE MOUNT

STATIONS OF THE CROSS
TRANSFIGURATION
TRIBUTE MONEY
TRINITY
Symbols for Jesus: a MONOGRAM, a fish or a lamb. Jesus is repre-
sented as a Good Shepherd, an idealized youth, a bearded ascetic.

CHRIST Pantocrator. (The Almighty Ruler of the Universe). An
image of CHRIST that combines the transcendent yet ever-present
qualities of God the Father with the features of the Son. In all
pantocrator representations, the eyes of CHRIST seem to be
fixed on, and following the viewer.

CHRIST Walking on the Water. Christ sent his desciples ahead to
cross the Sea of Galilee in a boat. As a storm came up, miracu-
lously, CHRIST came walking to them on the surface of the
water. When Jesus came into the boat, the storm ceased. St.
PETER then left the boat and tried to walk on the water but he
failed and CHRIST reached out and saved him. (Matthew
14:22-33; Mark 6:45-52; John 6:15-21).

Christopher, St. (Gr. Christ-Bearer) (3rd century) Martyr. A giant
from the land of Canaan, Christopher wished to serve the most
powerful monarch in the world. First he served a rich and powerful
king, but he learned that the king feared Satan; then he served
Satan but he learned that Satan feared CHRIST; so he left Satan
and served CHRIST by helping people cross a flooded stream with
the aid of an uprooted palm tree.
One night a small boy asked Christopher to carry him across the
river. When the burden felt heavier and heavier, Christopher asked
the child who he was, and learned that he was CHRIST himself.
Christopher is patron saint of travelers. Christopher is often repre-
sented grasping a palm-tree staff wading through the water carry-
ing the CHRIST Child on his shoulders. Related to: HERCULES
carrying the sphere in Greek mythology.

Chronos. See: CRONUS.

Ciborium. See: ALTAR.

Cinquecento. (CHEENG kwi CHEN toe) Sixteenth century in Italian
art; the High RENAISSANCE in which Rome came to the forefront.
Painters: Leonardo DaVinci, Raphael, Michelangelo. Sculptor:
Michelangelo.

Circe. In Greek mythology, an enchantress who lived on the
island of Aeaea where she decoyed sailors and changed them
into beasts. After the Trojan War, when ODYSSEUS visited

her, she changed his companions into swine. Aided by HERMES, ODYSSEUS forced Circe to break the spell and restore his men.

Cire Perdue. See: LOST WAX.

Circumcision of CHRIST. See: PRESENTATION.

Classical Abstraction. See: ABSTRACT CLASSICISM.

Classical Art. 1. Greek and Roman art from approx. 500 to 300 B.C. Harmonious and well proportioned, the art of this period achieves serenity, rationality and a sense of balance. Sculptors: Pheidias, Polyclitus, Lysippus. Architecture: The PARTHENON.
2. Art based on the clear, rational, harmonious balance characteristic of Ancient art. For example: NEO-CLASSICISM. Painters: Jacque Louis David, Jean-Auguste Ingres. Contemporary classical sculptors: Aristede Maillol, Henry Moore.

Cleopatra. (69 B.C.-30 B.C.). Queen of Egypt, famous for her charm and her intrigues.
Popular themes:
1. Anthony and Cleopatra on her luxurious barge on the Nile.
2. Cleopatra holding an asp to her breast after her defeat by Augustus.

Clio. See: MUSES.

Cloissonism. See: SYMBOLISM.

Cnossus. See: KNOSSOS.

Cobra Group. A continental European movement of ABSTRACT EXPRESSIONISTS in the late 1940s and early 1950s. The name is an acronym for the places from which most of the members came: *Co*penhagen, *Br*ussels, and *A*msterdam. Artists: Karel Appel, Asger Jorn.

Collage, Papiers Collés. (Fr. colle = paste) Compositions made of scraps of paper, cloth, string, hair and other usually irrelevant materials. The items are glued or welded on a plane, and space is created by the actual overlapping of layers, not by ILLUSIONISTIC techniques like FORESHORTENING. The use of collage marks the end of analytical CUBISM. Collages can be purely playful or have a definite aesthetic or social message. Artists: Kurt Schwitters, Pablo Picasso, Joseph Cornell. See also: ASSEMBLAGE.

Color. Sensation of our vision, produced by light waves emanating from our environment. Perception of color is a complex physical and psychological process in which the colors of the SPECTRUM are partly reflected and partly absorbed.*

32

Colors represent and can influence human emotions, and in different cultures have different symbolic meaning. For example, in the Roman Catholic church, pure white is the color of purity for Christmas and Easter; red is the symbol of fire, blood and passion for martyr's feast days; and violet stands for penance at Advent and Lent.

*The painter's color circle includes the colors of the SPECTRUM.

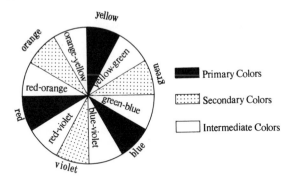

Complementary colors appear opposite each other. Warm colors lie within the red–yellow section. Cool colors are within the green–violet section.

Color-Field Painting, Abstract Image Painting, Post-Painterly Abstraction, COOL ART. Growing out of ABSTRACT EX-PRESSIONISM, Color-Field Painting emerged as an important movement in the 1960s. It focuses on a single central abstract image in large fields of color thus creating a dominant enveloping presence and emphasizing the expressive power of color. Color-Field Painting reduces a work of art to the bare essentials (canvas and color) by eliminating ILLUSION, PERSPECTIVE, naturalistic and even NON-OBJECTIVE elements. Painters: Morris Louis, Ad Reinhardt, Helen Frankenthaler. Related to: MINIMAL ART.

Color-Staining, Pictorial Method. A technique of COLOR-FIELD PAINTING. The paint is thinned with turpentine and soaked into the untreated canvas, so that the paint sinks in. The marks of pouring and brush disappear. Canvas and color become one and the same. There is no foreground or background. Painters: Helen Frankenthaler, Morris Louis, Paul Jenkins.

Combines. See: ASSEMBLAGE.

Complementary Color. See: COLOR.

Composition. Organization and arrangement of the elements of a work of art. Lines, forms, colors or objects, figures and light can be the components whose relationship determines the composition.

Conceptual Art, Process Art, Idea Art, Impossible Art, Anti-Illusion Art, EARTHWORKS. Art movement of the 1960s to date. Emphasis is on the idea and on the process of making a work of art rather than on the end product. The artists take great care not to present their own concepts, but to force the viewer to develop his own. They want him to be not only receptive, as in traditional art, but productive: "Live with your head" is their demand. The artist's materials include a great variety of media, including rocks, wood, hay, felt, grease, rope and hair. Procedures range from expert carpentry to random improvisation. Movements and methods related to Conceptual Art are: Anti-form, Arte Povera, Literalism, Micro-emotivism, Procedures, Radical Art. Conceptual Art is characterized by a complete break from formal aesthetic concepts and the question is often asked whether this is a new dimension of art or a visual social commentary. Artists: Keith Sonnier, Michael Goldberg, Richard Serra.

Concrete Art. Specifically applies to the geometric ABSTRACT ART of the Dutch artists Mondrian and Van Doesburg. It treats the painting as a concrete, independent entity; not as something abstracted from nature.

Concrete Expressionism. See: HARD-EDGE.

Constructivism. Beginning in Russia around 1913, this NON-OBJECTIVE ART movement strongly influenced modern European art of the 1920s.

Constructivism, and the whole tradition of constructed sculpture is now believed to be derived from the first known constructed sculpture 'Guitar', created (1911-1912) by Picasso, as well as the COLLAGE constructions of CUBISM.

Constructed sculpture presented a new concept, the importance of sculptural space; the voids became the forms defined by the lines. Before the new concept, sculpture in western art was solid mass CAST in bronze or MODELED in steel or wood; it now became open in form, built from metal, wire, plastic or wood.

The artists of Constructionism created art in space, combining geometric abstractions and industrial materials in logical structure to symbolize the relationship between art and everyday environment. Related to: SUPREMATISM, CUBISM, DE STIJL, BAUHAUS, HARD-EDGE, MINIMAL ART and OP ART. Sculptors: Vladimir Tatlin, Antoine Pevsner, Naum Gabo.

Cool Art. Style of the 1960s, characterized by calculation, impersonality and disengagement. The term was coined by art critic, Irving Sandler. See also: COLOR-FIELD PAINTING, SYSTEMIC ART.

Cool Colors. See: COLOR.

Coptic Art. Usually refers to Early Christian art in Egypt from the 4th to the 7th centuries. It is highly stylized, flat and decorative with abstract and geometric shapes. Wall paintings, figure sculpture, textiles and rugs are based on religious subjects from the Old and New Testaments. There is also contemporary Coptic Art in Egypt.

Copy, Facsimile, Replica, Reproduction.
Copy. Reproduction of an original work of art usually executed by someone other than the original artist. Generally in the same form as the original, a copy may differ in size and material. It is usually produced sometime after the original.
Facsimile. Reproduction intended to achieve the greatest possible likeness to the original. Obtained sometimes by artistic means, purely mechanical processes, such as photography and heliogravure, are usually employed today.
Replica. Exact copy of an original work executed by the original artist or under his supervision. (Usually refers to sculpture or other three-dimensional objects.)
Reproduction. A general term describing a copy or duplicate of an original work, usually produced sometime after the original, and often using mechanical means.

Corinth. Wealthy and powerful city in ancient Greece on the Gulf of Corinth. The city and the Temples of APOLLO and APHRODITE in Corinth appear in art works relating to APOLLO, POSEIDON, THESEUS, JASON, MEDEA and ATHENA.

Cornucopia. In Greek mythology, a horn of plenty, often represented as filled with fruit and flowers. It is said to have been the horn of the goat Amalthea (that suckled the infant ZEUS) or, in Roman mythology, the horn of the river-god Achelous. As an attribute to several gods and goddesses who bestow mankind with the riches of nature, the cornucopia is frequently depicted in paintings with classical themes.

Coronation of the Virgin MARY. The frequently depicted final stage of the life of MARY. Jesus receives his mother in heaven and crowns her as the Queen of Heaven.

Cressida. A character created in Medieval times, portrayed as the lover of the Trojan hero, TROILUS. She swore to be

faithful to TROILUS but deserted him for Diomedes, another brave hero in the Trojan War.

Crete. Largest of the Greek Islands in the Aegean Sea; seat of MINOAN civilization (named after King MINOS) which reached its height in 1600 B.C. Some of the characters in Greek legend related to Crete are: ZEUS and EUROPA; King MINOS and his wife Pasiphae ruling from the palace of KNOSSOS; THESEUS, the MINOTAUR, DAEDALUS and ARIADNE.

Cronus, Chronos, Kronos. In Greek mythology, the god of time, a TITAN: youngest son of URANUS and GAEA. He dethroned his father, made himself ruler of the world and married his sister RHEA. They were the parents of six of the twelve OLYMPIANS—ZEUS, HADES, POSEIDON, DEMETER, HERA and Hestia.
On learning he would be overthrown by one of his children, Cronus swallowed them all except ZEUS, whom RHEA hid, and who later overthrew him. Roman counterpart: SATURN.

Cross. One of the earliest and most widely used symbols. Traced back to the Tree of Paradise, the cross may be found in various forms in the ancient cultures of India, Egypt, and the American Indian. Among Christians, it is the symbol of the PASSION recalling the CRUCIFIXION of Jesus.
Shapes of the cross most frequently represented in art:

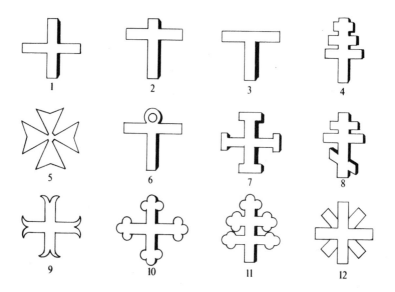

1. Greek Cross
2. Latin Cross
3. Egyptian Cross - also Antonius Cross
4. Papal Cross
5. Maltese Cross
6. Egyptian Ankh-Cross, Handle Cross
7. Jerusalem Cross (four Ts, related to the Egyptian Cross)
8. Eastern Orthodox Cross
9. Cross Fleury, Flowering Cross
10. Cross Botonée, Budded Cross - often used on top of Christian flag.
11. Cardinal's or Patriarch's Cross
12. Double Cross

Cross Hatching. See: HATCHING.

Crucifixion. CHRIST nailed to the cross with a sign above his head reading 'Jesus of Nazareth, the King of the Jews.' Representations vary. Some have him flanked by MARY and JOHN; others add the two other Marys; others include the two thieves who were crucified with CHRIST; others show two soldiers, one holding the reed topped by the vinegar sponge from which CHRIST drank. After CHRIST died, one of the soldiers pierced his side. (Matthew 27:35-56; Mark 15:22-41; Luke 23:32-49; John 19:17-37).

Crypt. A vaulted chamber, wholly or partly underground. It is usually located beneath a church and used as a place for burials or special services. It is believed to have developed from the CATACOMBS.

Cubism. Perhaps the most influential art movement and style of the early twentieth century. Although not entirely abstract, it pointed the way toward ABSTRACT ART. Cezanne had already suggested that all natural shapes can be reduced to cone, cylinder and square. The Cubists, then, led by Braque and Picasso and influenced by African sculpture, began to transform systematically, natural forms into geometric shapes. The movement developed through three stages:
Facet Cubism (approximately 1906-1909) Objects were dissected into geometrical units or facets and arranged into compositions that were not related to the original objects.
Analytical Cubism (1909-1912) Objects were broken down further and arranged on the canvas (painted or as COLLAGE) and in sculpture so the viewer could see the front, sides and back of a figure simultaneously. Color received little attention.
Synthetic Cubism (1912-1914) the last stage of Cubism, super-imposes one flat area on another. Whereas Analytical Cubism breaks apart forms, usually giving a calculated appearance, Synthetic Cubism organizes the elements more fully, re-introduces color and becomes more illusionary. Painters: Georges Braque, Juan Gris, Pablo Picasso. See also: CUBIST REALISM.

Cubist Realism, Precisionism. Post-Cubist American art movement in the 1920s characterized by clarity of form, precise lighting and rigid draftsmanship. When some CUBISTS turned away from REALISM toward abstraction, the PRECISIONISTS objected. Combining CUBISM and REALISM, they geometricized skyscrapers, bridges, barns, city buildings and other architectural subjects. The movement is also known as immaculatism and sterilism. Painters: Charles Demuth, Charles Sheeler, Georgia O'Keefe.

Cupid. Roman god of love. See: EROS.

Cybele. In Asian mythology, goddess of nature and fertility, known as "the Great mother of Gods." As guardian of cities and nations, she is often represented crowned and accompanied by lions. Greek counterpart: RHEA.

Cybernetic Sculpture System. Sculpture composed of suspended metal whose vibrations and appearance vary in response to a control of lights and motors which in turn respond to audience reactions. Interrelationship of machine (programming) and human participation are required for Cybernetic Sculpture. A microphone receives the laughter, whistles or conversations of the viewer, acts on the rate of light flashes, which in turn affects the floating patterns, changing them for each gallery viewer. Sculptor: Wen-Ying Tsai. Related to: PROGRAMMED CONSTRUCTIONS, PULSA.

Cyclopes (singular: cyclops). In Greek mythology, a family of giants having just one round eye in the middle of the forehead. Some were shepherds, some were blacksmiths. ODYSSEUS blinded POLYPHEMUS, chief of the Cyclopes, for having eaten several of ODYSSEUS men.

D

Dadaism. (DAH dah ism) Art and literary movement initiated in 1916 in Zürich, Switzerland. Young revolutionaries, mystics, and cynical jokers joined to express their protest against World War I and their criticism of society through demonstrations, noise concerts, and ANTI-ART exhibitions. Their media included FOUND OBJECTS, Ready-Mades and COLLAGES. Characteristically the name derives from playful serendipity, the accidental discovery of the word Dada: Hobby horse and perambulator, in a German-French dictionary. Dadaists strongly influenced SURREALISM, and the art of the 1950s and 1960s brought a revival in its ASSEMBLAGES, JUNK SCULPTURE and POP ART.
Painters: Marcel Duchamp, Max Ernst, Jean Hans Arp.
Sculptors: Marcel Duchamp, Jean Hans Arp, Francis Picabia.

Daedalus. In Greek mythology, an Athenian inventor and architect. Jealous of his ingenious nephew Talos, Daedalus murdered him and fled with his son Icarus to CRETE. There they built the LABYRINTH for MINOS who proceeded to confine them in it. Using feathers and wax, Daedalus made wings for himself and Icarus. When Icarus, against his father's warning, flew too close to the sun, his wings melted and he fell into the sea. Daedalus escaped to Sicily.

Dance of Death (Fr., Danse Macabre; German, Totentanz). ALLEGORICAL medieval MOTIF which appeared first on the walls of graveyards, later as a series of pictures. Death is leading people of all classes from pope to pauper in a dance to the grave. For example: the WOODCUT series of Hans Holbein the Younger.

Daniel. Jewish PROPHET in Babylon (6th century B.C.) favored by King Nebuchadnezzer because of his wisdom, imagination and keen

39

interpretation of dreams. Under the later rule of Darius, the Persian, the princes, jealous of Daniel's high position, established a decree that all in the land must pray only to the king. Daniel remained faithful to his own God, was thrown into the lion's den, where he miraculously escaped death. (Old Testament, Book of Daniel).

Danube School. Style of painting of the early 16th century, in Bavaria and on the Danube. Lucas Cranach the Elder discovered the beauty of romantic scenery in the Danube region and made the people of the area aware of it. Albrecht Altdorfer in 1522 painted the first landscape, without figures or story. In Danubian style, human activity is integrated into the framework of landscape; nature becomes an essential part of the pictorial composition reflecting the mood of the action depicted. The cosmic struggle of clouds and sea are, for example, painted to set a turbulent mood. Painters: Albrecht Altdorfer, Lucas Cranach the Elder, Wolf Huber.

Daphne. A nymph in Greek mythology who was saved from the pursuing APOLLO by being changed into a laurel tree.

Daphnis and Chloë. The famous lovers in an old Greek pastoral romance attributed to Longus in the 3rd century A.D.

Dardanelles. See: HERO AND LEANDER.

David. (11th-10th centuries B.C.) Second King of Israel, successor to Saul, he established Jerusalem as the eternal center of the Jews.
David Playing the Harp for Saul. Whenever the evil spirit from God was upon Saul, David, whom Saul had appointed as his young armor bearer, played the harp for him, and the evil spirit departed. (1 Samuel:16).
David and Goliath. With a sling and a stone David fell Goliath, the Philistine giant, then cut off his head with Goliath's sword. Thus David saved the Israelites from Goliath. (1 Samuel:17).

Décollage. 1960 version of COLLAGE, with emphasis on the mutilation, or deterioration, of the assembled objects. Torn posters or damaged objects are glued together to create an image of squalor or impermanence. Artists: Jacques de Villeglé, Francois Dufresne, Alberto Moretti. Related to: POP ART.

Deësis. The image of CHRIST Enthroned between the Virgin MARY and St. JOHN THE BAPTIST, who act as intercessors for mankind.

Delilah. See: SAMSON.

Delineavit, del., delin. (Latin - "he drew it") This term, or its abbreviations, often appears on GRAPHIC art with the name of the original artist. It is most frequently used where artist

and engraver are the same. In some cases, however, the artist's name appears with Del. and the engraver's name with the terms EXCUDEBAT, EXPULSIT or FECIT.

Delphi. An ancient city in central Greece; site of the Delphic oracles at the famous shrine of APOLLO. The oracles were pronounced by the priestess PYTHIA. Art works from Delphi, like the 'Victorious Charioteer' as well as paintings of Delphi testify to the importance of this city.

Demeter. In Greek mythology, goddess of agriculture – grain, harvest, fruits, flowers, fertility of the earth. In art, she is represented as a fully clothed, mature and dignified woman. Attributes: ears or sheaves of grain. Roman counterpart: CERES.

Denial of Peter. After being seized by the soldiers of the high priests, CHRIST was brought to the palace where the council tried to find witnesses against him. Peter had followed at a distance and was sitting in the palace. Three times servants accused Peter of knowing Jesus and each time Peter denied this. On hearing the cock crow, Peter remembered that Jesus had predicted that before the cock crowed twice, Peter would deny him three times. Realizing he had been unfaithful to Jesus, Peter wept. (Mark 14:30).

Dentils. Rectangular blocks projecting from a background to form MOLDINGS in woodwork or architecture.

Dentils

Descent from the Cross, Deposition. CHRIST's body taken down from the cross and wrapped in linen with spices (according to Jewish tradition) by Joseph of Arimathea and Nicodemus. Sometimes the Virgin MARY, St. JOHN THE EVANGELIST, St. MARY MAGDALENE and a few disciples are included. (Matthew 27:57-59; Mark 15:42-46; Luke 23:50-53; and John 19:38-40).

Descent Into Hell. See: CHRIST IN LIMBO.

Descent Into Limbo. See: CHRIST IN LIMBO.

Designo, des., desig. (Latin - "designed by") Used alternatively with DELINEAVIT to indicate the original artist in GRAPHIC art.

De Stijl. (de STYLE) (Dutch: the style). Originally the title of a Dutch magazine, founded in 1917, De Stijl became the name of a movement. Van Doesburg and his friends proclaimed that with World War I a new era based on pure form, on man-made, rather than nature inspired art was beginning. Universal and abstract forms should supersede bourgeois luxury, in all branches of the arts: sculpture, architecture, design and painting. Influenced by CUBISM,

the artists sought clarity, certainty and order through simplicity, abstraction, the rectangle and mathematical structure. The NEO-PLASTICISM of De Stijl was adopted by the BAUHAUS and greatly influenced commercial art of the 1920s. Artists: Theo Van Doesburg, Piet Mondrian, Gerrit Rietveld.

Diana. Roman moon goddess and patron of hunters. See: ARTEMIS.

Dido. In Roman mythology, founder and queen of CARTHAGE. After her brother PYGMALION murdered her husband Sichaeus for his riches, she collected the wealth and fled from Phoenicia to Africa where she founded CARTHAGE and became its queen. Following the Trojan War, when en route to Italy, AENEAS was shipwrecked at CARTHAGE, and Dido fell in love with him. When AENEAS departed for Italy, Dido killed herself. Elissa was her Phoenician name.

Dionysus. Greek god of fertility, sensuousness, wine and drama; son of ZEUS and Semele. He married ARIADNE after she had been forsaken on the island of Naxos by THESEUS, and they had many children. Represented at different times as a full-grown bearded man, as a beast, and as a delicate effeminate youth. Dionysus and his companions appear on thousands of Greek vases which were used for storing, drinking and mixing wine. Attributes: ivy and the grapevine which he wears as a wreath, the thrysus (a staff topped by a bunch of ivy leaves and a wine cup). Roman counterpart: BACCHUS or Liber.

Diorama. Method of showing paintings to produce spectacular effects. The paintings are different on the front and back of the canvas. The appearance of the painting changes depending upon the intensity and direction of the light. Invented by Daguerre and Bouton in 1822 and popular in mid-Victorian period.

Dioscuri. In Greek mythology, Castor and Pollux (Gr.-Polydeuces), twin sons of Leda and ZEUS. Both Greek heroes excelled: Castor as a horseman; Pollux as a boxer. Pollux, the mortal twin, was killed. Castor, the immortal twin begged ZEUS to allow his brother to share his immortality. In one legend, ZEUS arranged for them to divide their time between Heaven and HADES. In another legend, ZEUS created the constellation GEMINI, meaning twins.

Diptych. A picture or altar-piece folding into two panels by means of hinges.

Divisionism. See: NEO-IMPRESSIONISM, POINTILLISM.

Doctors of the Church. See: LATIN FATHERS.

Diptych

Dolphin. 1. Fish sacred to POSEIDON; symbol of POSEIDON.

2. In early Christian art the dolphin symbolized diligence, love, swiftness; also RESURRECTION and salvation.

Dominic, St. (13th century). Founder of the Dominican Order, he traveled widely and preached wherever he went. Usually represented in the black and white habit of his Order. Attributes: rosary (he instituted devotion to the rosary);

dog carrying a lighted torch (symbolizes St. Dominic and his order spreading the gospel);

star on his forehead (when he was baptized, a star is said to have appeared on his forehead);

loaf of bread (angels brought bread to the table of the monks when no food was available in the monastery);

a staff.

He lifts his robe to show a plague spot on his thigh.

Usually his dog accompanies him.

Don Quixote. Hero in Cervantes' novel Don Quixote de la Mancha. An eccentric, idealistic knight, who feels that he lives in a hostile, greedy world, he is usually portrayed seated on his horse Rosinante, and accompanied by Sancho Panza, his peasant squire, riding a donkey.

Drapery. Fabric that hangs in folds on a figure. The manipulation of the material is an important device to the sculptor or figure painter, for example, giving the appearance of wet or flying drapery. Changes in art styles through the years may be analyzed by studying changes in the treatment of drapery.

Dream of Jacob. See: JACOB.

Dream of the Magi. See: ADORATION OF THE MAGI.

Drip Painting. Technique initiated by Jackson Pollock in 1947. Pollock placed the untreated canvas on the floor and poured and dripped the paint directly onto it. This method strongly influenced the broader and bolder methods of ACTION PAINTING and ABSTRACT EXPRESSIONISM. Related to: AUTOMATISM.

Drypoint. Technique of ENGRAVING. Cutting deeply into metal, a hard steel needle causes a BURR to appear on both sides of the metal. When the BURR is inked it produces a soft rich black effect.

Duecento. (DOO eh CHEN toe) The 13th century in Italian art. Painters: Cimabue, Duccio, Giotto.

Dutch School. Although Dutch painting spans many centuries, this term is usually applied to Dutch painters of the 17th century. Art

flourished, especially in Amsterdam, Haarlem, Delft, Utrecht and Leyden. For the first time in history, prosperous citizens joined the church and royalty in the acquisition of art works on a large scale. Under the influence of the Italian RENAIS-SANCE painter Caravaggio, artists painted with strong light effects.

They selected their subjects from:

Landscape: Jacob Isaacsz van Ruysdael, Salomon van Ruysdael, Meindert Hobbema.

GENRE: Vermeer van Delft

STILL LIFE: Jan Steen

Portrait: Frans Hals

All of these and Biblical subjects: Rembrandt, Harmensz Van Rijn.

E

Earthenware. See: CERAMICS.

Earthworks, Ecological Art, Land Art. Art works initiated in the 1960s. Major media are earth, peat and petroleum jelly. Some earthworks are exhibited in museums, but more frequently land and landscape become the artist's work area. He digs ditches, cuts trees, or builds mounds to convey his concern with the interrupted process of growth and the manipulation of nature. His works may be exhibited through photographs or films; he may also sell bags of the earth affected by his action. Following Earthworks, artists began to experiment with waterworks and skyworks by creating, with chemical and physical means, patterns in water and atmosphere. Artists: Walter de Maria, Dennis Oppenheim, Michael Heiser. Related to: CONCEPTUAL ART.

Easel Painting. Painting on wood or canvas that is supported by a stand or frame. Developed in the RENAISSANCE, it reached its height in Holland in the 17th century, reflecting the demand of the middle-class for moderate and small size paintings depicting landscape, STILL LIFE and GENRE scenes. It continues to be very popular. ACTION PAINTING, COLOR-FIELD, MINIMAL ART, OP ART, REDUCTION ART, two-dimensional art reject the easel for the huge mural canvas. NEW REALISM artists are bringing back the easel.

EAT. *E*xperiments in *A*rt and *T*echnology, Inc. is an international service organization formed by Bill Kluver, an engineer and laser specialist, and artist Robert Rauschenberg in 1966. Its goal is to establish a working relationship between artists and engineers with the support of industry and labor unions. On several occasions, artists and engineers have joined together to produce exhibits of

the new technology in art, i.e. in 1968 their show at the Museum of Modern Art was an extension of the "Machine" exhibit. Art has always involved technology but cooperation between engineers, artists, industry and labor is EAT's contribution.

Ecce Homo. "Behold the Man." The words spoken by PILATE when, for the second time he appealed to the mob for sympathy for CHRIST, who wears a purple robe and a crown of thorns and often holds a mock sceptre. Often used as subject to depict the loneliness of man, exposed to the cruelty of the world. (John 19:5).

Eclecticism. (Gr. "eklegein," to choose, to gather.) The gathering and integrating of various styles is naturally a part of most art forms throughout the ages. The name eclectic is usually given to artists who have intentionally adopted previous styles and who consider themselves disciples of great masters. Most specifically the term Eclecticism has been applied to the Carraccis who, in the 16th century, founded an ACADEMY in Bologna, Italy, to work in the tradition of the greatest RENAISSANCE artists. Though rarely great, eclectics are usually prolific. Painters: Annibale Carracci, Domenichino, Guido Reni.

Ecological Art. See: EARTHWORKS.

Eden, Garden of. According to the Old Testament, God placed ADAM AND EVE in the Garden of Eden (Paradise). Satan, disguised as a serpent, convinced Eve, and through her ADAM, to eat the forbidden fruit of the tree of knowledge, resulting in their banishment from Paradise. Scenes of ADAM AND EVE in the Garden of Eden are represented in many paintings through the ages. (Genesis 2:8-3:24).

Editions. See: MULTIPLES.

Eight, The. Eight American Realist artists of the early 20th century who painted every-day, matter-of-fact scenes of the American experience. They sought a free and open attitude toward painting, independent of the European tradition, and of what they considered, the stuffiness of the American Academy of Art. They were later absorbed into the ASHCAN SCHOOL. Painters: Robert Henri, John Sloan, George Luks, William Glackens, Everett Shinn, Maurice Prendergast, Arthur B. Davies, Ernest Lawson.

Elijah. (9th century B.C.). Most popular Old Testament Hebrew PROPHET. Patron saint of Jewish life, he called for a return to the worship of the Jewish god Yahweh. He bitterly opposed Queen Jezebel and the foreign priests who adored the god Baal and imported gods and goddesses. It was Elijah who predicted the

coming of the Messiah who would bring a new world with no more suffering. In art Elijah is usually pictured as a white-bearded patriarch. (I Kings 17 and II Kings 2).

Elizabeth of Hungary, St. (13th century). One of the great saints of the Franciscan Order. Daughter of the King of Hungary, she was betrothed to a prince in her infancy. She went to live with the family of her betrothed where the jealous ladies of the court treated her badly. In her loneliness, she turned to religion. Shortly after her marriage, her husband died on a crusade and she was sent to his uncle. She dedicated her life to service of the poor and sick, and died young. She is usually depicted in one of her deeds of charity. Most popular is the rose miracle: while carrying a basket full of food for the poor, Elizabeth met her uncle who asked what she was carrying. When he opened her basket, the bread was miraculously turned into roses. In art, St. Elizabeth is frequently shown as a Franciscan nun, or with a triple crown, symbolizing her royal birth, her royal marriage, and her glorification in heaven.

Elizabeth, St. Mother of JOHN THE BAPTIST. Often represented in paintings of the VISITATION and of the Birth of JOHN THE BAPTIST, she appears as an elderly woman.

Embossing. Art of producing designs in RELIEF on metal, leather, textiles.

Emmaus. On the day of, but following the RESURRECTION, two of CHRIST's disciples went to the village of Emmaus near Jerusalem. While they talked, Jesus drew near and went with them, but they didn't know him. However, they urged him to join them at dinner. As he blessed and broke bread, they knew him and he vanished out of sight. (Luke 24:13-19, 30-35).

Enamel. 1. Dyed, liquid glass, applied to metal and then baked for decoration or functional uses. 2. An artwork made of enamel. 3. A special enameling technique, Champlevé, was developed in Medieval Europe and is still in use today. A design is cut into a copper plate, and after the plate has been gilded, powdered enamel, usually in bright colors, is put into the dug-out parts. The plate is then baked until the enamels harden and become translucent against the gilded copper. Plaques, crucifixes and other revered or precious objects are produced using this technique.

Encaustic. A technique of painting, popular in Egyptian, Greek and Roman times, in which hot colored wax is applied to the surface and then driven in by hot irons. Widely used by Egyptians for the

painting of mummies, this method provides lively, lasting colors and an opportunity for sculptural MODELING. Currently it is used by the painter Jasper Johns.

Endymion. In Greek mythology, a shepherd who was kept eternally youthful and handsome through everlasting sleep. Each night the moon goddess Selene, who loved him, visited him. The subject of Endymion and Selene is a frequent theme on Roman SARCOPHA-GI and later in paintings of Greek mythology.

English School. A broad term usually referring to English painters in the 18th and 19th centuries. It begins with Hogarth and ends with the PRE-RAPHAELITES and Victorians.

English School favored:	Artists
GENRE	William Hogarth
	Jean Siméon Chardin
Portraiture	Sir Joshua Reynolds
	Thomas Gainsborough
Landscape	John Constable
	William Turner
Visionary Paintings	William Blake

Engraving. A print made by inking a design cut with a BURIN into metal or wood. See also: CHAMPLEVÉ, DRYPOINT, ETCHING, LINE ENGRAVING, WOOD ENGRAVING.

Entombment. The burial of CHRIST by Joseph of Arimathea, a wealthy lawyer, who begged for and received the body of Jesus from PILATE, and Nicodemus. The body of Jesus is lowered into the ground by the winding sheet in which it is wrapped. The Virgin MARY, St. MARY MAGDALENE, St. JOHN THE BAPTIST and other assistants may be present. The place of burial was sometimes represented as a new tomb hewn out of rock with a huge stone door. (Luke 23:50-55).

Environmental Art. Arrangement of objects and creation of spaces to be experienced visually and physically. Environments are created indoors or outdoors using any available materials including earth and water, light and sound media. Although concept and methods of this art form go back to DADAISM, its current manifestation is

part of the revolt of the late 1960s against the separation of art from nature and life. The emphasis of Environmental Art is not on any traditional aesthetic principles, or on the intrinsic values of the created object, but on the total experience in a confined environment. Artists: Claes Oldenburg, Allan Kaprow, Joseph Bueys.

Eos. In Greek mythology, goddess of the dawn, mother of the stars and the winds. Because she loved ARES, APHRODITE cursed her with an insatiable desire for young men. She is represented in works of art as hovering in the sky, or riding on her chariot, moving with a torch before ARES, or sprinkling dew from a vase over the earth. Roman counterpart: Aurora.

Erato. See: MUSES.

Erinyes. See: FURIES.

Eros. God of love in Greek mythology. Son of HERMES (MERCURY) and APHRODITE (VENUS). Eros personifies all kinds of love: physical passion; tender love; playful love. He is usually represented as a winged, naked youth with a bow and arrows, often accompanying VENUS. Roman counterpart: CUPID or AMOR.

Esther. Through the efforts of her cousin, Mordecai, the beautiful Hebrew maiden Esther was chosen as queen by the Persian King Ahasuerus. *The Affliction of Mordecai.* Haman, a favorite of King Ahasuerus, was angry at Mordecai and prevailed upon the king to order the death of all the Jews in his lands. The king agreed to this not knowing that his queen was a Jewess. *Esther and Ahasuerus.* Esther appealed to King Ahasuerus who agreed to spare the Jews. *Mordecai Honored by Ahasuerus.* King Ahasuerus wished to reward Mordecai for his great service through the years. These themes are popular in RENAISSANCE paintings. (Old Testament: Book of Esther).

Etching. A process of ENGRAVING a design with an etching needle on a copper plate that has been covered with an acid-resistant coating. The plate is immersed in an acid bath which eats into the metal where the needle has pierced, thus producing the drawing. Like an ENGRAVING, the plate is then inked, wiped and printed.

Etruscan Art. Art of the pre-Roman inhabitants of Central Italy from the 9th to the 3rd centuries B.C. Their art shows common traits with the styles of Egypt, MYCENAE and MINOA. Walls of tombs, decorated with cheerful scenes of everyday life, other MURALS, TERRA COTTA statues, and various metal and ivory artifacts give testimony of their high creativity and fine craftsmanship.

Europa. In Greek mythology, a Phoenician princess who was loved by ZEUS. Appearing as a handsome white bull, he kneeled before Europa and enticed her to climb on his back. ZEUS carried her off to the Island of CRETE where she bore him three sons; one of them was King MINOS. The abduction of Europa was a frequently chosen theme of painters from the 16th through the 18th centuries.

Eurydice. In Greek mythology, the wife of ORPHEUS. See: ORPHEUS.

Eustace, St. (2nd century) Martyr. Originally known as Placidus, he was captain of the guards under Emperor Trajan. While hunting, he saw a crucifix shining like the sun between the horns of a white stag. Converted by this miracle, he, his wife and two sons were baptized. He took the name Eustace. Some years later, after torture and separation, the family when reunited was burned alive by Emperor Hadrian. Eustace is patron saint of huntsmen. Usually Eustace is represented as a soldier or knight on horseback, often accompanied by hounds. Attribute: stag with a crucifix between its horns.

Euterpe. See: MUSES.

Evangelists, The Four. St. Matthew, St. Mark, St. Luke and St. John, the authors of the four Gospels, the accounts of the life of Jesus.

Evangelists	Symbolic representations
MATTHEW	a man or angel
MARK	a lion
LUKE	an ox
JOHN	an eagle

Eve. See: ADAM AND EVE.

Excudebat, ex., exc., excud., excudit. (Latin — "struck out," or "made," "composed") Appearing with a name on an art PRINT this term indicates the name of the printer-publisher, or the place at which he worked, i.e. exud. Col [oniae] = published in Cologne. See also: DELINEAVIT.

Exculpsit. See: SCULPSIT.

Expressionism. Art form in which the artist expresses his personal feelings. In the 15th and 16th centuries this form of self expression was exemplified in the work of Grünewald and El Greco. The contemporary Expressionist movement began at the turn of the 20th

century and was influenced primarily by Gauguin and Van Gogh. Major exponents were two groups in Germany: THE BRIDGE (DIE BRÜCKE) and THE BLUE RIDER (DER BLAUE REITER) paralleled by the FAUVES in France. Painters: Edvard Munch, Ernst Ludwig Kirchner, Emil Nolde.

F

Facet Cubism. See: CUBISM.

Facsimile. See: COPY.

Faience. See: CERAMICS.

Fantastic Art. Art that questions reality and looks for a dimension of super-reality. Characterized by eccentricity, grotesquerie and irrationality, it is preoccupied with mythology, dead matter, magical objects and LABYRINTHS. Painters: Hieronymus Bosch, William Blake, Odilon Redon.

Faun. See: SATYRS and PAN.

Fauvism. (fove ism) AVANT GARDE EXPRESSIONIST movement in Paris about 1903 to 1908 led by Henri Matisse. Pure, intense, violent colors and bold design so shocked the critics, they named the artists "Les Fauves" meaning wild beasts. The use of flat areas of color and the primitive flavor of the paintings derive from the influence of Gauguin and the general interest in PRIMITIVE and exotic art. Fauves influenced EXPRESSIONISTS in other countries. Painters: Henri Matisse, Maurice De Vlaminck, André Derain. See also: BRIDGE and BLUE RIDER.

Fecit, f., fec. (Latin - "he made it") This term accompanies the name or initials of the artist on paintings, PRINTS or sculpture. See also: DELINEAVIT.

Federal Arts Project. Part of the Works Progress Administration established under President Roosevelt in 1933. The purpose of F.A.P. was to assist artists without income. The government in no way tried to influence their creativity. These artists decorated primarily federal buildings, post offices and schools. ABSTRACT EXPRESSIONISTS Gorky, de Kooning, Rothko and Pollock were some of the F.A.P. artists.

Figurative Art. Depicts a recognizable human figure, animal or image; as opposed to ABSTRACT or non-figurative art, for example, compare the paintings of Rembrandt with Mondrian.

Figurative Humanism. See: NEW REALISM.

Fixative. Thin varnish sprayed over chalk, pastel or pencil drawings to prevent smearing.

Flagellation, CHRIST at the Column. The scourging of CHRIST before the CRUCIFIXION is represented in art since medieval times. CHRIST, naked except for a loin cloth, is usually shown bound to a column while he is being lashed by two or three men each holding a cat-o'-nine-tails or a bundle of switches. Sometimes spectators look on. (Matthew 27:26; Mark 15:15; John 19:1).

Flemish School. Never a formal school, the name is often given to artists of the 16th and 17th centuries in Flanders. In addition to religious subjects, the painters selected STILL LIFE and everyday scenes from town and country around them. From the naturalistic, often ALLEGORICAL paintings and the satirical graphic works of Brueghel to the sensitive and often sensuous works of Rubens, the Flemish School represents many styles, especially RENAISSANCE, MANNERISM, and BAROQUE. Painters: Peter Brueghel the Elder, Jan Gossart, Peter Paul Rubens.

Flight into Egypt. Scene depicting the journey of MARY, JOSEPH and the infant Jesus (the HOLY FAMILY) to Egypt to escape King HEROD's decree. On learning that Jesus was to become King of the Jews, HEROD ordered the massacre of all babies in and around Bethlehem. (Matthew 2:12-15).

Florentine School. One of the most influential schools of the Italian RENAISSANCE of the 14th and 15th centuries, which is generally credited with laying the foundations of Modern European art. More strongly than the SIENESE SCHOOL of the same period, Florentine artists freed themselves from the STYLIZED two-dimensional medieval Italian art, and focused on humanity and reality. According to Boccaccio, Giotto's figures with their strong facial expressions and often dramatic gestures were so life-like, that people were frightened by them. A combination of the CLASSICAL ideals of beauty with a concern for the events and feelings of the present characterize the works of this school. Painters: Cimabue, Giotto, Masaccio. Sculptors: Pisano, Ghiberti.

Florian, St. (3rd century) Martyr. St. Florian was a soldier in the Roman army during the reign of Emperor Galerius. He extinguished the flames of a burning city by throwing a single bucket of water

on the conflagration. Converted to Christianity, he suffered martyrdom by being thrown into a river with a stone tied to his neck. St. Florian is protector against fire. In art, he is usually shown pouring water on a burning house or city, or with a mill-stone, the symbol of his martyrdom.

Folk Art. Paintings, pottery and sculpture by unschooled, unidentified artists that carry on a folk culture with its traditional MOTIFS, symbols and abstract decorative patterns. Subjects often are related to birth, death, marriage, religious ceremonies, festivals, everyday life. See also: PRIMITIVE ART.

Fontainebleau School. (fon ten blow) A 16th century group of French and Italian painters at the French castle of Fontainebleau who painted in the MANNERIST style. The highly decorative works of the artist lent themselves well to the palaces and representative buildings of this period. Artists: Giovanni Battista de 'Rossi, Niccolò dell' Abbate, Ambroise Dubois.

Fore-edge Painting. Technique of painting a picture on the fore-edge of a book. Gilding protects and conceals the design when the book is closed. Fanning the edges of a book usually reveals a WATER COLOR landscape. Although fore-edges were painted on books in the 15th and 16th centuries, especially in Italy, the term usually refers to the technique used in England, most prominently by Edwards of Halifax, binders, in the 18th and 19th centuries. To meet demands of book collectors, fore-edge painting is now being produced in England and the United States on current and old books.

Foreshortening. Reduction in the size of an individual form as it recedes from the eye. See also: PERSPECTIVE.

Fortuna. Roman goddess of fortune. See: TYCHE.

Found Object, Objet Trouvé, Ready-Made. A natural or manufactured article of every day life that becomes a work of art because the artist takes it out of its context and gives it a new meaning. For example: Duchamp called his bicycle wheel mounted on a chair a "Ready-Made", i.e. a man-made Found Object. Painters: Max Ernst, André Breton. Sculptors: Louise Nevelson, Kurt Schwitters. Related to: SURREALISM.

Four Horsemen of the Apocalypse. See: APOCALYPSE.

Francis of Assisi, St. (13th century). Founder of the Order of Friars Minor. Son of a rich merchant, he abandoned a carefree, hedonistic life for one of simplicity and dedication to God. Pope Innocent III granted St. Francis and his followers recognition as an order of

mendicant friars and approved the simple rules of the order. St. Francis had a vision of CHRIST on the cross, received the STIGMATA and preached to the birds. The gentleness of the Franciscan spirit is best exemplified by the numerous accounts of his love for wild beasts and other creatures, especially his sermon to the birds. Patron saint of Italy and saint of those who are separated. St. Francis is usually represented in the habit of his Order tied with a length of common rope (triple-knotted for poverty, chastity, obedience.) Sometimes he bears the STIGMATA, the wounds of the Crucified CHRIST. Attributes: STIGMATA, skull, lily, crucifix, wolf, LAMB.

Fresco (from Italian, affresco—"freshly painted"), **Buon Fresco, "True" Fresco.** Painting on wet plaster with PIGMENTS mixed in water (like WATER COLOR). The plaster absorbs the colors making the painting part of the wall itself. For example: Giotto's Scrogegni Chapel in Padua and Michelangelo's ceiling to the Sistine Chapel. Fresco painting was popular from the 13th to the mid-16th centuries, and was revived in the 19th century for MURAL paintings.

Fresco Secco (It. - "dry fresco"). Painting on dry plaster with PIGMENT in a medium of water or glue. Not as durable or as clear as 'TRUE" FRESCO.

Frieze. Band that runs along a wall, or around a building under the roof decorated with figures, patterns or sculpture. For example: the frieze of the PARTHENON.

1. Chessboard

2. MEANDER

3. Tooth

Frontality. Figures or objects are arranged to be viewed from the front and often stand parallel to each other. This concept was used heavily by the Egyptians and the Greeks. Contemporary example: sculptor Louise Nevelson.

Frottage. (fraw TAHZH) 1. A technique of making an impression by rubbing a pencil or soft charcoal into paper held against cloth, stone, wood or some other object. SURREAL-

ISTS, like Max Ernst, used Frottage as a semi-automatic method for impressions to suggest themes for works of art. 2. The impression itself is called a Frottage.

Functional Art. Art that is created to serve practical functions in human life, rather than for purely aesthetic enjoyment. William Morris, the artists of DE STIJL and the members of the BAUHAUS were concerned with bringing art back from the museums to daily life.

Funk Art. Anti-formal and anti-intellectual art of the 1960s. Not abstract, it is in the in-between-world, between sculpture and painting. Combining folk tradition and POP ART elements, Funk artists depict birth, growth, death and rebirth using biomorphic, glandular and erotic associations. The name was borrowed from "funky" jazz of the 1950s, which appealed to the artists with its hot rhythms. Painters: Jeremy Anderson, Sue Bitney, David Gilhooly.

Furies (Greek: Erinyes, Eumenides). In Greek mythology, goddesses of vengeance. Children of URANUS, their function was to punish the guilty. As three demonic women with bat's wings, dog's heads, grinding teeth, bloodshot eyes and snakes for hair, they symbolize the inferno. Their names were Megaera (the jealous one), Tisiphone (blood avenger) and Alecto (constant pursuit). In art and literature they often appear as personification of guilt turned into destructiveness.

Futurism. Italian movement of literature and art from 1909-1915. Its manifestoes called for the destruction of the past (libraries, museums, ACADEMIES) and extolled the beauties of revolution, war, aggressiveness, speed and dynamism. (In the 1930s the movement became identified with Fascism). Dynamic action, motion in sequence, speed and energy were portrayed by artists and sculptors. Every phase of movement is shown simultaneously by multiplying the number of limbs on a man or a horse. Concepts of ANALYTICAL CUBISM and NEO-IMPRESSIONISM are used. Marcel Duchamp's "Nude Descending a Staircase" which superimposes successive phases of movement on each other, shows the relationship of CUBISM to Futurism.

Statements like those in Boccioni's "Technical Manifesto of Futurist Sculpture" of 1912, *"We proclaim that* the environment must be part of the plastic block [in sculpture] ... and that the sidewalk can jump up on your table," characterize this movement which 60 years ago already used transparent planes, sheets of metal, wires and electric lights.

56

Boccioni also anticipated the concept of HARD-EDGE painting when he stated that the straight line is alive and palpitating, that it will lend itself to all that is necessary for the infinite expression of materials.

Painters: Giocomo Balla, Gino Severini, Carlo Carrà.

Sculptor: Umberto Boccioni.

G

Gabriel, St. ARCHANGEL and messenger of God. Usually portrayed according to Christian tradition as the ANGEL of the ANNUNCIATION and a trumpeter of the LAST JUDGMENT. In paintings of the ANNUNCIATION, he sometimes carries a sceptre and a lily (symbol of the Virgin), an olive branch and a scroll inscribed Ave Maria Gratia Plena (Hail MARY, full of grace).

Gaea. Greek earth goddess who sprang directly from Chaos (shapeless mass that existed before the forms of the universe). Gaea bore URANUS, to whom she was both mother and wife. They produced the CYCLOPES, the Hundred-headed ones and started the first race, the TITANS. Roman counterpart: Tellus.

Galatea. Greek mythology tells two stories:

1. A sea nymph who loved ACIS. Enraged at finding them together, POLYPHEMUS, a CYCLOPS enamored of Galatea, crushed ACIS with a boulder.

2. A statue brought to life by APHRODITE, in response to the prayers of PYGMALION, who made this statue and fell in love with it.

Ganymede. In Greek mythology, a beautiful Trojan youth, who was carried off by ZEUS, disguised as an eagle, to be cup bearer to the Gods.

Gargoyle. 1. A water spout to drain water from the roof gutter, carved as a GROTESQUE monster with an open mouth. Popular in the Middle Ages.

2. A GROTESQUE figure resembling a gargoyle.

Gathering of Manna. See: MOSES.

Gemini. See: ZODIAC.

Genre Painting. (ZHON r') (French "genre" kind, or type). Scenes from everyday life depicted in small scale, with every

58

part carefully observed and executed. Originating in the 16th century, Genre painting became especially popular in 17th century Holland. Painters: Jan Vermeer of Delft, Pieter de Hooch, Jean Baptiste Greuze.

George, St. (2nd century) Martyr. On his way to Palestine he freed a princess by slaying a dragon which had devoured many victims and was held to be invincible. In gratitude the king and his empire converted to Christianity. George was beheaded later and became one of the most revered martyrs, of whom many art works were created and after whom many churches have been named. He became the protector of the crusaders, the patron saint of England (the Order of the Garter is named after him) and of all those in distress, especially soldiers, and farmers. He is usually depicted as a young knight on a horse, slaying the dragon. Attributes: a broken lance, and sometimes a princess with a dragon on a leash.

One of the oldest subjects in mythology and art, the slaying of the monster symbolizes the struggle between good and evil. Sumerian creation stories tell about a young hero slaying Chaos.

Gesso. (JESS O) Preparation of plaster or chalk and glue that is applied to canvas or wood to act as a GROUND. This provides a smooth, level white surface to which the paint will adhere. (It takes three weeks to apply traditional Gesso. New Gesso, used by most artists today, contains a synthetic base medium which permits a canvas to be prepared for painting within an hour.) See also: GYPSUM.

Gethsemane. (fr. Aramaic, gath shemani; oil press). See: AGONY IN THE GARDEN.

Glaze. Thin translucent coat applied over other layers of paint, permitting it to show through and often modifying the color. Used a great deal by Rembrandt and Titian. See also: ENAMEL.

Glory. See: HALO.

Gods. Parallel Greek and Roman Gods.

Aphrodite	Venus	Eros	Cupid or Amor
Apollo	Apollo	Gaea	Tellus
Ares	Mars	Hades	Pluto
Artemis	Diana	Hera	Juno
Athena	Minerva	Hermes	Mercury
Demeter	Ceres	Poseidon	Neptune
Dionysus	Bacchus	Tyche	Fortuna
Eos	Aurora	Zeus	Jupiter

For explanation see individual Greek names.

Gold Ground. In Medieval and RENAISSANCE paintings and MO-SAICS, figures were placed against a gold leaf background which provided richness and a transcendental setting. Gold is applied in either leaf or powder.

Golden Fleece. See: JASON.

Golden Section, Golden Mean. 5:8 proportion for dividing a picture, a figure, a line. A line is divided so that the shorter part is to the longer part, as the longer part is to the whole. Since the time of Euclid this has been considered aesthetically pleasing because it is supposed to correspond to the laws of the universe.

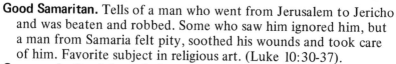

AE:EB=AB:AE

Golden Section

Golgotha. See: CALVARY.

Goliath. See: DAVID.

Good Samaritan. Tells of a man who went from Jerusalem to Jericho and was beaten and robbed. Some who saw him ignored him, but a man from Samaria felt pity, soothed his wounds and took care of him. Favorite subject in religious art. (Luke 10:30-37).

Gorgons. In Greek legend, three monster sisters (Itheno, Euryale and MEDUSA) with snakes for hair, wings, and brazen claws. Anyone who looked directly on their faces was turned into stone.

Gothic Art. West European style from the 12th to the 16th centuries. As in ROMANESQUE ART, religion was still man's central concern, and Gothic architecture, with its pointed arches, lightness of structure, and soaring spaces, symbolized man's desire to free himself from the burdens of this world. STAINED GLASS windows, sculpture, tapestries and manuscript ILLUMINATIONS of this period combine religious and everyday themes and are usually executed in strong colors. The Italian RENAISSANCE artist Vasari coined the term Gothic, to imply that the art represented the spirit of the Goths, which he despised. Gothic implied bad taste, until the 19th century, when ROMANTIC artists rediscovered its strength and beauty. Gothic Art is usually subdivided into five periods:
French Early Gothic from 1140 to 1194 (Chartres)
French High Gothic from 1194 to 1300 (Rheims)
English Gothic from 1180 to 1600 (York)
German Gothic from 1235 to 1520 (Freiburg)
International Gothic evolved toward the end of the 14th century and embraces styles that show fewer national characteristics. The last centuries of Gothic Art overlap with the RENAISSANCE.

Gouache. (gwash) Method of painting with opaque water colors. PIGMENTS are mixed with zinc and bound with gum. The mixture loses its transparency and becomes thick.

Graces. In Greek mythology, daughters of ZEUS; personifications of beauty, charm and grace. Usually there were three graces: Aglaia (brightness or splendor), Euphrosyne (joyfulness or mirth), and Thalia (bloom or good cheer). Three graces, standing in a circle with their arms entwined, are usually portrayed with APHRODITE, APOLLO, DIONYSUS, MUSES and gods concerned with the arts. Also known as Charities. Roman counterpart: Gratiae.

Graffito, Sgraffito. (It. scratched) 1. Technique for decorating the fronts of STUCCOED buildings in RENAISSANCE Italy. A coat of plaster is placed over another color and a design is scratched through the top layer before it dries, revealing the undercoat. This method is also used to adorn pottery and in Greek vase painting. 2. Graffiti refers to words, phrases and drawings scratched on walls.

Graphic Arts. The arts of drawing and ENGRAVING in all their forms: ETCHING, DRYPOINT, WOODCUT, LITHOGRAPHY.

Graver. See: BURIN.

Greek Art. See: CLASSICAL ART.

Grisaille. (gri ZI) Painting consisting only of shades of grey. It may be created as an independent work of art, as a model for an engraver or as the first stage of a FRESCO or oil painting. Grisailles often resemble RELIEF sculpture. For example: "Odalisque" by Ingres.

Grotesque. 1. Decorative art which is painted, drawn or sculptured representing human, animal or fantastic creatures intertwined with flowers, fruits, scroll and foliage. Originating in antiquity, classical ornaments were rediscovered during the Italian RENAISSANCE in grottoes. Italians called them grotteschi, from which the term grotesque is derived. Widely used by Italian painters, sculptors and engravers during the RENAISSANCE.
2. Currently, Grotesque artists paint and sculpt bizarre, hideous and revolting images to express despair, horror and frustration in the face of evil conditions of mankind; to shock the viewer out of complacency. Delving into the unconscious, the artists reject reason, juxtapose opposites (beauty and ugliness, humor and horror), ridicule accepted practices (war) and force man to confront himself. Artists: Gregory Gillespie, Nancy Grossman, Bruce Conner.

Ground. The coating applied to a canvas or panel before the artist begins to paint.

Guernica. (GWARE nee ca) The ancient capital of the Basques in Northern Spain. During the Spanish Civil War, German planes, serving General Franco, destroyed the town, indiscriminately bombing defenseless women and children. In horrified and angry response, Picasso painted Guernica, in 1937. In this work of social protest, the agony, anguish, violence and horror of war cry out. According to Picasso, this picture is ALLEGORICAL. The speared horse, inevitable victim of bullfights, represents victimized humanity succumbing to brute force. The mother and her dead child are descendants of PIETÀ. The woman with the lamp is reminiscent of the Statue of Liberty. Using exaggerations, distortions and shock techniques developed by EXPRESSIONISTS, combined with ABSTRACT techniques, the artist created one of the greatest paintings of the 20th century.

Gypsum. A mineral used to make plaster of Paris. Sculptors use it for casts and molds. See also: GESSO.

H

Haarlem School. See: DUTCH SCHOOL.

Hades. 1. In Greek mythology, the underworld where the eternally damned live after death. Early mythologies saw the universe as a three story structure consisting of hell at the bottom, the earth in between, and heaven above. Bad people were condemned to hell and the good rose to heaven. Starting with ROMANESQUE ART of the 11th and 12th centuries, many different concepts of hell developed. For example:

a. dragon's mouth.

b. devil and his followers.

c. an infernal city filled with fire and smoke.

d. seven successive circles of damnation shown on a terraced mountain.

2. Hades, Pluto. In Greek mythology, god of the underworld, king of Hades (hell). After the fall of the TITANS, Pluto and his brothers ZEUS and POSEIDON divided the universe. Pluto was awarded everything underground. Roman counterpart: Dis.

Hagar. See: SARAH.

Half-Tone. 1. A shade between light and dark in painting, drawing and GRAPHICS. Also called Middle-Tone.

2. Half-Tone Process is a method of reproducing images by breaking them down into small dots. According to the size and density of the dots, lighter or darker tones can be produced. The process applies to black and white as well as color reproductions, and can be used in various printing methods, i.e. ENGRAVING and INTAGLIO.

63

Halo, Nimbus. Radiant sphere or area of light around or above the head of a revered personage. The nimbus assumes different forms for different purposes: circle for CHRIST; triangle for God the Father; square for a living person; disk or circle for a saint.

Saints painted after their death have a round halo. Those painted during their life have a square halo.

Happenings. Events that emerged in the 1960s with the intention to free art and life from conventional forms. Creator, performers, and audience are simultaneously engaged, and many human activities and technological media are combined. Initiated by POP ARTISTS and musicians, HAPPENINGS frequently include the latest art forms. For example: SOFT SCULPTURE, KINETIC SCULPTURE and electronic music. Artists: Robert Rauschenberg, Claes Oldenburg, Allan Kaprow.

Hard-Edge, Concrete Expressionism. A style that emphasizes precise, hard lines as opposed to the blurred, dragged, stained edges of ABSTRACT EXPRESSIONISM. The term "Hard-edge," was coined by the art critic Jules Langsner in 1958. Artists in this group, second-generation abstractionists of the 1950s and 1960s, work in broad flat color areas. PERSPECTIVE disappears; the work is seen as a whole unit and foreground and background become one. Painters: Ellsworth Kelly, Ad Reinhardt, Al Held.

Harrowing of Hell. See: CHRIST IN LIMBO.

Hatching. Lines, usually parallel, for shading in drawing or printmaking.
Cross Hatching. Drawing parallel lines to cross other parallel lines to obtain deep shadow. Most often used in ENGRAVING.

1. Hatching

2. Cross Hatching

Hatching *Crosshatching*

Helen of Troy. In Greek mythology, the beautiful daughter of ZEUS and LEDA, who married MENELAUS, King of Sparta. When PARIS abducted Helen (See: PARIS), MENELAUS led the Greeks in war against TROY. Aided by ATHENA and HERA, the Greeks defeated the Trojans after a ten year war and MENELAUS and Helen returned to Sparta.

Hell. See: HADES.

Hellenistic Art. Late Greek art in Alexandria, Asia Minor and Rome from 323 to 27 B.C. Although based on classical Greek ideals, Hellenistic Art absorbs Egyptian and ETRUSCAN influences and departs from the ideal of perfect harmony. Dramatic effects are added, figures show movement, and faces express joy or grief, as in the "LAOCOÖN group", the "Nike of Samothrace" and the "Dying Gaul". In Rome, RELIEF sculpture on public monuments and SARCOPHAGI, and realistic portrait busts added a new dimension to Hellenistic Art.

Hellespont. See: DARDANELLES.

Hephaestus. In Greek mythology, the god of fire, metal working and handicrafts; son of ZEUS and HERA. According to legend, either he was born lame or he became lame when ZEUS threw him off Mt. Olympus because he took HERA's side in an argument. In works of art he is represented as a vigorous man, with mighty shoulders, bearded, equipped like a blacksmith with hammer and tongs, his left leg shortened to show his lameness. Roman counterpart: Vulcanus.

Hera. In Greek mythology, queen of Greek Gods, sister and wife of ZEUS, mother of ARES and HEPHAESTUS, protectress of women. Jealous of ZEUS and his many love affairs, she plagued his mistresses and his offspring. In works of art, Hera is a majestic figure, fully draped, crowned with a wreath and carrying a scepter. Attributes: peacock, pomegranate and cow. Roman counterpart: JUNO.

Herakles. One of the most famous Greek heroes, renowned for extraordinary strength and courage. Son of ZEUS and Alcmena, he performed 'Twelve Labors', including strangling the Nemean lion and capturing CERBERUS, the watchdog of HADES. In art he is portrayed as a powerful, muscular man, often bearded, wearing a lion's skin and carrying a huge club. Roman counterpart: HERCULES.

Hercules. Roman name for HERAKLES. See: HERAKLES.

Hermaphroditus. In Greek mythology, beautiful son of HERMES and APHRODITE. The nymph Salmacis, whom he rejected, prayed that she might be indissolubly united with him. When Hermaphroditus swam in her spring, she combined with him, and they became man and woman in one person. Hermaphrodite deities are found in Egypt, in India and in other ancient cults, symbolizing the original oneness of man.

Hermes. In Greek mythology, the messenger of the Gods; god of commerce, roads, invention, science, eloquence, cunning and theft; conductor of souls to HADES. Son of ZEUS and Maia, he was credited with inventing the lyre and rubbing sticks together to make fire. In art he is usually represented as a graceful, slender youth wearing a wide-brimmed winged hat (petasus) and winged sandals (talaria) and carrying the caduceus, a golden rod entwined by serpents. The latter is also the symbol of ASCLEPIUS, the Greek god of healing, and has become the insignium of the medical profession. Roman counterpart: Mercury.

Hero and Leander. In Greek mythology, Hero was a beautiful priestess of APHRODITE. Her lover, Leander, swam across the Hellespont, i.e. the Dardanelles to see her each night, guided by a torch provided by Hero. One night, during a bad storm, the torch blew out and Leander drowned. When Hero discovered his body, she threw herself into the sea. The fate of Hero and Leander was frequently chosen by RENAISSANCE artists.

Herod, The Feast of. St. JOHN THE BAPTIST had openly criticized Herod the Great for marrying Herodias, the wife of his dead brother. As a result, Herod threw St. JOHN into prison. Some time later, Herod gave a large birthday banquet. To entertain the guests, Salome, daughter of Herodias, danced magnificently. For this fine performance, Herod promised Salome anything she wanted. She turned to her mother who said to ask for the head of St. JOHN THE BAPTIST. See also: ADORATION OF THE MAGI and MASSACRE OF THE INNOCENTS. (Mark 6:24).

Hesperides. In Greek mythology, daughters of ATLAS and Hesperis. Together with a fierce dragon named Ladon, they carefully guarded a tree that bore golden apples. As one of his twelve labors, HERAKLES (Hercules) killed the dragon and obtained the golden apples.

Highlights. Areas on a painting or sculpture which catch and reflect the most light.

High Relief, Alto-Relievo. Sculpture in which the figures stand out from the block of wood or metal from which they are cut.

High Renaissance. See: RENAISSANCE.

Hippocrene. See: PEGASUS.

History Painting. In its broadest application, this term describes the selection of themes from the past. More specifically, History Painting refers to the work of 18th and 19th century artists, who idealized classical and biblical antiquity in their paintings. Legends, fairy tales, the lives of saints and heroes were reinterpreted, often with theatrical verve or sentimental nostalgia. With the interest in historical subject, artistic craft and techniques were revived: FRESCO painting, book illustration and print making. Gradually, beginning in France, more recent history was included. Painters: Benjamin West, Adolph von Menzel, Theodore Géricault.

Holography. The making of three-dimensional photographic images through laser beams, without the use of lenses. (Laser = Light Amplification by Simulated Emission of Radiation.) Holograms, invented by Dennis Gabor in 1948, are produced by placing an object behind a photosensitive glass plate and exposing both the plate and the object to laser beams. The exposure fixes a permanent "informational" pattern on the plate and each time the pattern is reactivated by a special light-source (radiation from a laser), a three-dimensional image of the object appears. Artists: Robert Indiana, Bruce Nauman, George Ortman.

Holy Family. The CHRIST child, MARY and JOSEPH. From anonymous ILLUMINATIONS in medieval manuscripts to the paintings and graphic work of Michelangelo, Rembrandt and El Greco, this subject has been one of the most popular religious themes. In some versions, St. Anne, the mother of MARY, and St. JOHN THE BAPTIST are included.

Holy Ghost. See: TRINITY.

Holy Spirit. See: TRINITY.

Hudson River School. Group of American landscape painters active between 1825 and 1870 in the Hudson River area.

Romantic and poetic in feeling, artists of the Hudson River School used formal composition and precise detail. Painters: Thomas Cole, George Inness, Asher Brown Durand.

Hudson Valley School. See: PATROON SCHOOL.

Hue. The basic property after which COLORS are named. There are six primary hues: red, orange, yellow, green, blue and violet. These may be mixed to form an indefinite number of combinations.

Icarus. In Greek mythology, son of DAEDALUS. See: DAEDALUS.

Icon (Gr. image, portrait). A picture or image usually referring to flat highly STYLIZED representations of Jesus CHRIST, MARY or saints. Forms and subjects of the Icons were prescribed and unchanging. Anonymous artists of the Eastern Orthodox faith portrayed the symbolic or mystical aspects of the divine being.

Iconography and Iconology. Both deal with the meaning of symbols and themes of works of art.

Iconography. Study of the apparent meanings of the subject matter of a work of art. History and classification of images and symbols.

Iconology. Study of the intrinsic meanings and contextual significance of symbols or images in a work of art. Understanding the symbols and themes of a work of art in terms of the cultural environment.

Idea Art. See: CONCEPTUAL ART.

IHS or IHC. See: MONOGRAMS.

Illuminations, Miniatures. Ornamental initials and illustrations in manuscripts to embellish the page or explain the text. Although Egyptians and Greeks illuminated their manuscripts, the term is usually applied to the decoration of Medieval (including BYZANTINE) manuscripts from the 5th-17th centuries. Illuminators were craftsmen who copied from samples, or gifted artists who produced magnificent works of art. Delicate design, strong colors and the frequent use of gold are characteristic of many medieval illuminations. Examples of illuminated manuscript: Book of Kells, Lindesfarne Gospel, Books of Hours. See also: MINIATURE PAINTING and ROMANESQUE ART.

69

Illusionism. Use of devices like FORESHORTENING, PERSPEC-
TIVE and CHIAROSCURA to create the impression of reality in a
painting. It fools the eye. (TROMPE-L'OEIL).

Immaculate Conception.
1. Belief in the perpetual virginity of MARY, the mother of
CHRIST. 2. The Roman Catholic dogma that MARY was con-
ceived and born without original sin. In art, the symbols used to
depict the virginity of MARY are the sun, moon, palm tree and
roses without thorns.

Impasto. (It. = paste) Thick bodies of paint that show the brush
stroke are applied to the canvas to catch the highlights and give a
RELIEF effect. Used by Rembrandt, Cezanne, Van Gogh and by
contemporary artists.

Impossible Art. See: CONCEPTUAL ART.

Impressionism. The term was coined by a French critic, who noticed
that the label "Impressions of . . ." was used so frequently at an
1871 Paris art exhibition, that he called it "Salon des Impression-
istes." The effects and techniques of Impressionist artists are al-
ready evident in earlier painting, for example in Rembrandt or
Turner, but Impressionist artists went further in their emphasis on
air and light, and on atmosphere and mood at different times of
the day. Painting was done "on the spot," out of doors as opposed
to "in the studio." Subjects were selected from contemporary life:
people, nature, views, race tracks. Artists painted quickly to cap-
ture the atmosphere of a moment. The colors of the rainbow (red,
orange, yellow, green, blue, violet) were primarily used. Instead of
mixing colors on the PALETTE, many Impressionists applied paint
in small dabs of pure color placed close to each other, so they
would bounce off and create OPTICAL MIXING. Painters: Pierre
Auguste Renoir, Claude Monet, Mary Cassat.

Inflatable Sculpture, Blow-Up Art, Pneumatic Sculpture. One of
the sculptural techniques developed in the 1960s. Air, and/or
various gasses are used to inflate POLYETHYLENE, POLYES-
TER film, vinyl or rubber into SCULPTURES that symbolize the
impermanence of form and the hollowness of reality. Sculptors:
Charles Frazier, Otto Piene, Christo Javachef.

Infra-Red. Special photographic films sensitive to Infra-Red rays are
used to examine the construction of a painting. The rays can de-
tect the number of underlayers, the corrections, the restorations
and forgery.

70

I.N.R.I. The four initial letters of the Latin words, "Jesus Nazarenus Rex Judaeorum" meaning "Jesus of Nazareth, King of the Jews." The sign with these initials nailed to the cross above the head of Jesus, appears on many paintings of the CRUCIFIXION. (John 19:19-22).

Intaglio. A design cut into the surface of metalplate or stone; the opposite of RELIEF where the design is raised. ETCHING, EN-GRAVING, DRY POINT are all Intaglio processes.

Intarsia. The art of wood inlay, for decorative purposes. Wood in various colors, metal, ivory or other precious materials are inserted by various techniques from carving to the gluing of multiple layers of wood. The term Intarsia was first used in 15th century Italy for a highly artistic application of inlay method. Designs include any-thing from landscapes and architecture to simple geometric forms. Examples of Intarsia can be found as independent panels, appear-ing like paintings, or as part of interior decoration and smaller wooden objects.

Intermedia Art. See: MIXED MEDIA.

Intermediate Color. See: COLOR.

International Style; International Style Modern.

1. *International Gothic, International Style.* (14th and 15th cen-turies). A transitional style, from GOTHIC to RENAISSANCE, in sculpture, painting and ILLUMINATED manuscripts that trans-cended national boundaries in Europe. This style is characterized by close attention to detail, carefully delineated foliage, flowers and animals, and by long, delicately modeled forms in natural posi-tions with soft loosely draped garments in flowing lines. Scenes like those in the ILLUMINATED manuscript "Tres Riches Heures du Duc de Berry" portrayed everyday events in real life. Artists were concerned with spatial depth and atmosphere. Painters: Gentile da Fabriano, Melchior Broederlam. Manuscript Artists: Limbourg Brothers. Sculptor: Lorenzo Ghiberti.

2. *International Style, Modern.* Architecture of the 1920s repre-sented in the styles of BAUHAUS, Le Corbusier, Mies Van Der Rohe. See: DE STIJL and BAUHAUS.

Intimism. In the late 19th and early 20th centuries, the use of IM-PRESSIONIST technique on indoor scenes of everyday life. These scenes were painted from memory, in subdued colors to suggest the intimacy of the interior. Painters: Pierre Bonnard, Eduoard Vuillard, Edgar Degas. Related to: NABIS.

Invenit, inv. (Latin- "he designed it") This term, added to the name on an art PRINT, indicates that the artist produced the original painting or drawing from which the print was made. Related to: DELINEAVIT, FECIT, and PINXIT.

Iphigenia. In Greek legend, daughter of Mycenean King AGAMEM-NON and Clytemnestra; sister of Electra and ORESTES. After waiting in vain for wind to sail to the Trojan War, AGAMEMNON, in desperation, promised Iphigenia as a sacrifice to ARTEMIS. The goddess sent the wind and saved Iphigenia, by substituting a stag and taking her as priestess to her temple at Tauris.

Iris. In Greek mythology, goddess of the rainbow which unites heaven and earth; also messenger of ZEUS and HERA.

Isaac, the Sacrifice of. See: ABRAHAM.

Isaiah. (Heb. "Salvation of God") (7th century B.C.). Most profound and most eloquent of the Old Testament PROPHETS. Early Christians interpreted Isaiah's prophecy as a prediction of the coming of CHRIST. RENAISSANCE painters sometimes included Isaiah in scenes of the life of CHRIST.

Ishmael. See: SARAH.

Isis. Egyptian goddess of fertility. She was the sister and wife of OSIRIS, usually represented as a woman with a cow's horns.

Ithaca. Island in the Ionian Sea, off the west coast of Greece, famous legendary home of ODYSSEUS.

J

Jacob. Son of REBECCA and ISAAC. Twin brother of Esau the hunter, he was the father of the twelve tribes of Israel. Popular themes: 1. *The Blessing of Jacob*. Before dying, ISAAC called his son Esau, the hunter, to be blessed. Rebecca substituted her favorite son Jacob, for Esau. Deceived, ISAAC blessed Jacob, naming him leader of the tribe. (Genesis 27) 2. *Jacob's Dream* in which Jacob dreams of a ladder that reaches to heaven on which ANGELS ascend and descend. He also dreams that God gives him the land on which he sleeps. (Genesis 28:12). 3. *Jacob Wrestling with the ANGEL*. While on a trip to visit his estranged brother Esau, Jacob wrestles all night with an ANGEL. Jacob releases the ANGEL only after he receives the ANGEL's blessing and the name Israel. (Genesis 32:24-32).

Janus. An ancient Roman god of beginnings, openings, doorways. January is named after Janus. He is usually represented as having one head with two bearded faces back to back, so he might look in two directions (past and future) at the same time.

Jason. In Greek mythology, son of Aeson, husband of MEDEA and leader of the Argonauts in their pursuit of the Golden Fleece.* Jason's trip with fifty-five of the most famous Greek heroes on the Argo, and his love affairs were famous themes in art and literature. See also: MEDEA. *The existence of a Golden Fleece is most likely based on the practice among tribes north of the Black Sea of putting sheepskins in the river to collect alluvial gold.

Jericho, The Battle of. See: JOSHUA.

Jerome, St. (4th century). One of the Four LATIN FATHERS of the church. Translating the Bible into Latin, the vulgar speech of the

common people, was his great contribution to the church. This Bible, the Vulgate, became the standard Catholic text. In painting he is shown as an old bearded hermit or as a scholar holding the Vulgate in his hand. Sometimes he is accompanied by the lion he tamed by removing a thorn from its paw. Often he wears a crimson cardinal's hat, signifying the rank bestowed upon him long after his death. Attributes: Cardinal's hat and a lion.

Jesus. See: CHRIST.

Job. One of the most dramatic books of the Old Testament tells about Job, the unswerving servant of God. As a test of his faith he is gradually deprived of health and all worldly goods. In spite of his despair he continues to believe in God, and in the end "the Lord restored his fortunes. . . .and blessed his latter days more than his beginning." Scenes depicting some of his desperate experiences are portrayed in art. (Book of Job, Chapters 1-42).

John, St. the Apostle. Youngest of the twelve apostles, brother of St. James the Great he is supposed to have been CHRIST's favorite disciple. He preached the Gospel in Judea and Asia Minor. According to tradition, the Emperor Domitian of Rome tried twice unsuccessfully to kill him. Charged with being a sorcerer, John was exiled to the Island of Patmos, where he supposedly wrote the last book of the New Testament, the APOCALYPSE, or the "Revelation of St. John the Divine." John is often depicted near CHRIST; he appears young, beardless with long, blond hair. His attribute is the cup, representing the cup of poisoned wine with which Domitian tried to kill him. Since St. John the Apostle and St. JOHN THE EVANGELIST were often considered to be the same in early and medieval accounts, their identity is sometimes confused in religious paintings.

John, St. the Baptist. Prophet and martyr. Son of ELIZABETH and Zacharias. The last Old Testament prophet and the first Christian saint, he foretold the coming of CHRIST, the Messiah. While still a child, St. John became an ascetic living in the wilderness of Judea, preaching repentance of sin. Later he baptized Jesus and recognized him as the Messiah. St. John was imprisoned by HEROD and ultimately beheaded to please SALOME. Attributes: His own head on a dish, a LAMB on a book and a long cross with a scroll inscribed "Ecce Agnus Dei" (Behold the LAMB of God). (John 1:28; Luke 3:4, 16; Mark 6:27, 28).

John, St. the Evangelist. Author of the fourth Gospel of the New Testament. In church literature and art his identity is often

confused with that of St. JOHN THE APOSTLE, the youngest of the twelve Disciples of Jesus. Little about his life is known. In Bible illustrations he is usually represented with a book, either on a lectern or on his knees, and with his attribute: an eagle, as symbol of divine inspiration.

Jonah. Hebrew PROPHET sent by the Lord to reform Nineveh, capital of Babylon in the 8th century B.C. To resist this task, Jonah sails for Tarshish. Angered by this rebellion, the Lord sends a storm; the sailors throw Jonah into the sea where he is swallowed by a whale, but vomited up on shore after three days (this is interpreted as prediction of the RESURRECTION OF CHRIST). Ready now to carry out his order, Jonah goes to Nineveh and warns the people that because of their wickedness the city will be destroyed in forty days. The people repent and the Lord forgives them.

Angry because his prophecy is not carried out, Jonah withdraws outside the city. The Lord grows a gourd to shade Jonah from the sun, then causes a worm to destroy it. Jonah resents this. The Lord points out that Jonah pities the gourd, why not pity the people, the city, and the cattle of Nineveh. (Old Testament, Book of Jonah).

Joseph. Son of JACOB and Rachel. JACOB gave Joseph, his favorite son, a coat of many colors. Jealous of Joseph, the older brothers sell Joseph as a slave and present the bloodied coat to their father as evidence of Joseph's death. (Old Testament, Genesis 37) Popular themes: 1. *Joseph and Potiphar's Wife*. Joseph is taken to Egypt and becomes servant to Potiphar. To escape the advances of Potiphar's wife, Joseph slips out of his coat leaving it in her hands. Infuriated, Potiphar's wife charges that Joseph has made advances toward her, and produces the coat as evidence. (Old Testament, Genesis 39) 2. *Joseph's Reunion with his Brothers*. Famine hits Canaan as well as Egypt. Joseph's brothers go to Egypt to buy corn from Joseph, now governor of Egypt; but at first they do not recognize him. (Old Testament, Genesis 42-47) 3. *Joseph Interprets Pharoah's Dream*. The false charges of Potiphar's wife land Joseph in prison where he becomes an interpreter of dreams. Pharoah, King of Egypt, sends for Joseph to interpret a disturbing dream. By explaining that the dream predicts seven years of plenty followed by seven years of famine, and advising the Egyptians to store their harvest, Joseph saves the people from disaster. (Old Testament, Genesis 40, 41).

Joseph, St., Joseph of Nazareth. Husband of the Virgin MARY, Joseph was a carpenter. He often appears in paintings of the early life of Jesus. Attributes: carpenter's tools; a lily—symbol of his purity; budded staff or dove on a staff (when MARY was fourteen, each of her suiters left his staff at the temple for a sign of favoritism by God. In the morning, Joseph's staff was budding into leaf and from it came a dove).

Joshua. Old Testament PROPHET and successor of MOSES. Under the leadership of Joshua, the Israelites crossed the Jordan River and won the Battle of Jericho which Joshua fought to get water for his people. Old Testament (Joshua 6:16-22).

Jove. See: ZEUS, JUPITER.

Judas Iscariot. See: BETRAYAL.

Jude, St. (Judas Thaddeus, St.) Apostle, brother of James the Less. After CHRIST died, Jude traveled through Syria and Asia Minor preaching the gospel. In Persia, he was martyred for his faith; transfixed with a lance or beheaded by a halberd (combination spear and battle-ax). He is revered as Saint of the impossible, of people with lost causes. Attributes: club, sword, hatchet, lance, halberd, T-square (he was an architect); processional cross with long shaft (showing he died not on but for the cross).

Judgment of Paris. See: PARIS, JUDGMENT OF.

Judith and Holofernes. When Nebuchadnezzar, King of Babylonia, ruled Nineveh in the 6th century B.C., he ordered Captain Holofernes to attack the Jews. Bethulia, a Jewish city deprived of water, was about to surrender, when Judith, a beautiful Jewish widow, entered the enemy camp, and beguiled Holofernes. One night when Holofernes was unconscious from drink, Judith decapitated him and returned to the city with his head. The Jewish warriors then defeated the Babylonians. Old Testament (Judith 2:6; 13:7)

Jugendstil. (YOO ghent shteel) See: ART NOUVEAU.

Junk Sculpture, Junk Art. Industrial or organic trash is assembled into works of art. Although Kurt Schwitters and others created their COLLAGES in the same way, the term was first applied to the Junk Sculpture of the 1960s. Perhaps the words of sculptor David Smith best describe Junk Sculpture.

"There is something rather noble about junk-selected
junk which has in one era performed nobly in function
stayed behind is not yet relic or antique or previous
which has been seen by the eyes of all men and left for me—

to be found as cracks in sidewalks. . .
to be used for an order
to be arranged
to be new perceived
by new ownership"
Sculptors: David Smith, Richard Stankiewitz, John Chamberlain.
Related to: ASSEMBLAGE and COLLAGE.*
Juno. See: HERA.
Jupiter, Jove. Supreme diety of the ancient Romans. Blessed fields
and watched over law. Greek counterpart: ZEUS.

*From DAVID SMITH BY DAVID SMITH, p. 152, edited by Cleve Gray, Holt,
Rinehart and Winston, Inc., 1968. Quoted by permission of the publisher.

K

Kinetic Sculpture. Sculpture set in motion by mechanical or natural means. For example: Duchamp's Bicycle Wheel of 1913, Moholy-Nagy's light machine of 1930 and Calder's machine-propelled MOBILES of 1932. More recent examples include sculptures driven by electric motors that involve participation by the viewer. Sculptors: Laszlo Moholy-Nagy, Jean Tinguely, Julio Le Parc.

Kiss of Judas. See: BETRAYAL.

Kitsch. Works that pretend to be art, but actually are inauthentic. Kitsch is characterized by false sentiment and showy, superficial finery. From German "Kitschen", to glue together.

Knossos, Cnossus. A ruined city on the Mediterranean island of CRETE; capital of ancient Minoan civilization (3000-1100 B.C.). In Greek legend related to: King MINOS, the MINOTAUR, LABYRINTH, ARIADNE, DAEDALUS and THESEUS.

Kore (pl. Korai). Archaic Greek statue of draped female figure. Korai have been found on the ACROPOLIS in ATHENS where they were originally painted in bright colors.

Kouros (p. Kouroi). Archaic Greek statue of a nude boy standing in a FRONTAL position with one foot slightly forward. The face wears the geometric smile of the ARCHAIC period (615-485 B.C.).

Kronos. See: CRONUS.

Kylix. Shallow, wide drinking cup with two handles and a slender stem used for drinking wine. Some of the best decorations from the late 6th to the early 5th century B.C. in Greece appear on the inner surface of the Kylix.

L

Labyrinth. Intricate construction of perplexing, winding passages to confuse those who enter the structure. In Greek mythology, King MINOS of CRETE ordered DAEDALUS to build such a vast maze to contain the MINOTAUR.

Lamb. 1. Symbol of CHRIST's sacrifice on the cross.

2. In early Christian art the lamb represents the APOSTLES and all Christians in general.

3. CHRIST, as the good shepherd, is shown with the lambs of his flock.

4. Agnus Dei – CHRIST as the lamb of God which taketh away the sin of the world (John 1:29).

5. In antiquity, the lamb was used as a sacrificial animal.

Land Art. See: EARTHWORKS.

Laocoön. (lay OCK oh on) In Greek mythology, a priest of APOLLO who warned the Trojans to distrust the TROJAN HORSE, a gift from the Greeks. Angered by Laocoön's act, ATHENA, who wanted to see the Greeks destroy Troy, sent two huge serpents to crush Laocoön and his two sons.

Laser Art. See: HOLOGRAPHY.

Last Judgment. Most early Christians believed in a second coming of CHRIST at the end of the world when he will judge mankind. First developed as an art subject in ROMANESQUE ART, the scene is carved on the doors of churches. In late RENAISSANCE art, it becomes highly imaginative with separate compositions for Heaven and Hell. CHRIST is shown as the presiding judge with the Virgin MARY at his right and St. JOHN THE BAP-TIST at his left. As the ANGELS sound their trumpets,

the dead rise up from their graves. The good rise toward Heaven; the evil descend to Hell. (Material for this subject is derived from descriptions of the day of judgment in different parts of the Bible.)

Last Supper. The last Passover meal which CHRIST had with his disciples. The celebration of Passover commemorates the exodus of the Hebrews from Egypt. At this meal Jesus broke bread*, blessed it and handed it to his disciples. Announcing that one of them would betray him, he then took a cup, gave thanks and asked them to drink his blood (in anticipation of his death).

In paintings of this scene, Judas Iscariot the traitor, usually sits apart from the other disciples. St. JOHN THE APOSTLE 'whom Jesus loved', sits at CHRIST's right hand, with his head resting on the table or against CHRIST. (Matthew 26:17-30) (Mark 14:12-26) (Luke 22:7-38).

*In paintings of the Last Supper the bread is represented errone-ously. It should have been matza (unleavened bread) because in their haste to flee Egypt the Jews did not have time to wait for the bread to rise and therefore they used matza.

Latin Fathers, The Four. St. JEROME, St. AMBROSE, St. AUGUS-TINE and St. Gregory are often grouped together as the Four Latin Fathers, or Doctors of the Church. As scholars, teachers, and interpreters of Scripture, the Fathers are leading representatives of CHRIST's Church on earth.

Lazarus, The Raising of. While Jesus was away, Lazurus, brother of Martha and Mary of Bethany, became ill and died. On his return to Bethany, Jesus went to the grave of Lazarus and called him forth from the grave, restoring him to life. Popular scene since Early Christian art. (John 11:1-44).

Leander. In Greek mythology, a youth who loved HERO. See: HERO.

Leda. According to Greek legend, the beautiful wife of the King of Sparta who was seduced by ZEUS in the guise of a swan.

Lekythos. Ancient Greek pottery jug shaped like a cylinder and decorated with domestic scenes. It was used as an oil flask and for funerary offerings.

Leo. See: ZODIAC.

Lettrisme. See: CALLIGRAPHY.

Libation. 1. Act of pouring wine, or other liquid, as a sacrifice to a deity.

2. The liquid that is poured.

Lekythos

Liberal Arts. Originally seven subjects considered essential for the education of the free man in classical Greece.

These seven subjects:

Grammar	Music
Logic	Geometry
Rhetoric	Astronomy
Arithmetic	

were personified by Marcianus Capelle around 400 A.D. From the CAROLINGIAN period around 800 on, they frequently appear in art as female figures with the attributes indicating their respective subject. See also: VIRTUES.

Libra. See: ZODIAC.

Light Sculpture. Beginning in the 1930s, artists have experimented with light as a MEDIUM that can produce sculptural effects. With new technology (i.e. neon light, lasers), the interest in light sculpture received new impetus. Transparent tubes, reflectors, steady light, moving beams, and HOLOGRAPHS are used to produce static and moving sculptural shapes. These sculptures are only visible, not TACTILE. Light sculpture and KINETIC SCULPTURE are often used together, and in conjunction with architecture, drama or music. Sculptors: Julio Le Parc, Chryssa, Rockne Krebs. See also: MIXED MEDIA.

Limning. Art of painting miniature portraits. Popular in 16th and 17th century Europe and in the American colonies, e.g. the PATROON or Hudson Valley School. See also: MINIATURE PAINTING.

Line Engraving. See: ENGRAVING.

Linear. Emphasis on the lines, or outlines in an artwork, rather than the fusion of form and COLOR. Early Italian and Flemish artists painted in linear style, while the works of Rembrandt or the French IMPRESSIONISTS are PAINTERLY, i.e. soft transition and emphasis on color. Examples of linear style: Botticelli, Dürer, ART NOUVEAU artists.

Linear Perspective. See: PERSPECTIVE.

Literary Art. The subject of Literary Art is derived from or dependent on a story. Much romantic art, for example, much of the art of Delacroix is based on text. See: ROMANTICISM.

Lithography. A technique based on the fact that oil and water do not mix. A design is drawn on a flat stone or a metal plate with a greasy crayon. Water is applied to the whole surface. Greasy printing ink which is then rolled on adheres only to the greasy lines of the drawing. The print is made by pressing a sheet of paper against the inked surface.

Local Color. The inherent color of an object without regard to the effect of light, atmosphere or the colors of nearby objects.

Lost Wax Process. Method of CASTING used mostly for hollow bronze statues. A heat resistant mold is built up around a wax pattern that is filled with clay. Baking melts the wax and hardens the plaster. Molten bronze is poured into the space that "lost" the wax. The Lost Wax Process has been used since the time of the Ancient Egyptians. It is also known as investment casting and "cire perdue" (Fr.).

Low Relief, Bas-Relief, Basso-Relievo. Sculpture that projects very little from the surface. For example: FRIEZE of the PARTHENON.

Lucifer. 1. Rebellious ARCHANGEL who fell from heaven, identified with Satan, the evil enemy of man. "How art thou fallen from heaven, O Lucifer, son of the morning" (Isaiah 14:12).
2. In Greek mythology, one of the human sons of ZEUS.

Luke, St. the Evangelist. Author of the third Gospel and "Acts of the Apostles." A physician of Antioch, Syria, he was devoted to PAUL THE APOSTLE, whose life he faithfully recorded. After Paul's death, Luke continued preaching in Greece. He became the patron saint of painters since he is said to have won converts by exhibiting his own paintings of the Virgin MARY and Jesus. Attributes: winged ox referring to the opening of his Gospel with the sacrifice of Zacharias; the Gospel Book; portrait of the Virgin.

Luminism, Luminosity. Concerned with the effects of light on a painting. Related to: IMPRESSIONISM.

Lunette. Decorative painting which fills a semi-circular window over a square window or door.

Lunette

Lyrical Abstraction. Style of ABSTRACT ART called lyrical because it aspires to be sublime and poetic. Growing out of COLOR-FIELD painting of the 1960s, it recalls the free techniques of ACTION PAINTING; artists use IMPASTO, splash, spatter, spray guns, sponges and hands to create depth illusion on a gestural, expressive surface. Not to be confused with ABSTRACT LYRICISM, a term associated with Kandinsky's attempt to spiritualize art, this art is soft, romantic, sensuous and PAINTERLY. Artists: John Seery, Philip Wofford, John Walker.

M

Madonna (It. 'My Lady'). Representation of the Virgin MARY in painting or sculpture. (See: MARY). The Madonna is a frequent subject from Early Christian art to our day.

Madonna Adoring the CHRIST Child. MARY kneels before the infant CHRIST in worship and adoration. One of the many themes of MARY and the CHRIST Child popular from the early Middle Ages through the late RENAISSANCE.

Madonna della Misericordia (It. 'Madonna of Mercy'). MARY spreads her mantle to protect kneeling crowds of the faithful.

Madonna of Humility. MARY sits on the ground (rather than on a throne) holding the CHRIST Child.

Maenads. In Greek mythology, female followers of DIONYSUS (Bacchus). They roamed the forests dressed in ivy and animal skins, dancing and singing mad songs. Roman counterpart: Bacchae, Bacchante.

Magi, Dream of. See: ADORATION OF THE MAGI.

Magic Realism. NATURALISTIC style of painting executed with painstaking care and filled with intensity. The term embraces 20th century painters like those of NEW OBJECTIVITY and META-PHYSICAL PAINTING and American SURREALISM. The meticulous craftsmanship used by the artist produces an incongruous and haunting effect, a fantasy. Painters: Andrew Wyeth, Peter Bloom, Ben Shahn.

Majolica. See: CERAMICS.

Malerisch. (ma le REESH) 1. PAINTERLY. See: PAINTERLY.
2. Picturesque (like a picture).

Mandorla. An almond-shaped area surrounding the figure of a sacred person, symbolizing the intersection of the two spheres, heaven and earth. See also: HALO.

Mannerism. A transition style between the HIGH RENAISSANCE and BAROQUE in Europe, 1520-1600. The term implies that emphasis is on the manner in which the work is executed rather than on the meaning of the subject. Highly complex and artificial, the paintings are often characterized by elongated human figures in strained theatrical poses and with distortion of proportion and PERSPEC-

Mandorla

TIVE. Vivid, often harsh and acid colors add to the dramatic effect. Painters: Tintoretto, El Greco, Il Rosso.

Marathon. In ancient Greece, a plain and village northeast of ATHENS, where the outnumbered Athenians defeated the Persians in 490 B.C.

Mark, St. the Evangelist. Author of the second Gospel. He accompanied St. PAUL and St. PETER on some of their missionary journeys and later became the first bishop of Alexandria, where he was martyred. It is told that in the 9th century, Venetian sailors carried off the body of St. Mark and buried it on the site of the great church of San Marco. St. Mark became the Patron Saint of Venice. Attribute: winged lion refers to the opening of his Gospel with the story of St. JOHN THE BAPTIST in the wilderness, the habitat of the lion.

Marriage at Cana. Jesus, his mother MARY and his disciples attended a wedding in the village of Cana, in Galilee. When wine was requested, MARY told Jesus no wine was available. Performing his first miracle, CHRIST asked the servants to fill six stone pots with water. These were brought to the head of the feast who found them all to contain wine. (John 2:1-11).

Mars. In Roman mythology, most honored god after JUPITER, he was the son of JUNO and the father of ROMULUS, founder of Rome. At first Mars was the god of nature and fertility; later he became the famous god of war. The month of March is named after him. Attributes: spear, shield, wolf and vulture. Greek counterpart: ARES.

Martin, St. (4th century). Officer of the Roman army, later Bishop of Tours, France. One cold day he passed a beggar, cut his coat in two and gave one half to the beggar. That night CHRIST appeared to him in a dream, revealing that he had been the beggar. Martin then decided to devote his life to the church. He became one of the most popular saints of the Middle Ages. Martin was patron saint of the needy. In art, he is usually shown on horseback, dividing his coat with his sword to cover the naked beggar.

Mary, Virgin Mary, Saint Mary, called 'Our Lady.' Mother of Jesus. In Christian art, the representation of the Virgin is called MADONNA.

Popular themes:

 ANNUNCIATION
 ASSUMPTION OF THE VIRGIN
 CORONATION OF THE VIRGIN MARY
 MADONNA
 MADONNA ADORING THE CHRIST CHILD
 MADONNA DELLA MISERICORDIA
 MADONNA OF HUMILITY
 MATER DOLOROSA
 NATIVITY
 PENTECOST
 QUEEN OF HEAVEN
 SACRA CONVERSAZIONE
 VIRGIN IN GLORY
 VIRGIN OF THE IMMACULATE CONCEPTION
 VIRGIN OF THE ROSARY
 VISITATION

Symbols of Mary:

 lily — her purity and chastity
 iris — Queen of Heaven and IMMACULATE CONCEPTION
 violet — Mary's humility
 enclosed garden, and sealed well — Mary's virginity
 crown — Queen of Heaven

Mary Magdalene, St. Regarded as the great example of the penitent sinner, absolved from sin through faith in CHRIST. With the other Mary, mother of St. James the Less, she witnessed CHRIST's PASSION and RESURRECTION. Mary frequently appears in paintings of: Bearing of the Cross, CRUCIFIXION, DESCENT FROM THE CROSS, Lamentation, The ENTOMBMENT. In the last two, she mourns near the feet of

CHRIST. She is usually richly dressed, alluding to her sinful life of luxury before her repentence. Her hair is usually unbound and very long since she used it to wipe CHRIST's feet. Attribute: ointment jar with which she anointed CHRIST's feet.

Massacre of the Innocents. King HEROD was told shortly after the birth of CHRIST, that this child would become the King of the Jews. When the MAGI did not return to him, to report where he could find CHRIST, he ordered his soldiers to kill all male children under two years in the region of Bethlehem. This cruel scene and the escape of the HOLY FAMILY, the FLIGHT INTO EGYPT, have been frequent subjects in Christian art. (Matthew 2:16-18).

Mater Dolorosa (It. 'Mother of Sorrows'). The Virgin sorrows for the PASSION of her son, with hands clasped and tears running down her face. See: MARY.

Matthew, St. the Evangelist. Author of the first Gospel, and APOSTLE. Before becoming an APOSTLE, he was a tax collector (publican) called Levi who preached to the Hebrews. His Gospel emphasizes the human ancestry of CHRIST for the Hebrews in Judea. According to legend he traveled to Egypt and Ethiopia where he was stabbed in the back as he prayed at the altar of his church. Attributes: sword or axe represent the slaying; man or ANGEL refers to the opening of Matthew's Gospel with the geneology of CHRIST, as "the son of David".

Meander. A winding MOTIF employed in CLASSICAL ART. It consists of angular patterns formed by the intersection of straight lines. See FRIEZE for illustration.

Medea. In Greek mythology, a sorcerer and enchantress. Against the wishes of her father Aetes, King of Colchis, she helped JASON steal the Golden Fleece. JASON and Medea then fled Colchis, married and had two children. Later JASON wished to leave Medea and marry Creusa, daughter of King Creon of CORINTH. Medea sent Creusa an enchanted wedding gown which burned her to death. Legend holds that Medea then killed her two children, fled to ATHENS, and married King Aegeus.

Medium. 1. Process used by the artist. For example: painting, sculpture, ENGRAVING.
2. Materials used by the artist. For example: oils, WATER COLOR, stone, metal, wood.
3. BINDING with which the PIGMENT is mixed. For example: water, egg, oil, wax.

Medusa. In Greek mythology, the only mortal of the three GOR-GONS. Killed by PERSEUS, her head was placed on the Aegis (shield) of ATHENA and ZEUS.

Melpomene. See: MUSES.

Memory Picture. The portrayal of the most characteristic aspects of forms as seen in PRIMITIVE and early art. The object is usually depicted as a combination of different parts, rather than an organic whole. It is assumed that these pictures are drawn as mnemonic devices, as in early HIEROGLYPHIC writing.

Menelaus. In Greek mythology, King of Sparta, husband of HELEN and brother of AGAMEMNON. See also: HELEN OF TROY.

Mercury. Roman god of commerce, messenger of the OLYMPIAN Gods. See: HERMES.

Mermaids. Imaginary sea-dwelling creatures having the head, torso and arms of a woman and the tail of a fish. The NEREIDS were mermaids.

Methacrylate Sculpture. A three-dimensional construction made of transparent synthetic RESIN. The objects may be CAST or welded.

Metaphysical Painting, Pittura Metafisica. Art movement in Italy from 1917 to 1920s, examining the metaphysical dimensions of life. To communicate the mystery behind the surface appearance of an object to the viewer, the artists combined on canvas the real and the unreal, the classical past with the spirit of their own times. The paintings, often with incongruous relationships of mannequin figures, empty streets, classical statues, deep shadows and city squares, have an enigmatic, dreamlike quality. Psychoanalysis and the philosophy of Nietzsche were strong influences on the Meta-physical painters, who are closely related to SURREALISM. Paint-ers: Giorgio De Chirico, Carlo Carrà, Giorgio Morandi.

Metope. Rectangular panel with LOW RELIEF sculpture on the FRIEZE of Greek temples.

Mezzotint. Reproductive process especially popular in England in the 18th century. To achieve soft black tones, a rough surface was used. (For ETCHING and ENGRAVING, a polished surface is used.) A steel tool with sharp teeth along its curved edges is rocked back and forth, repeatedly, from different directions over a copper plate. Light areas of the drawing are scraped out and smoothed. This technique was used to reproduce works of Reynolds, Constable and Turner.

Michael, St. (ARCHANGEL). Captain of the heavenly host, protector of the Jewish nation, guardian of the redeemed in Christendom,

commander of the other ARCHANGELS, St. Michael is depicted in RENAISSANCE art as young and beautiful, sometimes winged, dressed in a dazzling coat of mail with sword, spear and shield. He is often represented at war with Satan. (Revelations 12:7-9). When he carries the scales of justice in his hand, he is acting as weigher of souls. Attributes: a lance, sword and scales.

Middletone. See: HALF-TONE.

Minerva. Roman goddess of wisdom. See: ATHENA.

Miniature Painting. 1. Illustrations in Ancient or Medieval manuscripts executed in red (Latin "miniare" to color with "minium," red lead), to brighten the page and/or to explain the text. Gradually many different colors were used. See also: ILLUMINATIONS. 2. Small detailed portraits usually executed in GOUACHE or WATER COLOR on VELLUM, PARCHMENT or ivory. Used by Hans Holbein the Younger and others. Miniature painting flourished especially in England in the late 16th century in works by Nicholas Hilliard and Isaac Oliver.

Minimal Art, ABC Art, Primary Structures, Reduction Art. Term applied to sculpture and painting in the 1960s. It is on the borderline between art and non-art; hence Minimal Art. Reducing art to its simplest and most irreducible forms, and using geometry and classical lines, the Minimalist sculptor creates simple structures of monumental size, devoid of symbolic content. The artist either produces the work himself or has it executed in an industrial plant, where it is completed under his supervision. Usually the objects are brightly colored and placed out-of-doors to become integrated with the total environment. Unused or negative space becomes as important as used space. Minimal sculpture questions the tradition of sculpture as an isolated object, on a pedestal of marble or bronze. Sculptors: David Smith, Anthony Caro, Donald Judd.
In painting, Minimalists reduce a work of art to the bare essentials (the flat canvas, color and shape) and reject all representational form. They eliminate ILLUSIONISM, PERSPECTIVE, and even NON-OBJECTIVE elements. For example: COLOR-FIELD, REDUCTIONISM. Painters: Barnett Newman, Robert Morris, Frank Stella.

Minoan Art. Art of the ancient CRETAN civilization from approximately 3400 to 1100 B.C., named after the early dynasty of MINOS. Surviving FRESCOES and other artifacts are characterized by LINEAR designs from nature and geometric forms.

Minos. In Greek mythology, the name of two kings of CRETE. Minos I, the son of ZEUS and EUROPA, ordered DAEDALUS to build the LABYRINTH to house the MINOTAUR. See also: MINOAN ART.

Minotaur. In Greek mythology, the offspring of Pasiphae (wife of MINOS) and a white bull. It was a monster with the body of a man and the head of a bull. King MINOS of CRETE kept it in the LABYRINTH built by DAEDALUS. Each year, it was fed seven youths and seven maidens until it was finally killed, with the help of MINOS' daughter ARIADNE, by THESEUS, the Athenian hero.

Mixed Media. 1. Use of two or more media in a painting. For example: oil and tempera as used by Van Eyck.
2. Use of different media to produce a total effect; music, film, dance, light, speech, T.V. may be involved in various combinations. Also known as Intermedia Art and Multimedia Art. Artists: Gordon Mummy, David Rosenbloom, Salvatore Marturano. Related to: ASSEMBLAGE.

Mobile. Lightweight three-dimensional wire sculpture of movable parts usually suspended from above. Air currents and gentle touch set it in motion and produce changing patterns. According to Alexander Calder (their inventor in 1932) Mobiles represent the system of the universe, or part thereof. To him detached bodies floating in space seem the ideal source of form.

Mocking of CHRIST, CHRIST Crowned with Thorns. After CHRIST had been scourged, he was taken by soldiers into the Common Hall, stripped of his clothes, covered with a purple robe and a crown of thorns. The crowd put a reed in his hand and mocked him saying, 'Hail, King of the Jews.' (Matthew 27:27-30; Mark 15:16-19; John 19:1-3)

Modeling. 1. In sculpture. Shaping in clay or wax for future reproduction in a more permanent form.
2. In painting. The use of light and shade to make an object appear solid (three-dimensional) on a two-dimensional surface.
3. Posing for an artist.

Modernist Painting. Two-dimensional art which abandons the illusion of the third dimension and the PERSPECTIVE technique. For example: HARD-EDGE, COLOR-FIELD, SYSTEMIC.

Moiré patterns. (from French 'watered silk'). Watery and wavelike effects, created by applying two identical patterns in a slightly off-parallel relationship. Painters: Jesus Rafael Soto, Karl Gerstner. Related to: OP ART.

Molding, Moulding. Ornamental surface with a modeled profile, projecting or recessed, in various patterns. Used in architecture, SCULPTURE and frames to define, articulate and decorate. For example:

1. Ovolo Convex molding 2. Cavetto Concave molding

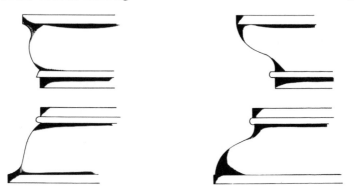

Money Changers. See: CHRIST CLEANSING THE TEMPLE.

Monochrome. Painting or drawing in different shades of a single color. For example: GRISAILLE.

Monograms. Signs consisting of two or more intertwined letters. Monograms symbolizing the name of CHRIST appear frequently in Christian art. Some of the most common are:

The two Greek letters Chi (X) and Rho (P), the first two letters of the Greek word for CHRIST, were combined by the early Christians so that they formed a cross.

IC XC NIKA was the ancient monogram symbolizing Christ the Conqueror. A very common abbreviation in BYZANTINE art, IC XC is derived from the first and last letters of the Greek "Ihcuc" (Jesus) and "Xpictor" (Christ). Nika is the Greek word for conqueror.

Alpha and Omega, the first and the last letters in the Greek alphabet, are based on Revelation 1:8, which reads: "I am Alpha and Omega, the beginning and the ending saith the Lord. . . ."

Monotype. Single PRINT made from a metal or glass plate on which a picture is painted in oils, printing ink, or other media. A quality of texture different from painting directly on the surface is achieved by this method. Castiglione, Degas and William Blake used this technique.

90

Montage. Arrangement made by placing one layer of material on top of another. Sections of photograph or motion picture are most commonly used for Montage. COLLAGE, used by CUBISTS, is a form of Montage.

Monumental. Art works of any size that are conceived as grand, noble and inspiring.

Mordecai. See: ESTHER.

Mosaic. Colored pieces of stone, CERAMIC or glass, arranged in patterns to decorate walls and floors. The pieces are set in wet plaster which holds them firmly in place on hardening. Highly developed art in Ancient Roman buildings, early Christian and BYZANTINE churches and palaces. Today mosaics are used for external wall facings, table tops and other surfaces.

Moses (13th century B.C.). Hebrew lawgiver who led the Israelites out of Egypt and in their wanderings through the wilderness for forty years. At the time of Moses' birth, the King of Egypt ordered all Hebrew male children put to death at infancy. Floating down the Nile in a basket, he was saved by the Egyptian princess who later adopted him. Moses is frequently depicted with horns, an attribute coming from an awkward Latin translation of the Hebrew text, in which Moses is described with "rays of light like horns", symbolizing his glory after he had encountered God.

Popular themes:

1. *Moses and the Burning Bush.* One day Moses, tending sheep, saw a bush burning, but the bush was not destroyed. Through the burning bush God called to Moses and told him to return to the land of Pharoah and lead the people of Israel out of Egypt. (Exodus 3:2).

2. *Gathering of the Manna.* After escaping from Egypt, the Jews were lost in the wilderness without food. Miraculously, a small white round substance (which they called manna) appeared. For 40 years, before coming to Canaan, the Israelites subsisted on manna. (Exodus 16:13-36)

Motif. 1. Main subject of a painting. Often it is a repeated theme.
2. In sculpture, it is the way an artist arranges his figure(s).

Multi-Media Art. See: MIXED MEDIA.

Multiples, Editions. A term first applied in the 1960s to art works that are intended to be in multiple copies; not as one original from which reproductions can be made later. Some artists, concerned that original art was left to the domain of wealthy collectors and museums, used new media, (i.e. plastics, styrofoam) to create objects in series or editions with each copy

alike, yet unique. The multiple concept originated with Marcel Duchamp and his contemporary media. Today they constitute an inexpensive mass-produced alternative to traditional reproductions which can never be completely faithful. The term multiples is used broadly for anything from GRAPHIC ART and SILK SCREEN to products of intricate technology. Artists: Ernest Trova, Robert Morris, Rory McEwen.

Mural Painting. FRESCO, or painting in any medium, usually in large scale, designed for wall decoration, and frequently painted directly on the surface.

Muses. Nine Greek goddesses of the arts, daughters of ZEUS and Mnemosyne.

	Muse of:	**Attributes**
Calliope	Epic poetry	tablet and stylus
Clio	History	wreath of laurel, scroll or book
Erato	Love poetry	lyre
Euterpe	Music and lyric poetry	flute
Melpomene	Tragedy	ivy wreath, thick-soled high boot, tragic mask, sword
Polhymnia	Sacred song, oratory, singing	veil
Terpsichore	Dancing	lyre, crown of laurel
Thalia	Comedy	ivy wreath, shepherd's staff, comic mask and "sock"
Urania	Astronomy	globe and a pair of compasses

Mycenae. Ancient city of Greece significant in the past as a center of Mycenean civilization. Some characters of Greek legend related to Mycenae are: AGAMEMNON and Orestes.

Mycenaean Art. Art of the ancient Greek civilization centering around Mycenae from approximately 1600 to 1100 B.C. Influenced by MINOAN and other Near Eastern styles, Mycenaean art works show lively imagery, based on age-old MOTIFS from nature, on royal ceremonies and war scenes. Carvings and inlays in gold, silver, copper and ivory testify to highly developed techniques and the finest craftsmanship.

N

Nabis. (Heb. prophet). Group of French artists 1880-1899. Influenced by Gauguin's painting and philosophy, and by Japanese prints, they used flat areas of bold color in heavily outlined patterns. Religious, mystical or primitive subjects prevailed. Painters: Edouard Vuillard, Pierre Bonnard. Sculptor: Aristede Maillol. Related to: ART NOUVEAU, INTIMISM and SYMBOLISM.

Naiades. In Greek mythology, water nymphs presiding over lakes, rivers, springs and fountains.

Narrative Painting, Anecdotal Art. Painting that depicts a story or a definite message. The artist's emphasis is on the content of the painting. Related to: LITERARY ART.

Nativity. Depicts the birth of CHRIST in a stable in Bethlehem, at midnight. Surrounding the infant may be the ox and the ass, and/ or MARY and JOSEPH, the Shepherds and the Wise Men. (Luke 2:1-20)

Naturalism. A style that represents the natural appearance of subjects. It is characterized by careful, loving reproduction of detail and harmonious composition of the whole. BAROQUE is often characterized as a period of sensuous Naturalism; Dutch GENRE painting as intimate Naturalism.

Nature Morte. French for "Still life." See: STILL LIFE.

Nazarenes. A group of ROMANTIC artists who, in 1810, went from Vienna to Rome to live as a brotherhood of artists in the Medieval monastic tradition. Although they never realized their aim to bring about a religious revival of German painting, their ideals of simplicity and purity, and their work, especially some large group

MURALS, had a profound influence on later artists, for example the PRE-RAPHAELITES. Painters: Friedrich Overbeck, Franz Pforr, Peter Cornelius.

Nectar. See: AMBROSIA.

Negro Art. Art produced by black artists irrespective of country of origin. See also: BLACK ART.

Neo-Classicism. Eighteenth century movement to recreate the harmonius art of ancient Greece and Rome. Excavations of Pompeii and Herculaneum in 1748 provided the material and stimulus for Neo-Classicism. Artists copied antique models faithfully. Painters: Jacques Louis David, Jean-Auguste Ingres.

Neo-Impressionism, Pointillism, Divisionism. Method of painting developed by Georges Seurat and Paul Signac in the 1880s. Thousands of tiny dots of pure color are applied to the canvas. These are supposed to fuse in the eye of the viewer. By dividing (divisionism) color into tiny points, all the benefits of light and harmony are secured. Neo-Impressionism, with its strictly ordered composition, is different from IMPRESSIONISM. In Neo-Impressionism, forms are reduced to their basic geometric shapes. The silhouettes are then assembled so that they are integrated with one another and with the space around them. Seurat and Signac were artist-scientists whose geometric structures are similar to the pure ABSTRACT ART of the 20th century. Related to: POST-IMPRESSIONISM.

Neo-Plasticism, New Plasticism. A term attributed to the Dutch artist Mondrian in 1918 to describe the qualities of the art works of the DE STIJL movement. Characterized by the use of right angles in horizontal/vertical positions, its simplicity is opposed to the ornamental ART NOUVEAU of the preceding period. Colors are equally pure: only red, yellow and blue in conjunction with black, white and grey are used. Artist: Piet Mondrian.

Neo-Romanticism. Style of romantic realist painting in the 1920s concerned with loneliness, nostalgia and fantasy. In reaction against CUBISM and ABSTRACTION, the Neo-Romantics wished to return to man and his emotions as the subjects of art. This movement paralleled SURREALISM. Painters: Christian Bérard, Eugene Berman, Pavel Tchelitchew.

Neptune. Roman god of the sea. See: POSEIDON.

Nereides, Nereids. In Greek mythology, the fifty MERMAIDS, daughters of Nereus, who lived in the depths of the Mediterranean Sea. These sea NYMPHS were attendants of POSEIDON.

Neue Sachlichkeit, Die. (NOI eh ZAHKH likh KITE) See: NEW OB-
JECTIVITY.

New Objectivity, The. (Ger. Die Neue Sachlichkeit)(NOI eh ZAHKH
likh KITE) Verism. German EXPRESSIONIST movement in
1920s that is concerned with the disillusionment, cynicism and
despair that existed at end of World War I. Characterized by clini-
cally detailed REALISM, bitter humor and exaggerated forthright-
ness, the paintings appear fantastic and shocking. Painters: Otto
Dix, George Grosz. Related to: SURREALISM, MAGIC REALISM.

New Plasticism. See: NEO-PLASTICISM.

**New Realism, Post-Modernist Art, Figurative Humanism, Sharp-Fo-
cus Realism and Photographic Realism.** Starting in the 1960s, this
art movement is characterized by an impersonal, yet not uncon-
cerned, literal rendition of commonplace people and things. React-
ing to the increasing abstraction in art, there is renewed interest in
recognizable images and themes. Forms of expression: 1. Photog-
raphy and airbrush. Photographs are projected on the canvas and
as the artist follows the lines with great attention to the photo-
graphic image, he attempts to reproduce life as the camera views it.
In contrast to a moving picture, the artist sets out to catch one iso-
lated fragment of reality. Examples: Richard Estes, Chuck Close.
2. Realistic painting in two-dimensional flat areas. Photography is
rejected as an intermediary and the artists go directly to nature or
the depicted object. Examples: Philip Perlstein, Alfred Leslie.
3. Use of various media to reproduce plastic life-like figures and
scenes; not unlike the wax figures of Mme. Tissaud. Example:
Duane Hanson.

New York School. Artists active on the New York scene since World
War II; they include Geometrical Abstractionists, ABSTRACT EX-
PRESSIONISTS, COLOR-FIELD PAINTERS. New York emerged
as a vital art center in the 1940s as a result of (1) W.P.A. FEDER-
AL ARTS PROJECT of the 1930s (2) emigration here during
World War II of such European artists as Duchamp, Léger, Mon-
drian and Ernst. They transferred much of the talent from the
European continent to New York.

Nicholas of Bari, St. (4th century). Bishop of Myra. The son of rich
parents, Nicholas distributed the wealth of his parents after their
death. One legend about St. Nicholas tells of his visit to an inn
where the innkeeper executed three children by placing them in
salting tubs. Nicholas found the bodies and brought them back to
life. St. Nicholas serves a twin purpose—warning children against

disobedience and fostering the spirit of generosity in giving. He was elected patron saint of seamen because the ship transporting his remains reached port safely, despite severe storms. He is also patron saint of Russia, and children, to whom he brings gifts (Santa Claus). St. Nicholas is usually represented as a bishop. Attributes: anchor and ship in the background; sometimes a child kissing his hand; also, three gold balls represent three bags of gold that he threw into the bedroom of a poor nobleman so that his daughters would have the dowry essential for marriage.

Niello. A dark substance consisting of lead, silver, copper and sulphur, which is poured into ENGRAVED metal plate. The term is also used for the process and the final product. Beautifully executed Niello work has survived from MYCENAEAN daggers and other ancient artifacts.

Nike. Greek goddess of Victory. A draped, winged woman, she presided over all contests, athletic and military, holding a palm branch or a laurel wreath over the head of the victor. "Winged Victory", or "The Victory (or Nike) of Samothrace" (c 200 B.C.) is one of the finest extant Greek sculptures. Roman counterpart: Victoria.

Nimbus. See: HALO.

Niobe. In Greek mythology, Queen of Thebes who boasted of her fecundity while taunting Leto for having had only two children. Archers ARTEMIS and APOLLO, children of Leto, punished Niobe by killing all her children with their arrows. ZEUS turned Niobe into a stone that continued to weep incessantly.

Noah. Hebrew patriarch of the Old Testament selected by God to be saved with his family, and animals of every species, while the rest of mankind was to be destroyed by the Flood. (Genesis: 5-9). *FAVORITE SUBJECTS IN ART: Building of the Ark* depicts Noah constructing the ark according to God's specifications. (Genesis 6:15, 16). *The Flood* portrays the downpour of 150 days survived in the ark by Noah, his family and the animals. When a dove, sent out by Noah, returned carrying an olive leaf, the patriarch knew the flood was receding. (Genesis 8:11). *Sacrifice of Noah* portrays Noah sacrificing burnt offerings on an altar in gratitude to God. (Genesis 8:20). *Drunkenness of Noah* portrays his youngest son Ham spying on the naked, drunken Noah, a deed for which his father cursed him. (Genesis 9:25).

Noli Me Tangere (Latin: 'Don't touch me'). Between the RESURRECTION and Easter, CHRIST appeared several times to his

disciples. His first appearance was before MARY MAGDALENE when she went to his tomb. He told MARY 'Noli Me Tangere' because he had not yet ascended to his Father. (John 20:14-18)

Non-Art. See: ANTI-ART.

Non-Objective Art. Painting and sculpture devoid of a recognizable subject. Color, line, form and their relationships constitute a subject. Non-Objective Art includes ABSTRACT EXPRESSIONISM, ABSTRACT CLASSICISM, TACHISME, CONSTRUCTIVISM, KINETIC and MINIMAL ART and others. The concepts and art works of Wassily Kandinsky strongly influenced Non-Objective painting. Examples of Non-Objective sculpture are seen in the works of Jean Arp, Vladimir Tatlin, David Smith and Alexander Calder. Related to: ABSTRACT ART.

Nouveaux Réalistes. See: NEW REALISM.

Nymphs. In Greek and Roman mythology, the female divinities associated with nature. These beautiful maidens were usually musical, amorous, gentle and eternally young, although some were known to be vengeful and destructive. Nymphs inhabited trees, woods, mountains, the sea, and frequently attended a superior diety. Some of the groups of nymphs are the Dryades, NAIDES, NEREIDES, and Oceanides.

O

Obelisk. Tall, narrow, four-sided monument, usually made of one great piece of stone, tapering as it rises and ending in a point. For example: Washington Monument, Washington, D. C.

Objet Trouvé. See: FOUND OBJECT.

Odalisque. Female slave or concubine; popular subject for Ingres, Delacroix, Renoir and Matisse.

Odysseus. In Greek mythology, the wisest and shrewdest of the Greek heroes in the Trojan War, in which he fought for ten years. After ten more years of adventures, he returned to his faithful wife PENELOPE. Homer's Iliad and Odyssey recount his experiences, which were popular subjects for Greek and Roman painters. Especially: Nausicaa, Telemachus.

Oedipus. In Greek legend, son of Laius, King of THEBES, and Jocasta. As was prophesied at his birth, he unwittingly murdered his father and married his mother, Jocasta. They had four children. As the truth of his deeds revealed itself to him, King Oedipus of THEBES blinded himself in grief. Guided by his devoted daughter, Antigone, he left THEBES.

Oil Painting. Process of applying layers of PIGMENT ground and mixed with drying oil (usually linseed) to a PRIMED canvas or to a wood panel. Oil gives added brilliance to the PIGMENTS and it enables an infinite number of layers to be applied. Introduced in the 15th century in the Netherlands and Italy, oil paint became one of the most frequently used media in painting.

Olympia. A plain in Greece. 1. On it stands the Temple of ZEUS and HERA with the famous statue of ZEUS by Phidias; considered one of the SEVEN WONDERS OF THE ANCIENT WORLD. 2. Place of

Olympic games, which according to tradition were initiated in 776 B. C. by HERAKLES. They were held every four years in July and became the most famous athletic event of classical antiquity. The winners were honored with an olive wreath.

Olympians. The twelve great Gods who succeeded the TITANS as rulers of the universe and lived on Mt. Olympus. ZEUS ruled the heavens and earth with HERA, his queen. His brothers: POSEIDON, HADES (PLUTO). His sister: DEMETER. The divine children: ARES, HERMES, APOLLO, HEPHAESTUS, ATHENA, APHRODITE and ARTEMIS. They were immortal and lived on NECTAR and AMBROSIA.

One Image Art. See: SYSTEMIC ART.

Op Art, Optical Art, Retinal Art. A NON-OBJECTIVE art movement beginning in the 1960s. Various devices like MOIRÉ-patterns, designs of rectangles, squares, circles, dots, stripes or lines, create illusions of change and movement that dazzle the eye. Exploiting scientific theories of our visual perception, the artists intend to overcome the static aspect of ABSTRACT ART in order to create an "adventure of the eyes." Op Art can be programmed by computer and is conceptually related to KINETIC ART. Painters: Josef Albers, Victor Vasarely, Yaacov Agam.

Open-Air Painting. See: PLEIN-AIR PAINTING.

Optical Art. See: OP ART.

Optical Mixing. Fusing, by the eye, of primary colors, applied to the canvas in separate dots or brush strokes. When the viewer stands back from the canvas a certain distance, blue and yellow appear bright green. IMPRESSIONISTS and NEO-IMPRESSIONISTS theorized that this method produced a truer, brighter representation of light and color than the method of premixing the colors before applying them to the canvas.

Orpheus. In Greek mythology, a divinely inspired musician, son of APOLLO and CALLIOPE. He soothed the wild beasts, stopped the rivers from flowing, charmed even the stones and the mountains with the sound of his lyre. When his wife Eurydice fled from a pursuant admirer, she was bitten by a snake and died. Orpheus descended to HADES enchanting all dark powers. PLUTO and PERSEPHONE promised to restore Eurydice provided Orpheus would not look at her until he had led her into the sunlight.

Orphic Cubism. See: ORPHISM.

Orphism, Orphic Cubism. Starting in 1912, this movement, although

deriving from CUBISM, departed from the geometrical structures and emphasized color as the only element of a painting, making it both form and subject. Through dynamic arrangements of the colors of the SPECTRUM, Delaunay created simultaneous contrasts of pure color with quiet rhythm, movement and depth. His color orchestration suggested to Guillame Apollinaire the name 'Orphism', while Delaunay referred to it as "the Law of Simultaneous Contrasts." Orphism influenced Blaue Reiter and SYNCHROMISM. Painters: Robert Delaunay, Frantisek Kupka.

Ottonian Art. 10th and 11th century art in Central Europe. Although based on CAROLINGIAN style, Ottonian Art showed a stronger BYZANTINE influence than the preceding period. Pictures became flatter, the outlines stronger, and in both sculpture and ILLUMINATION, figures and faces showed the intense expressiveness of Eastern styles.

P

Painterly. (Germ. 'Malerisch'). (ma le REESH) Technique of painting that emphasizes color rather than line. The use of light and shade with soft transition, and the visibility of the brushwork in Rembrandt, or the blurred use of color in ABSTRACT EXPRESSIONISM are painterly. The opposite of painterly is the clear definition of color used in HARD-EDGE or the LINEAR painting (use of line as in drawing) of Botticelli and Dürer. Recent painterly painters: Jackson Pollock, Hans Hofmann, Willem de Kooning.

Palette. 1. Thin board on which an artist arranges his colors and mixes his PIGMENTS. It is round, square or eggshaped, made of wood, metal or glass and has a hole in it for the artist's thumb.

2. The set of colors an artist selects for a painting is also known as his palette.

Palette

Pallas Athena. See: ATHENA.

Pallium. 1. Large square woolen sheet or blanket worn as a cloak by men in ancient Greece and Rome.

2. Vestment worn by the pope consisting of a narrow ringlike band of wool that rests on the shoulders with two short pendants, one hanging down the front, the other down the back. It is ornamented with six black crosses. Sometimes the pope confers the pallium on archbishops on their promotion.

Pallium

Pan. In Greek mythology, the son of HERMES. Pan was the mischievous pastoral god of fertility in the ARCADIAN fields and forests; patron of shepherds and hunters. Represented as a SATYR, he was usually involved in amorous affairs. In one myth, he pursued the NYMPH Syrinx, who was changed into a bed of reeds by her sister, in an effort to protect her. From these reeds, Pan created the panpipe or 'syrinx', named after the NYMPH. From his habit of frightening unwary travelers comes the word 'panic'. Roman counterpart: Faunus.

Pandora. In Greek mythology, the first woman on earth, and, endowed by the Gods with all the charms. ZEUS gave her a box and forbade her to open it. In the box, PROMETHEUS had confined all of mankind's evils. As the Gods had anticipated, Pandora opened the box, releasing all the misfortunes that have plagued mankind since. Only hope remained inside the box.

Panel Painting. Painting, not on canvas, but on wood or metal. Frequently used by artists in the early Middle Ages.

Pantheon. Roman temple, largest circular building in antiquity. It was built by Agrippa in 27 B.C., destroyed by lightening and rebuilt in the 2nd century by Hadrian. In Christian times, it became a church in which Italian kings and famous men, for example, Raphael, were buried.

Pantocrator. See: CHRIST PANTOCRATOR.

Papiers Collés. (pa PYAY kaw LAY) See: COLLAGE.

Papier-Mâché. (Fr. chewed paper). A material made by gluing and pressing together bits of paper. While still moist papier-mâché is molded to form various articles. These become strong and hard as they dry and are then usually varnished and painted. This technique is first known to have been used in France in the 18th century.

Papyrus. Principal writing material used by ancient Egyptians, Greeks and Romans from approximately 4th century B.C. to 5th century A.D. The pith (soft inner part) of the papyrus plant was made into thin sheets by slicing and pressing. Then the sheets were glued end to end and rolled on wooden rods to form 15 ft. scrolls that were used for writing.

Paradise. See: EDEN, GARDEN OF.

Parchment. Sheep or goat skin, cleaned and prepared for various purposes, especially for writing. More broadly, the term is often used for all kinds of animal skins, including calfskin, VELLUM. Parchment preceded paper as writing material.

Paris, Judgment of. In Greek mythology, Paris was the son of Priam, King of Troy, and Hecuba. ZEUS appointed Paris to decide who of the three quarreling goddesses, ATHENA, APHRODITE and HERA, should receive the apple thrown to them by the goddess of Discord, and inscribed "to the fairest." Each goddess offered Paris a bribe: HERA offered power and all the kingdoms in Asia; ATHENA offered victory in battle, beauty, wisdom; APHRODITE promised HELEN, the most beautiful woman in the world, for his wife. Paris selected APHRODITE who helped him kidnap HELEN from her husband, King MENELAUS of Sparta, thus causing the Trojan War.

Parnassus. A mountain in central Greece, more than 8,000 ft. high. In ancient Greece it was sacred to APOLLO, DIONYSUS and the MUSES. At the foot of the mountain lies DELPHI.

Parnassus. A mountain in central Greece, more than 8,000 ft. high. In ATHENS built in the 5th century B.C. during the Age of Pericles. Regarded as the masterpiece of Greek architecture, it was designed by Ictinus and Callicrates. The sculpture was supervised by Phidias, who executed the statue of ATHENA himself.

Passion. The last events of CHRIST'S earthly life, from his entry into Jerusalem to his burial, are called the Passion. Popular themes: CHRIST'S ENTRY INTO JERUSALEM; CHRIST Washing the Feet of the Disciples; LAST SUPPER; AGONY IN THE GARDEN; BETRAYAL OF CHRIST; CHRIST BEFORE CAIAPHAS; DENIAL OF PETER; FLAGELLATION; MOCKING OF CHRIST; CALVARY; STATIONS OF THE CROSS; CRUCIFIXION; DESCENT FROM THE CROSS; PIETÀ; ENTOMBMENT.

Symbols of the Passion:

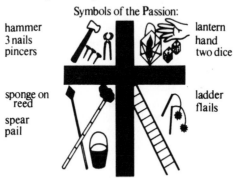

hammer
3 nails
pincers

lantern
hand
two dice

sponge on
reed

spear
pail

ladder
flails

Pastels. Sticks of finely ground PIGMENTS pressed together with glue. Works of art created with pastels may be called Pastel Drawing or Pastel Painting. It is almost impossible to distin-

103

guish one from the other. The pale colors of pastel have a dusty look, and because they tend to smudge, they are often affixed with a weak solution. Pastels were used in the 16th century by Holbein and others. The medium was popular with the IMPRESSIONISTS and the POST-IMPRESSIONISTS, especially with Degas.

Pastiche, Pasticcio. Work of art that imitates and admits that it imitates the style of another artist or school of art. The MOTIFS, as combined by the artist, give the impression of being an original creation.

Pastose. Thick application of paint.

Patina. Film or crust produced on bronze by exposure to weather or artificially induced oxydation. The dark, often green shades give an aura of age to the object, and are frequently admired as adding special beauty.

Patroon School. 18th century school of portrait painters or LIMNERS in New York and the Hudson Valley. Influenced by English 17th century painting, these portraits are an interesting combination of BAROQUE composition and primitive execution. Painters were named after their patrons or the places in which they were active. For example: Van Epps Limner, Schuyler Limner. See also: LIMNING and MINIATURES.

Paul the Apostle, St. Greatest of the early Christian missionaries. Originally named Saul, he was born of Jewish parents and educated in rabbinical studies. While en route to Damascus, taking part in the persecution of Christians, he was blinded by a light from heaven and converted to Christianity. St. Paul and St. PETER are frequently represented together or on either side of CHRIST since the two are considered to be founders of the Church. Paul may be recognized by his high forehead, long prominent nose, brown hair and full beard. Attributes: the sword with which he was martyred in Rome; the book of his epistles to the faithful (written while he was imprisoned in Rome).

Pegasus. In Greek mythology, the winged horse that sprang from the neck of MEDUSA when PERSEUS cut off her head. Shortly thereafter, PEGASUS, striking the earth with his hoof, created the Hippocrene, a fountain sacred to the nine MUSES, called the source of poetic inspiration.

Peleus. In Greek mythology, King of Myrmidons, father of ACHILLES by THETIS. At the wedding of Peleus and THETIS, in the presence

of all the Gods, Eris, goddess of Discord, rolled in a golden apple inscribed 'For the Fairest.' This led to the Judgment of PARIS and eventually to the Trojan War. See also: PARIS.

Penelope. Wife of ODYSSEUS. See: ODYSSEUS.

Pentecost. A Christian festival celebrated on the seventh Sunday after Easter, commemorating the descent of the Holy Spirit upon the APOSTLES. According to the New Testament, the APOSTLES were gathered together when a sound from heaven like a rushing wind filled the house. Thus the Holy Spirit made his presence felt, granted the APOSTLES the gift of many languages and inspired them to spread the gospel throughout the earth. This subject, popular in BYZANTINE ART, first appeared in the 6th century. (Acts 2:24)

Persephone, Proserpine. In Greek and Roman mythology, goddess of fertility. Daughter of ZEUS and DEMETER, she was kidnapped by PLUTO to be queen of HADES. DEMETER convinced the Gods to permit her daughter to return to the earth but because Persephone had eaten a pomegranate (food of the dead) while in HADES, she was required to stay there for four months every year. When Persephone left the earth, all vegetation died, but when she returned, life blossomed again.

Perseus. Greek hero; son of ZEUS and Danae. Perseus slew the MEDUSA as she gazed at her reflection in his shield. Later he saved ANDROMEDA from a sea monster and married her.

Perspective. The technique of representing a three-dimensional object on a flat surface as it would appear to the eye if it were in space. Artists use perspective to create an illusion of depth and distance. In *Linear Perspective,* based on geometry, objects diminish in size as they recede into the background. To achieve this illusion, the artist makes his objects progressively smaller and closer together. In *Aerial Perspective,* the color and distinctness of an object change when viewed from a distance; objects tend to look bluish. To achieve this illusion, the artist paints in cool colors (blue and green).

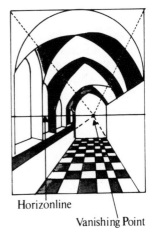

Horizonline

Vanishing Point

Various techniques of perspective were used by CLASSICAL and

HELLENISTIC painters, but it was during the RENAISSANCE that the use of perspective flourished and changed the direction of western art. From the RENAISSANCE until the 20th century, western artists used perspective unquestioningly. In the 20th century, however, many artists reject perspective as an illusion. See also: ILLUSIONISM, COLOR-FIELD PAINTING, MODERNIST PAINTING.

Peter, St. Spokesman for the APOSTLES and chosen by CHRIST as leader of the church. A fisherman of Galilee, he, with his brother Andrew, was first called to follow CHRIST. His name was Simon but Jesus called him Peter, which means rock. "Thou art Peter and upon this rock I will build my church." (Matthew 16:18) After the ASCENSION, Peter spread the gospel throughout Asia Minor, then went to Rome where he was martyred. At his own request he was nailed to the cross upside down because he did not consider himself worthy to die in the same manner as CHRIST. Peter is usually given a prominent place among the APOSTLES, appearing as a stolid, robust old man. Often he is represented with PAUL. Attributes: keys signify the keys to the kingdom of heaven; a fish to show he is the fisherman of souls; the cock refers to the DENIAL of PETER; a bright yellow mantle, symbolic of Revealed Faith; a cross.

Phaedra. In Greek mythology, daughter of MINOS and Pasiphae; wife of THESEUS. When her stepson Hippolytus rejected her advances, Phaedra accused him of having attacked her. Without investigating, THESEUS asked POSEIDON for revenge. A sea monster sent by POSEIDON, so terrified Hippolytus' horses, they bolted and dragged him to his death.

Pharoah's Dream. See: JOSEPH.

Phoebus. Another name for APOLLO, the sun god. See: APOLLO.

Phoenix. 1. A mythical Egyptian bird that regenerated itself periodically. According to legend, the Phoenix lived in the Arabian wilderness for 500-600 years, burned itself on a pyre of flames, and from its ashes, a new Phoenix arose. Herodotus described the Phoenix as red and golden, resembling an eagle.

2. In Greek mythology, he was a brother of EUROPA, who was abducted by ZEUS. When he searched for his sister, he settled in Phoenicia which is named after him.

Photographic Realism. See: NEW REALISM.

Photomontage. Derived from COLLAGE (Papiers Collés), photomontage is created by cutting up and pasting together in new

106

Photoscreen. See: SILK SCREEN.

Pictorial. 1. Representation in form of a painting or drawing.

2. Often used to indicate the quality of an art work in which figures, objects and space are organized according to an aesthetic principle, and in which COLOR and COMPOSITION form a pleasing unity.

Pictorial Method. See: COLOR STAINING.

Picturesque (Ital. pittoresco "like a picture"). This term has different meanings.

1. First became popular in the 18th century when it meant picturelike scenery. For example: paintings of Claude Lorraine, Nicolas Poussin.

2. At end of 18th century, picturesque meant beauty characterized disorderliness and roughness. For example: scenes of ruins and roughly dressed peasants.

3. In the early 19th century, it referred to landscapes with special charm. For example: Landscapes of the BARBIZON SCHOOL and HUDSON RIVER SCHOOL.

Related to: MALERISCH. See also: PAINTERLY.

Pietà. (from Latin pietas, piety and love). Representation of the Virgin mourning over the dead CHRIST, usually shown lying on her lap.

Pigment. Coloring substance, usually in the form of fine powder. When pigment is mixed with a "vehicle" or MEDIUM such as glue, egg, oil or water, it forms paint.

Pilate, CHRIST before. According to the New Testament, the morning after CHRIST had been accused before CAIAPHAS, the high priest, he was taken before Pontius Pilate, the Roman governor of Judea, and charged with treason for calling himself "King of the Jews." Pilate presented Jesus to the mob suggesting that he be released because it was the custom to free one prisoner at the time of Passover. The mob, however, stirred up by the priests cried for the release of Barabbas, a murderer, and demanded that Jesus be crucified. The Roman governor alone could order a man's death. Pontius Pilate tried to evade the action but feared the repercussions. Washing his hands before the people, Pontius Pilate declared himself innocent of the blood of this just person. (Matthew 27:11-26; Luke 23:1-7; Mark 15:1-15; John 18:28-40; 19:4-16).

Pinxit, pinc., pinx. (Latin – "he painted it") This term may be found in one of the lower corners of an art PRINT. It accompanies the name of the painter, from whose picture the ENGRAVING has been made. Related to: DELINEAVIT, PECIT and INVENIT.

Pisces. See: ZODIAC.

Pittura Metafisica. See: METAPHYSICAL PAINTING.

Plastic Art. (Greek – plastikós, something formed or molded). A general term for three-dimensional art work, whether it is molded or carved. Sculpture, CERAMICS, and various RELIEF techniques are considered Plastic Art.

Plasticity. The capability of materials like clay or wax, of being molded into various shapes. Today many synthetic resin products lend themselves to PLASTIC ART.

Plein-Air Painting, Open-Air Painting. Pictures painted outdoors, conveying an open-air feeling, emphasizing the effects of light and atmosphere. Characteristic of IMPRESSIONISM.

Pluto. See: HADES.

Pneumatic Sculpture. See: INFLATABLE SCULPTURE.

Pointillism. Application of thousands of tiny dots of pure color to the canvas. These colors, mixed in the eye of the viewer, produce other colors (more luminous than can be obtained by premixing on the PALETTE). For example: red and yellow become orange. Pointillism is considered IMPRESSIONIST theory carried to a logical, scientific, almost mathematical conclusion. This dot by dot technique earned the artists the nickname 'confetti painters.' Seurat preferred the term Divisionism to Pointillism. Painters: Georges Seurat, Paul Signac. Related to: NEO-IMPRESSIONISM.

Polyester. Any of numerous synthetic RESINS, plastics and textile fabrics, used in contemporary painting.

Polyethylene. A synthetic RESIN used chiefly for containers, electrical insulation, packaging and films. Used in contemporary MIXED MEDIA ART.

Polyhymnia. See: MUSES.

Polymer. A compound formed from two or more synthetic RESINS. The substance is milky white, but dries to a transparent film, which is highly water resistant. Even when used in thick layers it does not crack when the right proportions are used. Polymer is a popular medium in contemporary art.

Polyphemus. In Greek mythology, a man-eating CYCLOPS, son of POSEIDON. He fell in love with the sea NYMPH GALATEA and murdered her lover ACIS. After the Trojan War,

108

ODYSSEUS and his men stopped at the island of Polyphemus who imprisoned them and proceeded to eat two of the men. In order to escape, ODYSSEUS made Polyphemus drunk and blinded him. Tied under the bodies of some sheep, ODYSSEUS and his men escaped.

Polyptych. Art work on several hinged panels often used for ALTARS.

Pop Art. Art movement of the 1960s based on popular mass culture sources like advertisements, comics, billboards, movies and TV. The movement was influenced by Duchamp, Schwitters, and John Cage, the composer. The latter urged artists in all fields to erase the boundary between art and life, and to react to the present. Robert Rauschenberg requires that the viewer participate in the creation of the work of art. To him, works of Pop Art are "Deep-frozen HAPPENINGS." Artists: Claes Oldenburg, Jim Dine, Robert Rauschenberg. See also: DADAISM, MINIMAL ART, and NEW REALISM.

Poseidon. In Greek mythology, god of the sea, god of horses and father of PEGASUS. He is usually represented as a powerful, bearded god with a violent, vengeful disposition, using his trident to smash boulders, cause earthquakes, raise tempests or calm the sea. Roman counterpart: NEPTUNE.

Post-Impressionism. Umbrella term covering painters at the end of the 19th century who reacted against the limitations of IMPRESSIONISM and developed more independent styles. Post-Impressionism moved toward CUBISM emphasizing the formal qualities of a picture; color and line. Painters: Paul Cezanne, Vincent Van Gogh, Paul Gauguin.

Post-Modernist Art. See: NEW REALISM.

Post-Painterly Abstraction. See: COLOR-FIELD PAINTING.

Precisionism. See: CUBIST REALISM.

Pre-Columbian Art. Art of North, Central and South America before the time of Christopher Columbus. Includes works by North American Indians, Aztecs, Mayas, Peruvians.

Predella. See: ALTAR.

Prehistoric Art. Art prior to historic times. For example: 4,000 B.C. It includes the CAVE PAINTINGS of Altamira and Lascaux and fertility images.

Pre-Raphaelites. Group of English painters and poets formed in 1848 to recapture the innocence, purity and honesty of the Italian artists before Raphael. Closely related to ROMANTICISM, they also chose their subjects from scenes of great

literature, the Bible and Shakespeare. Elaborate symbolism, lively design and brilliant color characterize their work. The movement died before the end of the 19th century. Painters: Dante Gabriel Rossetti, William Morris and Burne-Jones.

Presentation in the Temple. After Jesus was born, MARY and JOSEPH, in accordance with Jewish custom, brought him to Jerusalem for his Presentation in the Temple and his circumcision. St. Simeon, who was promised that he would not die before seeing the Lord's CHRIST, and St. Anna, the prophetess who hailed the child Jesus as the redeemer are often depicted in this scene. (Luke 2:22-39).

Primary Colors. The three basic colors – red, yellow and blue – from which, in theory, all other colors can be mixed.

Primary Structures. See: MINIMAL ART.

Primavera. (Italian for spring). A theme representing the RENAISSANCE spirit.

Priming. Application of first coat or layer (usually white lead and linseed oil) to a canvas. Prepares the canvas to receive and absorb subsequent layers of paint, acting as a GROUND.

Primitive Art. 1. The art of primitive societies. For example: Africa, Oceania, North American Indians. Human and animal subjects project tribal, religious and sociological characteristics. Head, limbs and breasts may be treated as separate entities or joined without regard to natural proportions. The design is usually centered on the head. Gauguin, French FAUVES, German EXPRESSIONISTS and Picasso found a new stimulus in the exotic masks and figures of Primitive Art.
2. Art of the early Italian schools; before 1450.
3. Simple, innocent naïve style of self taught artists. For example: Henri Rousseau ("Le Douanier" – customs officer) Grandma Moses (real name – Anna Mary Robertson).

Print. Impression on paper taken from a treated plate, block or stone.

Kinds of Prints	Technique	Examples
RELIEF	design cut away from the surface	WOODCUT WOOD ENGRAVING
INTAGLIO	design cut into the surface	ENGRAVING ETCHING on metal
Surface	design drawn on the surface	LITHOGRAPHY

Original prints are usually numbered in the following way:
1/100, 58/100
The first and the 58th print from a total of one hundred prints, made from the original plate. See also: COPY.

110

Process Art. See: CONCEPTUAL ART.

Prodigal Son. Parable of the son who asks the father for his portion of the family estate, then leaves and proceeds to squander it. Returning poor and humble, the repentant son is warmly welcomed by his father who regards him as found after having been lost. (Luke 15:11-32).

Programmed Constructions. Art rendered automatically by a computer that has been provided with a set of instructions. For example: the flashing lights in the light panels created by Howard Jones are programmed; also Otto Piene's "Red Rapid Growth." Related to: CONSTRUCTIVISM, PULSA and KINETIC ART.

Prometheus. In Greek mythology one of the TITANS, great benefactor of mankind. Out of clay and water, he created the first man and woman. From the Gods on Mt. Olympus, he stole fire, gave it to man and taught him many useful arts and sciences. For this crime, ZEUS ordered HERMES to chain Prometheus to a rock on Mt. Caucasus where a vulture fed daily on his liver, which grew back each day. Prometheus was finally freed by HERAKLES. All the troubles of mankind Prometheus confined in a box, which ZEUS treacherously gave to PANDORA. Prometheus warned her not to touch it but her curiosity prevailed.

Proof. In the GRAPHIC ARTS, a trial impression taken from a block, stone, plate or a SILK SCREEN to be examined for correction or clarification.

Prophets. (Gr. foreteller). In Judaism the prophets were religious and social reformers, inspired by God and revealing His will. ISAIAH, Jeremiah, Daniel, Ezekiel and JONAH are the prophets most often represented in art. Jonah's attribute is the whale. The other prophets usually carry a book or scroll bearing their prophecy. The ceiling of the Sistine Chapel by Michelangelo is the most famous example of prophets in art.

Proportion. Relation of one part to another and of each part to the whole. In CLASSICAL ART and during the RENAISSANCE artists were concerned with finding mathematical relationships between the parts of the human body. For example: the normal body is about 7 or 7½ "heads" high. See also: GOLDEN SECTION.

Propylaeum (pl. lae-a). In Greek architecture, a vestibule or monumental entrance to a sacred enclosure, group of buildings or citadel. Most famous Propylae in the world are on the ACROPOLIS at ATHENS, completed in 432 B.C. by order of Pericles, by the architect Mnesicles.

Proserpina, Proserpine. See: PERSEPHONE.

Provenance. Origin and history of ownership of a work of art or of other, usually valuable, objects.

Psalter. Book containing the 150 Psalms of the Old Testament. Many richly ILLUMINATED Psalters, dating from the middle ages, still exist.

Psyche. In Greek mythology, personification of the human soul. EROS fell in love with her and ZEUS made her immortal.

Psychedelic Art. Art usually produced under the influence of "mind-expanding" drugs (LSD, mescaline, or psilocylin). Paintings are usually heavily figured with wavy lines, brilliant acid colors, bursts of bright light, minute decoration, sequin-like dots and shifts of color. Painters: Isaac Abrams, Arlene Sklar-Weinstein, Allen Atwell. In style it is related to: ART NOUVEAU, SYMBOLISM.

Ptah. Ancient Egyptian deity worshipped in Memphis. Creator of the universe at the command of THOTH. As master craftsman, he was patron of metal work and artisans. Usually he is represented in human (or mummy) form. Greek counterpart: HEPHAESTUS.

Pulsa. A group of seven young artists (formerly painters, engineers, a film maker and a photographer) that formed in the late 1960s at Yale University to effect a "group effort to produce an art experience by organizing various sound and light activities in environments." Taking elements from our daily lives in our urban culture, like TV films, sounds and light, they attempt to make these experiences meaningful and pleasurable. They feel that public art must use everything in the environment as potential media for artistic expression. Using large environments (like a golf course) and complicated machinery (like electronic music generators, analog and digital computers and punch paper tape readers), they take changing amplitudes and pitches of sound and translate them into frequencies and brightnesses of light patterns. For the viewer Pulsa provides an experience; nothing remains to own or to show in a museum. Wishing to remain anonymous, the group has assumed the name Pulsa. One's first reaction will be to associate Pulsa with pulse (the rate or vibration of light changes), however the artists maintain the name has "no special significance." Related to: PROGRAMMED CONSTRUCTIONS, CYBERNETIC SCULPTURE.

Purism. Movement founded in France in 1918 by architect Charles-Eduoard Jeanneret (Le Corbusier) and artist Amédeé Ozenfant, in opposition to the elaborate decorative form to which CUBISM had developed. Their object was to create

'pure' painting (CUBISM) based on the efficient and functional appearance of the machine. Purism ended around 1927, and left very few paintings, however it strongly influenced some artists, especially Fernand Léger and Ben Nicholson.

Putti (plural of Italian putto 'boy'). Cherubic often winged and naked figures symbolizing happiness and love. A Christian version of the Roman Cupid, the god of love, they appear as decorative MOTIFS especially in RENAISSANCE and BAROQUE art.

Pythia. Famous priestess of APOLLO at DELPHI through whom the oracle spoke. Seated on a golden tripod in the inner sanctum of the temple, she uttered sounds that were interpreted to the questioner by a priest as prophecy.

Q

Quatrefoil. (Fr. quatre feuilles, - four leaves). Trefoil (Fr. trois feuilles, – three leaves). Both are ornamental work used especially in GOTHIC windows. Quatrefoil design is shaped like a four-leaf clover; trefoil, like a three-leaf clover.

Quattrocento. (KWAT tro CHEN toe) The 15th century in Italian art; the RENAISSANCE. Painters: Masaccio, Botticello, Fra Filippo Lippi. Sculptors: Donatello, Michelangelo Buonarroti, Lorenzo Ghiberti.

R

Radical Art. See: CONCEPTUAL ART.

Rayonnism. Like Italian FUTURISM, Russian Rayonnism seeks to express visually the new concepts of time and space. The canvas must give the impression of gliding out of time and space, to convey the feeling of the 4th dimension. To achieve this end, the artist uses parallel or crossed beams of color. This movement which' started in 1911 left few paintings; however, it greatly influenced Malevich and the development of SUPREMATISM. Painters: Mikhail Larionov, Natalia Goncharova.

Ready-Made. See: FOUND OBJECT.

Realism. Realism existed as soon as people tried to reproduce reality through art. In art, the term is usually applied to the movement started by Courbet in France in the 1840s. Realism seeks the truth, representation of objects as they exist without ideals and without symbolism. There are various versions of realism, e.g. representational or FIGURATIVE realism in which reality is copied faithfully or PAINTERLY realism which is not realistic in detail, but intends to convey a "realist impulse" through the quality of its brushwork. Painters: Honoré Daumier, Gustave Courbet, Thomas Eakins. See also: MAGIC REALISM and NEW REALISM.

Rebecca, Rebekah. Wife of ISAAC, mother of JACOB. When ABRAHAM decided it was time to find a wife for his son ISAAC, he sent his steward Eliezer to Nahor (land of ABRAHAM's kinsmen) to select a bride. Seeing Rebecca draw water from the well, he asked for some. As she generously provided water for him and his camel, Eliezer selected her for ISAAC. After years without children she bore the twins JACOB and Esau. Later, she deceived the blind ISAAC by sending him JACOB, her favorite son, to be blessed instead of Esau. (Genesis 24-27).

Recession. Use of various techniques to cause objects in a picture to appear receding and thus convey the illusion of depth. For example: PERSPECTIVE, FORESHORTENING.

Red-Figured. Style of Greek vase painting practised in the 6th century B.C. in which the figures were left in the natural color and the background was given a black glaze. This technique permitted greater freedom in drawing than BLACK-FIGURED.

Reduction, Reductive Art. See: MINIMAL ART.

Refectory. Dining hall in a monastery or convent.

Relief. 1. In sculpture, carving or CASTING. A technique that projects the figures, or parts of the work, from a background to which they are attached. See also: HIGH RELIEF, LOW RELIEF.
2. In painting, the effect is obtained by MODELING or gradation of tints.
3. In the GRAPHIC ARTS, refers to relief process in which the PRINT is made from the surface that remains after parts of the block of wood have been cut away. For example: WOODCUT, WOOD ENGRAVING.

Relief Print. See: WOODCUT.

Reliquary. A container, box or shrine for keeping or exhibiting sacred relics; usually of precious material and richly decorated.

Remus. In Roman legend, twin brother of ROMULUS. See: ROMULUS.

Renaissance. Rebirth of an earlier life style or artistic expression. The term is usually applied to the revival of classical Greek ideals in Italy around 1400. This movement spread to other parts of Europe and lasted — in some countries simultaneously with GOTHIC ART — into the 16th century. Replacing medieval religiosity and scholasticism with humanistic and scientific elements, Renaissance artists stressed the beauty and dignity of man. The study of PERSPECTIVE and human anatomy is characteristic of their work. Among the technical advances were the development of OIL PAINT, of printing with movable type and of several ENGRAVING processes. Representative Italian artists:
Early Renaissance (1420-1500). Giotto, Brunelleschi, Masaccio, Donatello.
High Renaissance (1500-1580). Michelangelo Buonarroti, Titian, Leonardo da Vinci.
In the Netherlands, Renaissance artists discovered landscape and natural light. Representative artists: Jan van Eyck, Pieter Brueghel, Rogier Van der Weyden.

Replica. See: COPY.

Repoussé. (French: Repousser – to push or pound). Technique of decorating metal plates through hammering or ENGRAVING. Covers of ICONS are frequently executed in repoussé.

Representational Art. Painting and sculpture which portrays an object so that the viewer can recognize it. Non-representational and NON-OBJECTIVE ART have the opposite aim.

Reproduction. See: COPY.

Reredos. See: ALTAR.

Resins. Transparent substance used in varnishes or other coating materials.

1. Natural resins are exudates from coniferous trees (cone bearing - like pine or cypress).

2. Synthetic resins are a product of modern chemistry, granules derived from coal tar, not from nature. See: ACRYLICS, POLY-MER.

Resurrection. 1. CHRIST's. As the soldiers guarding the tomb of Jesus slept, the body of CHRIST, arrayed in a white (or gold) garment rose from the grave, the third day after his death and burial. (Matthew 27:62-66).

2. Resurrection of the dead refers to the rising again of all men at the LAST JUDGMENT.

Retable. See: ALTAR.

Retinal Art. See: OP ART.

Rhea. TITANESS. Daughter of URANUS and GAEA; sister and wife of CRONUS, by whom she bore ZEUS, POSEIDON, HADES, DEMETER, HERA and Hestia. She was called "Mother of the Gods." Asian counterpart: CYBELE. Roman counterpart: Ops.

Rhino-Horn Art. One of the movements of the 1970s, opposed to the technological art of the 1960s. Concerned with man and his emotions, the artist's hand and heart are involved in his work. Painters: Michael Fauerbach, Nicholas Sperakis, Peter Dean. Related to: FUNK ART and some of the NEW REALISTS.

Rocaille. (ro KI) (Fr.-rockwork) Asymmetrical ornament with playful, elegant shapes. Probably developed during the ROCOCO period and especially popular in France. Rocaille ornaments are usually composed around a firmly outlined shape.

Rocaille

Rococo Art. (Fr. rocaille and coquille - rock and shell). Developing out of BAROQUE

art, it is a light fanciful decorative style that originated in France in the 18th century and spread to other parts of Europe. Paintings and sculpture of shells, scrolls, foliage and animal forms intertwined in asymmetrical fantastic arrangements that burst into a playful display. France and Italy had many painters of renown, while Germany and Austria produced great Rococo architecture, sculpture and CERAMICS. Painters: François Boucher, Antoine Watteau, Giovanni Battista Tiepolo. Sculptors: Franz Ignaz Günther, Johann M. Feichtmayr, Dominikus Zimmerman.

Roman Art. See: HELLENISTIC ART.

Romanesque Art. West European style of the 7th to the 12th centuries including various regional styles, notably CAROLINGIAN and OTTONIAN. As the name implies, major stylistic elements are based on Roman art, especially the architecture with its rounded arches and vaults. Among other influences the BYZANTINE and CELTIC are strongest. Romanesque painting has survived in monumental FRESCOES, colorful MOSAICS and elaborate manuscript ILLUMINATIONS. As in the following Gothic period, Romanesque themes and forms reveal the religious aspirations, the fears and fantasies of medieval man, as well as creativity and the highest craftsmanship. Human beings, animals and plants, sometimes realistic, sometimes distorted are intertwined alternately with geometric designs. Most painting is flat and LINEAR, while sculpture, especially free standing figures show deft handling of PLASTICITY. *Examples:* Cathedrals: Autun, Mainz, Worms. Manuscripts: Codex Aureus Epternachius, Lorsch Gospels.

Romanticism. Nineteenth century movement in art, music and literature following NEO-CLASSICISM. Romantic artists often turned to subjects from the past, especially the Middle Ages: ALLEGORY, mythology and religion, or selected idyllic landscapes and scenes of contemporary life. Romantic paintings in France are characterized by exotic or sensational themes and vivid colors; in Germany and England by nostalgia, love of the mysterious. At its best, Romantic art is characterized by great intrinsic beauty and harmonious composition, at its worst by sentimental NATURALISM. With the interest in the past, came a revival of old techniques and art forms, MURAL painting, book illustration and print making. Painters: Eugene Delacroix, Albert Pinkham Ryder, Caspar David Friedrich. Related to: NAZARENES and PRE-RAPHAELITES.

Romulus. In Roman legend, twin brother of Remus, son of MARS, founder of Rome over which he ruled for 39 years. When the twins

were infants, they were placed in a basket and set adrift on the Tiber. They floated safely to shore where a she-wolf suckled them and a shepherd raised them. When they were grown, they decided to build a city, fought over who should be the founder and Remus was slain. In 753 B.C. Romulus founded Rome and filled the city with fugitives. To get wives for them, he led the rape of the SABINE women.

The Romans ranked Romulus as a god, named him Quirinus and built temples in his honor.

Roughcast. A coarse plaster dashed against a wall. The coarse surface permits the subsequent coats of plaster for FRESCO painting to adhere to it.

Rubbing. See: FROTTAGE.

Ruth. Moabite widow who remained loyal to her Jewish mother-in-law, Naomi.

Ruth and Boaz. Ruth and Naomi return to Bethlehem where Ruth marries Naomi's relative Boaz. Ruth and Boaz are ancestors of King DAVID. (Old Testament, Ruth 1:16).

Sabines. Ancient people of the Sabine Hills, northeast of Rome. According to legend, ROMULUS, in order to provide women for the men of Rome, invited the Sabines to a festival, seized the Sabine women and drove off their men. To avenge the rape of their women, the Sabines fought the Romans, but when the wives threw themselves between the opposing armies, the Sabines and the Romans united under the rule of ROMULUS and Titus Tatius, the Sabine king. After the death of Tatius, ROMULUS alone ruled over both people.

Sacco and Vanzetti. In 1908 Nicola Sacco and Bartolomeo Vanzetti came from Italy to the United States. Sacco found work in a shoe factory; Vanzetti worked at various jobs and became a fish peddler. In 1920, the paymaster and guard of a shoe factory were murdered and robbed of $16,000 on the main street of South Braintree, Mass. Shortly thereafter, Sacco and Vanzetti were accused of the crime and arrested; at the time they were carrying guns. Neither the escape car nor the stolen money was traced to them. However, they were found guilty of 1st degree murder and the death sentence was imposed in April 1927. Reaction during the trial and after was marked by violent demonstrations throughout the world. Writers and intellectuals appealed for justice expressing the view that Sacco and Vanzetti were being punished because of their anarchist views.

Ben Shahn, sensitive social artist, created numerous works of the Sacco and Vanzetti case. One of his most famous was a serigraph called "Passion of Sacco and Vanzetti" created in 1958. On the lower part, in the CALLIGRAPHY of the artist, are the famous

words spoken by Vanzetti a short time before his death and jotted down by a reporter.

"If it had not been for this thing, I might have live out my life talking at street corners to scorning men. I might have die, unmarked, unknown, a failure. Now we are not a failure. This is our career and our triumph. Never in our full life can we hope to do such work for tolerance, for joostice, for man's onderstanding of man, as now we do by an accident.

Our words—our lives—our pains—nothing! The taking of our lives—lives of a good shoemaker and a poor fish peddler—all! That last moment belong to us—that agony is our triumph."

Sacra Conversazione (SAH kra kon ver sa TZIO nay) (It. "Holy Conversation"). A picture of the MADONNA and child popular in Italian RENAISSANCE painting. The enthroned MADONNA and child are surrounded by saints. The composition of the figures makes them appear to be in conversation.

Sagittarius. See: ZODIAC.

Salome. See: HEROD.

Salon. Exhibition of works of living artists. Taken from French "drawing room," in which art works were often exhibited. For example: Salon des Indépendants, Salon des Refusés, Salon d'Automne.

Samson. Samson, a man of superhuman strength, was ordained to be born to save the Jews from the Philistines. (Old Testament, Judges 13:5). Popular themes: 1. *Samson and Delilah*. The story of Samson (Hebrew — 'sun' and Delilah Hebrew — 'night') is an ALLEGORY in which the forces of light combat the forces of darkness. (SHEH-mesh = sun; LIE-lah = night). Delilah, a woman of the Philistines, was much loved by Samson. On learning that the secret of Samson's great strength lay in his long hair, she arranged to have his hair removed. Stripped of his strength, Samson became a prisoner of the Philistines. (Old Testament, Judges 16:19). 2. *Death of Samson*. Samson was blinded, chained and imprisoned by the Philistines. When later he was brought to a large gathering to be mocked, he used his strength (which had returned with his regrown hair) to tear down the pillars and the roof of the building, killing himself and those present. (Old Testament, Judges 16:30).

Sappho. (Early 6th century B.C.). Greatest poetess of antiquity. Born on the island of Lesbos, where she later became the head of a school of poets. In antiquity her fame equalled that of Homer.

121

Sarah. Wife of ABRAHAM and mother of ISAAC. Aware of ABRA-
HAM's desperate need for an heir, the childless Sarah suggested
that he marry her handmaiden, Hagar. From this union, Ishmael
was born. Years later, an apparition of three angels announced to
ABRAHAM and Sarah that they would have a son. When ISAAC
was born to them, Sarah drove Hagar and Ishmael from their
home, into the desert. (Genesis 11:31 − 23:20) In Judeo-
Christian tradition, Ishmael is symbolized as the outcast; in Mo-
hammedanism, Ishmael, revered as one of the prophets, establishes
the link of this religion to ABRAHAM.

Sarcophagus. Large stone coffin used in late antiquity and Early
Christian times, ornamented with RELIEF sculptures and inscrip-
tions. Themes for carvings ranged from Biblical to Homeric sub-
jects.

Satan. See: LUCIFER.

Saturn. Roman god of agriculture. Greek counterpart: CRONUS.

Satyrs. In Greek mythology, woodland deities, part human, part
beast. Boisterous, lustful, lascivious companions of DIONYSUS,
they were always drinking and dancing. Usually represented as be-
ing very hairy, they looked like men but had the legs and feet of
goats, short pointed horns on their heads, and a tail. Similar in
appearance to SILENUS and the faun.

Scorpio. See: ZODIAC.

Scriptorium. Workroom in a medieval monastery where CALLIGRA-
PHERS copied and ILLUMINATED manuscripts by hand. Fre-
quently represented in Medieval MINIATURE PAINTING.

Sculpsit, S., sc., sculp. (Latin − "he carved it") This term, or its ab-
breviations, often accompanies names on sculptures and on art
PRINTS. It identifies either the sculptor, the engraver or the
etcher.

Sculpture. Traditionally, the term referred to the art of creating
shapes in stone, marble, wood, clay, glass, metal or other firm
materials. Carving, CASTING and MODELING used to be the
main techniques of the sculptor. In the 20th century, artists
began to include textiles and plastics to produce CON-
STRUCTED SCULPTURE, SOFT SCULPTURE and LIGHT
SCULPTURE. In the 1960s various technological media and
methods, i.e. HOLOGRAPHY introduced an entirely new dimen-
sion; sculpture that is visible, but not TACTILE. Thus today the

term embraces almost everything that is developed in three dimensions, whether it is static or moving, silent or combined with sound.

Scumbling. Dragging a thin layer of opaque paint with a dry brush over another layer so as to reveal the underlying paint. This tends to modify the undercoat and produce transparent effects. Rembrandt used Scumbling a great deal. Opposite of GLAZING.

Sebastian, St. (3rd century). Martyr. A Roman soldier who because of his expressed belief in CHRIST was ordered by Diocletian to be bound to a stake and executed with arrows. He was left for dead but found by a martyr's widow, who nursed him back to health. Again he testified to his faith before Diocletian. This time he was clubbed to death. In ancient times the arrows of APOLLO were thought to have brought the plague. This may explain why St. Sebastian is venerated as the plague saint. In painting and sculpture, Sebastian is represented as a handsome youth bound to a stake, his body pierced with arrows.

Secco. See: FRESCO SECCO.

Secondary Colors. See: COLOR.

Seicento. (say CHEN toe) Seventeenth century of Italian art; BAROQUE art. Painters: Guercino, Pietro Da Cortona, Salvatore Rosa.

Sepia. Brown pigment derived from the ink sac of the cuttlefish, used mainly for pen or brush drawing. In the 19th century, Delacroix was a master of Sepia drawing.

Seraphim. Celestial beings absorbed in perpetual love and adoration around the throne of God, Seraphim are usually painted in red robes and sometimes hold burning candles. See also: ANGELS. Related to: CHERUBIM.

Serial Forms. The constant repetition of identical elements in sculpture or painting. Artists: Andy Warhol, Robert Morris, Donald Judd. Related to: SYSTEMIC ART.

Serigraph. See: SILK SCREEN.

Sermon on the Mount. One of the most significant events in CHRIST's preaching. The sermon includes the Beatitudes with their blessing of the poor in spirit, of the pure in heart, and of those who seek peace. Christian painters, especially the NAZARENES, have depicted the scene with great feeling. (Matthew 5-7).

Seven Wonders of the Ancient World: The Pyramids of Egypt, the Hanging Gardens of Babylon, the temple of ARTEMIS (Diana) at

Ephesus, Phidias' statue of ZEUS (Jupiter) at ATHENS, the tomb of Mausoulos (Mausoleum) at Halicarnassus, the Colossus of Rhodes, and the Pharos (lighthouse) at Alexandria. Only the Pyramids of Egypt have survived.

Sfumato ("like smoke"). Subtle blending of light tones into dark by gradual stages. The effect is to make a picture appear as though enveloped in mist or smoke, with outlines and contours blurred and in shadow. Technique of Sfumato was developed by Leonardo da Vinci. It was also used by Corregio and Giorgione.

Sgraffito. See: GRAFFITO.

Shade. 1. A color mixed with black; therefore a darkened color. 2. Portion of a picture that is not illuminated. 3. The mixture of several colors.

Shading. Darkening of parts of a painting, print or drawing for the purpose of lifting an object from its background. This can be achieved through a variety of techniques, for example HATCHING.

Shaped Canvas. 1. Where the canvas holds any shape other than the traditional flat rectangle. Other shapes are square, oval, diamond, cross, U shape, L shape. HARDEDGE painters of the 1960s experimented with shaped canvas. For example: Frank Stella, Sven Lukin, Barnett Newman. 2. Building the canvas out from the plane in three-dimensional forms. For example: Charles Hinman.

Sharp Focus Realism. See: NEW REALISM.

Sibyl. Prophetess of antiquity. The most famous was the Cumaean Sibyl, inspired by APOLLO, who lived in a cave in Cumae in southern Italy. Later, as many as twelve Sibyls were recognized, among them the Persian, Erythraean, DELPHIC and Libyan. Sibyls were frequently portrayed in RENAISSANCE art, and their role is related to that of the Old Testament PROPHETS. For example: Michelangelo's Sistine Ceiling.

Sienese School. In the 13th and 14th centuries, Siena, Italy became one of the centers of early RENAISSANCE painting. While artists in Florence and Venice broke away from medieval tradition, it appears that Sienese artists incorporated their medieval heritage, especially BYZANTINE elements into their style. Delicate, graceful figures were often set against a solid gold background; landscape, plants and animals were STYLIZED, and colors were rich. Painters: Duccio, Simone Martini, Sasseta.

Silenus. In Greek mythology, a god of the forest, oldest of the SATYRS and companion and teacher of DIONYSUS. Silenus is

124

usually represented as a fat jolly old man, with ears and legs of a horse, seated astride a donkey and always drunk; yet he is also noted for his wisdom and prophetic powers. FAUNS and SATYRS were often called Sileni. See: SATYRS.

Silk Screen, Serigraph. A technique of color reproduction developed early in the 20th century. It was used primarily for commercial and industrial purposes: for posters, printing on glass, plastics and textured surfaces. Silkscreening became increasingly popular in the 1950s and 1960s. The great versatility of color application and the integration of photography into the process give a new dimension to artistic expression. In addition, the possibility to produce MULTIPLE copies, meets the intention of many contemporary artists to make original art available at low cost. Examples: Robert Rauschenberg, R. B. Kitaj, Roy Lichtenstein. Technically, in silkscreening the design is separated into its constituent colors. For each color, a wooden frame is prepared with silk stretched across it. Glue SIZING is applied to block out the areas that are not to be painted. A squeegee is used to force the color through the pores of the material (in the areas that are not blocked out) to make the print on paper, metal or fabric. The same procedure is repeated for each color.

Silver-Point. A technique of drawing with a silver tipped instrument on specially prepared paper. The result is a fragile work with a delicate grey line. Artists: Sanzio Raphaël, Leonardo da Vinci, Albrecht Dürer.

Sinopia. 1. A reddish-brown earth color. 2. In FRESCO painting, a preliminary drawing in red, on the rough plastered wall, which served as a guide to the artist for the general lines of his composition.

Sirens. In Greek mythology, three sea NYMPHS, part bird, part woman, who by their seductive singing, lured sailors to their death against the rocky coasts. JASON and the Argonauts were saved from them by the more beautiful music of ORPHEUS. ODYSSEUS escaped them by having himself tied securely to a mast and by stuffing wax into the ears of his companions.

Sisyphus. In Greek mythology, son of Aeolus (god of the winds) and founder and ruler of CORINTH. He was noted for his trickery and cunning. Because of his disrespect toward ZEUS, Sysiphus was condemned to severe punishment in TARTARUS. It was his fate to roll a heavy rock to the top of a steep hill; just before reaching the top, the stone rolled down.

125

Sizing. Application of Size (gelatinous preparation made from glue or starch) to fill the pores of cloth or paper. See also: PRIMING.

Sketch. Quick drawing or painting made by the artist to determine the scale, COMPOSITION and lighting of the finished product.

Skyworks. See: EARTHWORKS.

Social Realism. Art movement of realistic painting of the contemporary scene beginning in the 1920s. Especially strong in the U.S.A. and England, this movement should not be confused with SOCIALIST REALISM of the USSR. The social realist conceives his role as social critic; he shows injustice and squalor to move the complacent viewer. Painters: Ben Shahn, George Grosz, Philip Evergood.

Socialist Realism. Related to SOCIAL REALISM of the 1920s, this movement became the officially supported art in Soviet Russia. In reaction against fragmented and distorted forms of ABSTRACT ART, especially the SUPREMATISTS and CONSTRUCTIVISTS, the first Soviet realist group, the "Association of Artists of revolutionary Russia" (AKhRR) was formed in 1922 with the aim to document real life. This realism is, however, limited, since the artists cannot depict squalor, sorrow, or anything negative. Their works show active, healthy people and shining machines inspiring trust and optimism. Socialist Realism is often cited as an example of the influence that a political system can exert on art. Although it is still the official Russian art, a movement to revive CONSTRUCTIVISM and to make contact with contemporary art outside of Soviet Russia is gaining momentum. Painters: A. Deineka, N. J. Dormidontov, V. Papkow.

Soft Sculpture. This art form of the 1960s and 70s takes common objects such as typewriters, electric mixers and fans and makes soft, flopping and bulging replicas of them. Claes Oldenberg literally takes the stuffing out of his sculpturing by creating them of cloth, vinyl, felt, plastic, latex, string and rubber. Soft Sculpture is one of the many means of contemporary artists to comment on the lack of backbone and firm substance in our consumer society. See also: POP ART and INFLATABLE SCULPTURE.

Soft Style. Art form of the final period of the chivalrous-feudal civilization of the 14th and early 15th centuries. Emerging from GOTHIC ART in France, it spread quickly to Italian and German art. Soft Style is characterized by gentle forms and color, and genuine feeling without sentimentality. NAZARENES and PRE-RAPHAELITES were greatly attracted by this style. Painters: Fra Angelico, Lorenzo Monaco, Giovanni di Paolo.

Solomon. King of Israel in the 10th century B.C.; son of DAVID and Bathsheba. Popular themes: 1. *The Judgment of Solomon*: Two women claimed the same child. Solomon proposed dividing the living child in two. The true mother revealed herself to King Solomon by pleading with him to give the baby to the other woman rather than see it harmed. (Old Testament, 1 Kings 3:16-25). 2. *Solomon and the Queen of Sheba*. Solomon became so famous for his wisdom that the Queen of Sheba came to Jerusalem to ask him questions. His answers pleased her very much and they exchanged gifts. (Old Testament, 1 Kings 10:1-13).

Spectrum Palette. Red, orange, yellow, green, blue, violet. These are the colors that are produced when sunlight is passed through a prism (a triangular piece of glass or plastic). French IMPRESSIONISTS used primarily these colors to achieve greater luminosity. For example: Auguste Renoir and Camille Pisarro.

Sphinx. 1. In ancient Egypt, a mythical beast sculpture, usually representing the Pharoah, having the head of a man and the body of a lion in a recumbent position. The most famous is the Great Sphinx of Gizeh, a colossal figure sculptured out of natural rock. 2. In Greek mythology and art, the Sphinx was a winged monster with the head and breasts of a woman and the body of a lion.

Squaring. A method of transferring a small sketch to a larger area. The small drawing is divided into equal squares. The larger area is divided into the same number of squares. Contents of each small square are enlarged and then transferred to the corresponding square of the larger area.

Stabile. Immobile, abstract, large-scale, constructed sculpture made of wire and sheet metal, and attached to fixed supports; as opposed to MOBILE. Sculptor: Alexander Calder.

Stained Glass. Glass that has been colored either through the addition of metallic oxides in the melting process, or which has been painted on with translucent paint. In either process, the pieces are joined with lead or iron strips. These heavy dark outlines seem to make the glass appear even more colorful and luminous and give stained glass designs their special character. While the use of stained glass can be traced back two thousand years (to classical antiquity) the golden age of stained glass came with the GOTHIC period in the 13th century. The tall windows of the lofty structures provided an ideal setting for designs in colored glass. The art has recently been brought to new heights by Rouault, Matisse and Chagall.

127

State. In the GRAPHIC ARTS, one set of COPIES of an edition of PRINTS which differs from other prints. Any changes, additions, corrections, however minute, designate another state.

Stations of the Cross. Representations in religious art of CHRIST's last hours usually consist of fourteen scenes. 1. Jesus condemned to death before PILATE. 2. Jesus receives his Cross. 3. Jesus falls the first time beneath his Cross. 4. Jesus meets his sorrowing mother. 5. Simon of Cyrene helps Jesus carry his Cross. 6. St. Veronica wipes the face of Jesus. 7. Jesus falls for the second time. 8. Jesus admonishes the Daughters of Jerusalem. 9. Jesus falls for the third time. 10. Jesus is stripped of his garments. 11. Jesus is nailed to the Cross. 12. Jesus dies on the Cross. 13. DESCENT from the Cross. 14. ENTOMBMENT. In the Middle Ages there were usually seven scenes but by the 18th century they were increased to fourteen stations. Stations of the Cross are frequently executed in RELIEF sculpture.

Stele. An upright stone slab carved, decorated or inscribed as a gravestone, to mark a site, or to commemorate an historic event.

Stereochromy, Waterglass painting. A technique of producing a picture using water glass as a vehicle or as a preservative coating. Water glass or soluble glass is a colorless, transparent glasslike substance when solid.

Stigmata. [(plural of stigma) (from Gr. = brand)]. Stains or marks on skin. The five wounds received by Jesus CHRIST at the CRUCIFIXION are the stigmata that appear in paintings of CHRIST and saints. Most frequently represented in the paintings of St. FRANCIS of ASSISI.

Stijl, De. See: DE STIJL.

Still Life (Fr. Nature Morte). In painting, the formal COMPOSITION of inanimate objects, including fruits, flowers, musical instruments, oysters, herring, CERAMICS, textiles. Still Life was not recognized as an independent subject until it was so used by the 17th century Flemish and Dutch artists. In recent times, it has been a fine vehicle for POST-IMPRESSIONIST, CUBIST and Post-Cubist artists. Painters: Jean-Baptiste Siméon Chardin, Paul Cezanne, Georges Braque.

Stippling. A method of painting, ENGRAVING or drawing executed by small dots, or points, placed close together.

Stucco. A plaster used as outdoor or indoor wall cover. During the RENAISSANCE, BAROQUE and ROCOCO periods, sculptors

produced elaborate stucco RELIEF decorations, especially in castles and churches. Painters used stucco as a GROUND for FRESCOES.

Style. The mode of expression of a particular artist, group, period, or place, as the style of Raphael or GOTHIC style. A style has intrinsic characteristics that can be analyzed and defined as unique; as opposed to a fashion, which is a prevailing trend and may feature a style or styles. It can be difficult to differentiate between style and fashion.

Stylized. Designed to conform to a conventional taste; highly formal, even stereotyped. In contrast to natural, REALISTIC representation, stylized figures show hardly any individual characteristics. Early Egyptian and Greek ARCHAIC art were highly stylized.

Styx. In Greek mythology, river of HADES over which the souls of the dead were ferried by CHARON. It was a sacred river by which mortals and gods took sacred oaths.

"Suffer Little Children to Come Unto Me." See: CHRIST BLESSING THE LITTLE CHILDREN.

Super-Realism. See: SURREALISM.

Suprematism. NON-OBJECTIVE, ABSTRACT ART derived of CUBISM, started by Kasimir Malevich in Moscow in the early 20th century. As pure geometrical abstraction, it limits the painter to simple geometric shapes: the rectangle, the circle, the triangle and the cross. The goal of the Suprematist is to achieve supremacy of pure feeling. He could only accomplish this by freeing himself of all objects. Therefore, as a symbol of purity in art, Malevich painted a "Black Square on a White Field" and "White on White." These Suprematist paintings expressed nothing; or, the "feeling of the absence of the object." Suprematism, disseminated by the BAUHAUS, greatly influenced the development of modern European art, architecture and industrial design. Painter: Kasimir Malevich. Related to: CONSTRUCTIVISM, NEO-PLASTICISM, NON-OBJECTIVE ART.

Surrealism, Super-Realism. Movement in art and literature, strongly influenced by the psycho-analytic theories of Sigmund Freud, started in 1924 by André Breton. Searching for a greater reality underlying the world of appearances, artists turned to dreams, fantasy, hallucinations, and images of the unconscious mind. Free of control, reason and inhibition, the unconscious mind states the content and composition of their art works. Surrealists used various techniques; for example: AUTOMATISM, ink blots, and

129

FROTTAGE. Earlier painters, for example Bosch or Goya have strong surrealistic elements. The term is, however, most consistently applied to the 20th century movement. Painters: Salvador Dali, Max Ernst, René Magritte. Sculptors: Alberto Giacometti, Hans Arp. Related to: FANTASTIC ART. The term Super-Realism is sometimes used to describe the works of some of the artists in the NEW REALIST movement. See: NEW REALISM.

Susanna and The Elders. Two elders of Babylon try to seduce Susanna, the beautiful and virtuous wife of a Babylonian. In revenge for her rejection, they accuse her of adultery. A young man named Daniel appears and insists she be given a fair trial. He separates the two witnesses who give conflicting testimony thus proving they were both lying. (Old Testament, Apocrypha 9:1-64).

Symbiotic Art. In music and art, electronic systems can convert sound into light and light into sound. In the late 1960s, Symbiotic Art works attempted to have these two systems interact with human participants as well as with each other. Symbiosis in nature occurs when two dissimilar organisms live together to their mutual advantage.

Symbolism, Synthetism. 1. Art and literary movement in France at the end of the 19th century. Wishing to express personal feeling, dreams, mystery and simplicity, the artists of Symbolism turned for their inspiration to the art of the PRIMITIVE, Persia, the Far East and Ancient Egypt. In Symbolism, color, line and form could become symbols for ideas, moods and emotions; could express and communicate the painter's message. ("The medium is the message"). To achieve this end Gauguin tried to fuse (synthesize) his technical composition (lines, forms and colors) with his ideas. His flat shapes, and his simplified heavy outlines (also known as Cloissonism — derived from the French "cloitre" to cloister or immure) created abstract color patterns, often with an unreal dreamlike quality. Symbolists are the forerunners of EXPRESSIONISM and influenced ABSTRACT ART. Painters: Paul Gauguin, Odilon Redon, Gustav Moreau. Related to: NABIS. 2. Use of symbols to imply ideas, events, or personal attributes. See also: GUERNICA and EVANGELISTS.

Synchromism. American equivalent of ORPHISM. Interested in making colored forms more dynamic, the Synchromists built structure on planes of color. Painters: Stanton Macdonald-Wright, Morgan Russell. See also: ORPHISM.

Synthetic Cubism. See: CUBISM.

Synthetic Media. See: ACRYLIC PAINT.

Synthetism. See: SYMBOLISM.

Systemic Art, One Image Art, COOL ART. Art movement in the 1960s that approaches art by the use of systems, i.e. units in which the individual elements are executed with regularity, thoroughness, routine and repetition. Systemic Art refers to paintings (individual or in groups) which consist of a single field of color, often using repeated symmetrical patterns. The effect is a cool, calculating, impersonal art. Included is a group called "One Image Art," characterized by variations on a single theme. For example: Noland painted first circles, then chevrons. Painters: Ellsworth Kelly, Kenneth Noland, Frank Stella. Related to: COLOR-FIELD PAINTING and SERIAL FORMS.

T

Tachisme, Art Informel. French movement similar to and simultaneous with American ACTION PAINTING of the 1950s: intuitive, spontaneous, undisciplined art. Tachisme is derived from Fr. tache meaning blot, stain. Painters: Hans Hartung, Gerard Schneider, Bram van Velde. See also: ACTION PAINTING.

Tactile Values. Those qualities that create the illusion that the objects in a picture can be touched and felt. This is achieved by representing objects in three-dimensional form on a flat canvas (by use of PERSPECTIVE, MODELING, FORESHORTENING and SHADING). Bernard Berenson first used this term in a discussion of the essence of RENAISSANCE painting. Works by Florentine artists Giotto, Masaccio and Michelangelo are rich in tactile values. Sometimes called PLASTIC values. See also: PLASTIC ART.

Tantalus. In Greek mythology, a Phrygian king, son of ZEUS and father of Pelops (whom he cooked and served to the gods) and NIOBE. He was condemned to suffer eternally in TARTARUS because he is said to have divulged divine secrets and stolen AMBROSIA and given it to mortals. He was condemned to hang from the bough of a fruit tree over a pool of water. When he tried to eat or drink, the fruit and the water would recede. Also, a great stone hung over his head, threatening to fall.

Tartarus. In Greek mythology, the lowest region of HADES where the most wicked men and rebellious TITANS (for example: SISYPHUS and TANTALUS) were punished.

Taurus. See: ZODIAC.

Tempera. 1. Technique of painting in which the PIGMENTS are ground in water and mixed or tempered with egg, milk and/or glue. Most medieval paintings before the 15th century

were executed in egg tempera. Unlike oil, tempera dries almost instantly and was therefore usually applied in a fine HATCHING and CROSS HATCHING of short strokes. To relieve the dry effect of pure tempera painting, many artists used a "mixed method," superimposing oil glazes over a Tempera underpainting.

2. Painting executed in this technique.

Temptation of CHRIST. According to the Gospel of St. MATTHEW, the devil tempted CHRIST three times.

1. After his BAPTISM, Jesus fasted and prayed in the wilderness for forty days. Satan dared the starving Jesus to use his power and change the stones to bread. To which Jesus replied, "Man shall not live by bread alone, but by every word that proceedeth out of the mouth of God."

2. Another time, Satan challenged Jesus to throw himself down from the top of the temple, for surely the ANGELS of God would intercede to save the Son of God. To this Jesus replied, "Thou shalt not tempt the Lord thy God."

3. Finally, as Satan and Jesus observed the world and all its wealth from the top of a mountain, Satan offered this wealth to Jesus if he would worship Satan instead of God. To which CHRIST replied, "Get thee hence, Satan: for it is written, thou shalt worship the Lord thy God, and him only shalt thou serve." (Matthew 4:1-11). Any of these scenes may be depicted in paintings entitled 'The Temptation of CHRIST.'

Tenebrism. (It. tenebroso, obscure, dark, gloomy) Style of painting, in the early 17th century, influenced by Caravaggio using strong dramatic contrasts of light and dark (CHIAROSCURO). Painters: Georges de La Tour, Adam Elsheimer.

Terpsichore. See: MUSES.

Terra cotta. (It., baked earth). 1. CERAMIC material of brownish-red color molded and baked until it is hard. Used since ancient times for unglazed pottery, sculpture and architectural ornaments.

2. Items made of Terra cotta.

3. Brownish-red color.

Tesserae. The small squares of stone, glass or marble used in making a MOSAIC. See also: MOSAIC.

Thalia. One of the three GRACES. See: MUSES.

Thebes. Capital of Boetia in ancient Greece. Many incidents and characters in Greek legend are related to Thebes. OEDIPUS, Fall of TROY, ARGONAUTS, EUROPA are just a few.

Thermopylae. A narrow pass used in ancient times as an entrance into Greece. At Thermopylae the Persians, under Xerxes, defeated the hero Leonidas and his Spartans in 480 B.C. This scene is often chosen for paintings, GRAPHIC ART and RELIEF sculpture in which Greek heroism is symbolized.

Thermo Sculpture. Heated sculpture. "Thermo sculpture is sculpture which employs heat as a *tactile* sensation." This differentiates thermo sculpture from fire, lighted works where fire or incandescence is primarily a *visual* phenomena. Viewers are encouraged to get close to the sculptures and feel the sensation of heat. Sculptor and source for definition: John Goodyear.

Theseus. In Greek mythology, great King of ATHENS, involved in many heroic experiences. En route to visit his father, King Aegis of ATHENS, he tangled with and destroyed a number of bandits and villains. When he arrived in ATHENS, MEDEA, then wife of King Aegis, was jealous and tried to kill him. Theseus was saved and MEDEA was exiled. His most famous adventure was against the MINOTAUR of King MINOS of CRETE, in which ARIADNE provided him with a ball of thread that he used to find the MINOTAUR and then to find his way out of the LABYRINTH. Other exploits included battles against the AMAZONS, the CENTAURS and the attempt to abduct PERSEPHONE. Numerous women were involved in his life including ARIADNE and PHAEDRA.

Thetis. In Greek mythology, a NEREID, wife of PELEUS and mother of ACHILLES. POSEIDON and ZEUS were both interested in her until they learned that it had been prophesied that she would bear a son greater than his father. They deserted her and arranged for her marriage to PELEUS, a mortal. Their son was ACHILLES. Thetis dipped ACHILLES into the River STYX to render him invulnerable. Only the heel, by which she held him, was not immersed. (In the Trojan War, PARIS killed ACHILLES by shooting him in his heel.) See also: PELEUS, PARIS, ACHILLES.

Thomas, St. the Apostle. One of the twelve disciples of CHRIST called "doubting Thomas" because he refused to believe in the RESURRECTION until he could touch CHRIST's wounds. As an apostle in India, he received money from King Gondophorus to build a palace. Instead of building it, he distributed the money to the poor and told the king that faith and charity in this world would assure him a palace in heaven. He became the saint of masons and architects. Attributes: T-square (architect); lance (instrument

of martyrdom); the Virgin's girdle (lowered from heaven by the Virgin after the ASSUMPTION to convince the "doubting Thomas" of the ASSUMPTION of the Virgin).

Thoth. In Egyptian mythology, god of wisdom, learning and magic; inventor of writing, numbers and letters. Scribe of all the gods. Represented as a man with the head of an ibis (large bird like a stork) or a baboon. Greek counterpart: HERMES.

Thule, Ultima. Ancient Greek and Latin name for an island in the northernmost part of the North Sea, probably the Shetland Islands. To the ancients it was supposed to be the northern limit of the habitable world. Visions of this island appear especially in ROMANTICISM, when writers and painters were drawn to mythological places.

Tint. In painting the changing of one color through the addition of another. In graphics a shading effect achieved through roughing of the plate. See also: AQUATINT, MEZZOTINT.

Titans. In Greek mythology, there were twelve Titans*, the six sons and six daughters of URANUS and GAEA; the first race.

Titans	Titaness	Attribute
Oceanus	Tethys	sea
Hyperion	Thia	sun
Crius	Eurybia (Mnemosyne)	memory
Coeus	Phoebe	moon
Cronus	Rhea	harvests
Iapetus	Themis	justice; planets

Offspring of Titans are also often called Titans. For example: PROMETHEUS, ATLAS. The Titans, led by CRONUS, the youngest Titan, dethroned their father and ruled the universe. The Titans, in turn, were overthrown by the OLYMPIANS, led by ZEUS, son of CRONUS.

Tobias and the Angel. Tobit, a devout Jew suffering from eye disease, sends his son, Tobias to a distant city on business. Under the guidance of ARCHANGEL Raphael who accompanies Tobias and his dog on their journey, all goes well: Tobias collects the money due his father; he finds Sara, who becomes his wife; on returning home he restores his father's sight with the gall of a fish. As the family is overjoyed, the ARCHANGEL Raphael reveals himself as having been sent by God. The most frequently depicted scenes are Tobias carrying a fish followed by the angel, and Tobias and the angel returning home to the parents. (Old Testament, Apocrypha, Book of Tobit 6:1-5 and 11:6-17).

*Chart (p 275) in DICTIONARY OF CLASSICAL MYTHOLOGY
by J. E. Zimmerman, Harper & Row, 1964. Reprinted by permission
of the publisher.

Tone. 1. The TINT or SHADE of a color. For example: Is it a light or dark tone of red?

2. The brilliance, intensity of a color. For example: warm tones, cold tones.

Totentanz. See: DANCE OF DEATH.

Tower of Babel. See: BABEL.

Transfiguration. After the first missionary journey of the twelve disciples, Jesus is supposed to have taken PETER, JOHN THE EVANGELIST and James up a mountain to pray. Before their eyes, Jesus changed his appearance; his face shone like the sun, his white garments glowed with heavenly radiance and the PROPHETS MOSES and ELIJAH talked to him. This scene most often introduces the episodes of the PASSION. Popular subject in BYZANTINE and RENAISSANCE painting. (Matthew 17:1-13; Luke 9:28-36; Mark 9:2-13).

Trecento. The 14th century in Italian art, associated most particularly with FLORENTINE and SIENESE SCHOOLS. The last phase of the Middle Ages and transition to the RENAISSANCE. Painters: Giotto, Simone Martini.

Trefoil. See: QUATREFOIL.

Tribute Money. The term usually refers to the money paid in tribute to the Roman Emperor. Two scenes in the life of CHRIST involving tribute money have been depicted, especially during the RENAISSANCE:

1. When CHRIST and his disciples were in Capernaeum, tax collectors asked PETER whether CHRIST had paid his tribute to Caesar. CHRIST asked PETER to go fishing, and in the mouth of the first fish, he found a coin with which the tribute was paid. (Matthew 17:27)

2. CHRIST angered the priests by teaching in the temple at Jerusalem. To find him guilty of something, he was asked whether it was lawful to pay tribute to Caesar. CHRIST pointed to the image of Caesar on a coin and answered "Render therefore unto Caesar the things that are Caesar's and unto God the things which be God's." (Luke 20:25).

Trinity. God the Father, God the Son, and God the Holy Ghost are three roles of one and the same God. In RENAISSANCE painting the Trinity may be represented as one (Godhead) or as three persons appearing separately or together. When the idea of the Oneness or the Unity of God is being stressed, one figure, or three identical figures may be shown. For example: the trefoil or triangle. When the Trinity is

represented as three figures, God the Father, the creator, is an old man; God the Son is younger and appears as the Good Shepherd; the Holy Ghost, symbolizing purity and transcendence, is represented as a dove. The Trinity has been a favorite art subject since the 5th century.

Triptych. Three panels hinged together. See also: ALTAR.

Triptych

Triton. In Greek mythology, a gigantic sea god, son of POSEIDON and Amphitrite. He was represented as having the head and trunk of a man and the tail of a dolphin. Attribute: twisted sea-shell (conch), like a trumpet, on which he blew to raise or calm the waves. Later legends speak of many tritons, minor sea deities, attendant on the major sea gods.

Trojan Horse. In Greek mythology, a large wooden horse built by the Greeks, occupied by some Greek soldiers. The Greeks appearing to have departed, left the horse and a bound and gagged Greek soldier named Sinon outside the gates of TROY. Despite the warnings of CASSANDRA and LAOCOÖN, Priam, King of TROY, permitted the horse within the gates, convinced by Sinon that it was an offering to ATHENA. At night, Sinon opened the door to the horse and let out the Greeks. They opened the gates of TROY to ODYSSEUS and his men who then sacked the city.

Trompe L'oeil. (trawmp loy) (Fr., to deceive the eye). Use of various painting techniques with the purpose of tricking the viewer into accepting an illusion as a reality. For example: when a fly in a painting makes you want to brush it off. Popular in the BAROQUE and ROCOCO eras, and today. Painters: William Harnett, Claudio Bravo. See also: ILLUSIONISM.

Troy. (Latin: Ilium; Greek: Ilion). Ancient city in Northwestern Asia in the 12th century. For ten years, Troy was besieged by the Greeks and held out valiantly. The word Trojan describes endurance, determination; for example, he works like a Trojan. Some famous Trojans according to Homer's Iliad, are Andromache, AENEAS, CASSANDRA, Hecuba, Hector, PARIS and Priam.

Trucage, Truquer. The forgery (a forger) of painting.

"True" Fresco. See: FRESCO.

Tutankhamen (Popularly known as King Tut) 14th century B.C. Son-in-law of one of the most famous Egyptian rulers, Ikhnaton, and King of XVIII dynasty in Egypt. In 1922, Howard Carter and the earl of Carnarvon discovered the tomb of

Tutankhamen almost intact, near Luxor in upper Egypt. The contents, some of the finest Egyptian treasures, include the king's golden mask and the gold SARCOPHAGUS; they now are in the Egyptian Museum in Cairo.

Tyche. Greek goddess of chance and happiness. Attributes: CORNUCOPIA, ship's rudder. Roman counterpart: Fortuna.

U

Ulysses. Roman name for ODYSSEUS. See: ODYSSEUS.

Underpainting. Preliminary painting applied to the canvas to establish the main contours and TONE values.

Unfurleds. [a flag or a canvas is unfurled (unfolded) after having been furled (rolled up)]. Unfurleds is the term used to describe paintings of Morris Louis (in the 1960s) in which parallel patterns are soaked diagonally across the lower corners of the painting, opening the vast untreated center of the canvas.

Unprimed, Unsized Canvas. Raw, unprepared canvas. See also: PRIMING.

Urania. See: MUSES.

Uranus. In Greek mythology, he represents the heavens, ruler of the world. He was both son and husband of GAEA (the earth). Their children were the TITANS, the CYCLOPS and the Hundred-handed ones. The TITAN CRONUS, his youngest son, instigated and aided by GAEA, castrated him and usurped his throne. Roman counterpart: Coelus.

Uriel. ARCHANGEL. Uriel means 'the light of God.' In art, Uriel carries a scroll and a book signifying his role as interpreter of judgments and prophesies.

Ursula, St. (4th or 5th century). Virgin and martyr. According to legend, Ursula was a beautiful, intelligent English princess. With her companions, she went on a pilgrimage from Great Britain to Rome. On their return journey, she and her attending virgins (some say there were 11, others say 11,000) were killed by arrows of the Huns who were besieging the city of Cologne. St. Ursula is one of the patrons of travelers and of unprotected women. Usually, she is

represented as a crowned princess. Her attributes are an arrow, banner(s), and a mantle sheltering virgins.

Utrecht School. See: DUTCH SCHOOL.

Value. 1. Tone Value. The amount of light and dark in a COLOR. Light colors are high in value. Dark colors are low in value. See also: TONE. 2. Color Value. Intensity of color; the more intense a color, the higher the color value.

Vanishing Point. In PERSPECTIVE, that point on the horizon where parallel lines appear to meet and vanish.

Variable Environmental Paintings. Developed in the 1960s, paintings in which the image elements can be moved around on the surface to form any number of different pictures. Manipulating the images on hinges or by magnets provides a new way to push space around by viewer participation. Artist: Öyvind Fahlström.

Veduta (It. view). Drawings, paintings or ENGRAVINGS of a view of a city. For example: Venice, Rome. Popular in Venice in the 17th and 18th centuries. Painters: Giovanni Antonio Canale Canaletto, Giovanni Battista Piranesi, Francesco Guardi.

Veil Paintings. Paintings by Morris Louis (in 1958 and 1959) in which he stained the canvas with transparent films of paint, one over the other, to provide a dazzling lyrical image of multiple veils.

Vellum. Fine grade of calfskin. Used for the most treasured manuscripts. See also: PARCHMENT.

Venetian School. One of the great schools in RENAISSANCE art, the Venetian School flourished in the 15th and 16th centuries. Artists emphasized the use of light, air and fine shades of color. There is a sense of openness in Venetian landscapes, and the figures are fuller and more passionate than in the paintings of the FLORENTINE and SIENESE SCHOOLS. Venetian painting paved

the way for MANNERISM and BAROQUE art. Painters: Giovanni Bellini, Titian (real name – Tiziano Vecelli), Tintoretto (real name – Jacopo Robusti).

Venus. Roman goddess of love. See: APHRODITE.

Verism. See: NEW OBJECTIVITY.

Vestal Virgins. In Roman mythology, six priestesses devoted to Vesta, goddess of the hearth and symbol of the home. The Vestal Virgins, who had to be near perfect in conduct and appearance, were chosen between the ages of six and ten, from prominent Roman families. They served Vesta for thirty years, prepared the sacrifices and tended the communal fire, which was never permitted to go out. If any Vestal Virgin broke her vows she was entombed alive. The Vestals had great influence in the Roman state. Greek counterpart: Hestia.

Vices. See: VIRTUES.

Victoria. Roman goddess of victory. See: NIKE.

Vignette (Fr. la vigne, the grape vine). 1. Small delicate vine patterns used to decorate the borders and initials of illustrated manuscripts. Also used on the title page of a book or at the beginning or end of a chapter. 2. Portrait, ENGRAVING, or drawing with softened, indefinite edges. 3. Any small delicate decoration that is shaded off gradually leaving no definite line at the border.

Virgin in Glory. MARY is shown standing in the sky surrounded by a radiance and by the heads of CHERUBS.

Virgin of the IMMACULATE CONCEPTION. MARY is shown either with her parents Joachim and Anna or with the Godhead (Father, Son and Holy Ghost – the TRINITY).

Virgin of the Rosary. Virgin MARY appears to St. DOMINIC, founder of the order of Dominicans and gives him a rosary.

Virgo. See: ZODIAC.

Virtues. Virtues, vices and their attributes appear in artworks throughout the ages. In Western art, the seven virtues are an order of ANGELS, all women. The number and sex of the vices varies, although in most art works we find seven female vices. In some RENAISSANCE works the virtues are accompanied by seven LIBERAL ARTS.

1.	Virtues	Vices
	Faith	Pride
	Hope	Covetousness
	Charity	Lust

Virtues	Vices
Temperance	Anger
Prudence	Gluttony
Fortitude	Envy
Justice	Sloth

2.

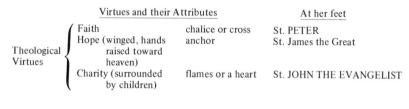

Virtues and their Attributes		At her feet	
Theological Virtues	Faith	chalice or cross	St. PETER
	Hope (winged, hands raised toward heaven)	anchor	St. James the Great
	Charity (surrounded by children)	flames or a heart	St. JOHN THE EVANGELIST

Virtues and their Attributes		At her feet	
Cardinal Virtues	Temperance	sword or two vases	Scipio Africanus
	Prudence (may have two heads)	mirror and a serpent	Solon
	Fortitude	sword, club, shield, globe, lionskin	SAMSON
	Justice	scales and a sword	Emperor Trajan

Visitation. MARY, overjoyed to learn that her cousin ELIZABETH is pregnant, goes to call on her. Shortly thereafter Jesus is born to MARY and JOHN THE BAPTIST is born to ELIZABETH. (Luke 1:36-56).

Vorticism (vortex, a whirling movement that draws into its powerful current everything that is near it.) Shortlived English movement in painting, sculpture and literature early in the 20th century started by Wyndham Lewis. Using angles and arcs to form a focal point, Vorticism drew the viewer into the action of the picture. Although only few artists were involved, Vorticism was significant for England, as it represented England's participation in the experimental art of Europe. Painters: Wyndham Lewis, William Roberts. Sculptor: Gaudier-Brzeska. Related to: CUBISM and FUTURISM.

Votive Images. (Latin – "votivus" = vows) Paintings, drawings or sculptured figures produced in fulfillment of a vow made to the Virgin or saints by people in great danger. These images of a

rescued person or a saved animal are usually executed by local artists and exhibited in churches or other sacred places.

Vulcan. See: HEPHAESTUS.

Wall-Painting. See: MURAL.

Warm Colors. See: COLOR.

Wash. Thin, transparent film of WATER COLOR applied in broad strokes. Used to indicate shadows and MODELING effects.

Wash Drawing. Drawing, usually in one color, made with brush and ink. Uses transparent WASH (SEPIA, bistre or Chinese ink) often combining it with other drawing media like charcoal, pen, pencil, chalk. Especially effective for SHADOW and MODELING. First used in the late 15th century. Artists: Rembrandt Hermensz Van Rijn, Claude Lorraine, Nicolas Poussin.

Washington Color School. Central to the development of COLOR-FIELD PAINTING, Washington Color School (Washington, D. C.) was founded by Morris Louis in the 1950s. Painters: Morris Louis, Kenneth Noland, Sam Gilliam. See: COLOR-FIELD PAINTING.

Water Color. 1. PIGMENTS mixed with water-soluble substance (usually gum arabic) rather than oil. This includes AQUARELLE, FRESCO and TEMPERA. 2. Paintings produced by this process. These are transparent paintings. The white paper supplies the light. When white pigment is added to the water color, it becomes opaque and is called GOUACHE. See also: AQUARELLE, FRESCO, TEMPERA, GOUACHE.

Waterglass Painting. See: STEREOCHROMY.

Waterworks. See: EARTHWORKS.

White-ground. A type of Greek vase emerging in the 5th cent. B. C. in which the background is a creamy white. Figures usually appear in outline in different colors.

Winged Victory. See: NIKE.

Woodcut, RELIEF Print. Print made from a design drawn directly on the surface of a block of wood, the unwanted parts being cut away with gouges and knives. The print is made by inking the raised part of the design; the cut away area remains white. Woodcutting was a common art technique in the late Middle Ages and Dürer and Holbein perfected it. In the 20th century, Munch, Nolde and others revived this process.

Wood Engraving, Xylography. Process of cutting, across the grain, into a block of hard wood with a BURIN or graver. Like a WOODCUT, the non-printing areas are cut away and the print is made from the areas in RELIEF. Popular in Albrecht Dürer's time, Wood Engraving, revived by Thomas Bewick in England in the 19th century, cuts very fine lines thus permitting delicate TONES and greater detail than a WOODCUT.

X

XP. See: MONOGRAMS OF CHRIST.

X-ray Photography. Method used to examine a picture. X-ray pierces layers of paint to reveal manner of painting, UNDERPAINTING, alterations and possible forgery.

Xylography. See: WOOD ENGRAVING.

Z

Zeus. Supreme deity of the ancient Greeks. Father god, and prime protector of the state; concerned with all aspects of life. Zeus was the son of CRONUS and RHEA, who were the children of the sky god URANUS and the earth goddess GAEA. His brother and sisters joined him in overthrowing their father. Zeus, HADES and POSEIDON then divided the universe among themselves. HADES became the ruler of the underworld, POSEIDON dominated the oceans and Zeus ruled over heaven and earth. He resided on Mt. Olympus and married his sister HERA, but as supreme deity took the freedom to love many beautiful women. He is often depicted as bull, as awan, or in any of the guises he chose to pursue his loves. Attributes: thunderbolts; the eagle, his messenger. Roman counterpart: JUPITER.

Ziggurat. Stepped, pyramidal structure with ramps for ascent and descent. It developed in the Ancient Near East around 2000 B.C.

Zodiac. In astronomy, an imaginary belt of the sky, about 16° wide, and 8° on each side of the ecliptic (the apparent annual path of

the sun). Since they looked like animals, many of the constellations were named after animals and the zone was called zodiac meaning "a circle of animals." There are twelve constellations; the twelve divisions are called signs of the zodiac.

Zoomorphic. Term used to describe highly STYLIZED MOTIFS of animal forms. These are often used as symbols attributed to men or deities.

It would not have been possible to compile the Selected List of Museums without the following invaluable sources:

AMERICAN ART DIRECTORY. N.Y., Bowker, 1970.

MUSEUMS OF THE WORLD. N.Y., Bowker, 1973.

THE OFFICIAL MUSEUM DIRECTORY. N.Y., American Association of Museums and Crowell-Collier Educational Corp., 1971.

WORLD OF LEARNING (1972-1973) 2 vols. 23rd ed. London, Europa Publications, 1972.

Museum News was consulted to bring the Selected List of Art Museums up-to-date.

Key to Description of Art Museum Holdings

To describe museum holdings in the shortest space, the code, outlined as follows, has been used. Continents, Countries, Movements and Periods, such as African and Baroque, all start with a capital letter. Media and/or art forms, such as drawing and sculpture, all start with a small letter. Thus, CAmp=Contemporary American painting.

Continents, Countries,
Movements, Periods

Afr=African Art
Am=American (U.S.) Art
AmI=American Indian Art
AmW=American western Art
 (N.W. or S.W.)
An=Art of Antiquity
Ar=Argentinian Art
Aus=Austrian Art
Austl=Australian Art

B=Baroque Art
Bel=Belgian Art
Bibl=Biblical Art
Bl-A=Black American Art
Braz=Brazilian Art
Bud=Buddhist Art

By=Byzantine Art

C=Contemporary Art and/or
 Modern Art
Ca=Canadian Art
CaI=Canadian Indian Art
Ch=Chinese Art
Cl=Classical Art
Co=Coptic Art
Czech=Czechoslovakian Art

Dan=Danish Art
Du=Dutch Art

Ea=Eastern Art (Far East, Near
 East)

151

Continents, Countries,
Movements, Periods

Eg=Egyptian Art
En=English Art
Esk=Eskimo Art
Eu=European Art
EuO=European Old Masters
Exp=Expressionism

Fin=Finnish Art
Fl=Flemish Art
Fr=French Art

Ger=German Art
Go=Gothic Art
Gr=Greek Art

Hu=Hudson River School
Hung=Hungarian Art

Ice=Icelandic Art
Im=Impressionist Art
In=Asian Indian Art
Is=Islamic Art
It=Italian Art

Ja=Japanese Art
Je=Jewish Art

L=Art by local or regional
 artists, and/or on local sub-
 jects
La=Latin American Art

M.A.=Medieval Art or Middle
 Ages Art
Me=Mexican Art
MED=Mediterranean Art

Ne=Negro Art
No=Norwegian Art

Oc=Oceanic Art
Or=Oriental Art

pC=pre-Colombian Art
Per=Peruvian Art
Po=Polish Art
Port=Portuguese Art

Q=Quaker Art

R=Renaissance Art
Ro=Roman Art

S.A.=South American Art
Scand=Scandinavian Art
Slov=Slovenian Art
Sp=Spanish Art
Sw=Swedish Art
Swiss=Swiss Art

Tas=Tasmanian Art
Tur=Turkish Art

V=variety; usually too much to
 list: Eastern Art, Western Art —
 all periods and forms

W=Western Art
We=Welsh Art

Media/Art forms

br=bronzes

ca=calligraphy
ce=ceramics, pottery
cr=crafts

d=drawing
dec=decorative arts
di=diorama

en=enamels

f=furniture

g=glass

h=holography

ill mss=illustrated manuscript

m=maritime
mix=mixed media
mo=mosaics

p=painting
ph=photographs
pr=prints, graphics

r=religious art

sc=sculpture

t=totem poles

wa=water colors
wc=wood carving

Annual Attendance*

1= 1,000,000 and over
2= 500,000 - 999,999
3= 100,000 - 499,999
4= 50,000 - 99,999
5= 10,000 - 49,999
6= 9,999 and under

*If there is no number, the annual
attendance is not known.

ART MUSEUMS IN THE UNITED STATES

Arranged Alphabetically by State

ALABAMA

BIRMINGHAM MUSEUM OF ART, 2000 Eighth Ave. N., *Birmingham*, Ala. 35203 V 3
THE MOBILE ART GALLERY, Langan Park, *Mobile*, Ala. 36608 p, d, pr, sc 5
MONTGOMERY MUSEUM OF FINE ARTS, 440 S. McDonough St., *Montgomery*, Ala. 36104 Am 4

ALASKA

ALASKA STATE MUSEUM, Department of Education, Alaska Office Bldg. Pouch FM, *Juneau*, Alsk 99801 Esk; Am I

ARIZONA

MUSEUM OF NORTHERN ARIZONA, Fort Valley Rd., *Flagstaff*, Ariz. 86001 CAmI4
PHOENIX ART MUSEUM, 1625 N. Central Ave., *Phoenix*, Ariz. 85004 V 3
PUEBLO GRANDE MUSEUM, 4619 E. Washington St., *Phoenix*, Ariz. 85034 AmI 4
THE SCOTTSDALE GALLERY, Scottsdale Public Library, *Scottsdale*, Ariz. 85251 V 5
ARIZONA STATE UNIVERSITY ART COLLECTIONS, *Tempe*, Ariz. 85281 Am 5
TUCSON ART CENTER, INC., 325 W. Franklin St., *Tucson*, Ariz. 85705 pC; Oc; Afr; Am 5
UNIVERSITY OF ARIZONA MUSEUM OF ART, Olive & Speedway, *Tucson*, Ariz. 85721 V 5

ARKANSAS

ARKANSAS ARTS CENTER, MacArthur Park, *Little Rock*, Ark. 72203 V
SOUTHEAST ARKANSAS ARTS & SCIENCE CENTER, Civic Center, *Pine Bluff*, Ark. 71601 V

ARKANSAS STATE UNIVERSITY ART GALLERY, Fine Arts
Center, *State Univ.*, Ark. 72467 C 5

CALIFORNIA

UNIVERSITY OF CALIFORNIA UNIVERSITY ART MUSEUM,
Berkeley, Cal. 94720 V 3

MEMORIAL UNION ART GALLERY, University of California,
Fourth Floor Memorial Union, *Davis*, Cal. 95616 CAm 5

DOWNEY MUSEUM OF ART, 10419 Rives Ave., *Downey*, Cal.
90241 LC 5

FRESNO ARTS CENTER, 3033 E. Yale Ave., *Fresno*, Cal. 93703
C; Me; Or 5

LA JOLLA MUSEUM OF ART, 700 Prospect St., *La Jolla*, Cal.
92037 C Eu Am 4

**CALIFORNIA STATE COLLEGE AT LONG BEACH ART
GALLERY**, 6101 E. Seventh St., *Long Beach*, Cal. 90804 CAmd,
p, sc & cr 5

LONG BEACH MUSEUM OF ART, 2300 E. Ocean Blvd., *Long
Beach*, Cal. 90803 V, L 5

**THE ART GALLERIES OF UNIVERSITY OF CALIFORNIA AT
LOS ANGELES**, 405 Hilgard Ave., *Los Angeles,* Cal. 90024 Eu 3

LOS ANGELES ART ASSOCIATION AND GALLERIES, 825 N.
La Cienega Blvd., *Los Angeles*, Cal. 90069 Lp; sc & pr 5

LOS ANGELES COUNTY MUSEUM OF ART, 5905 Wilshire
Boulevard, *Los Angeles*, Cal. 90036 V, C 1

MÉCHICANO ART CENTER, 4030 Whittier Blvd., *Los Angeles,*
Cal. 90023

SOUTHWEST MUSEUM, Highland Park, *Los Angeles*, Cal. 90042
pC; AmW; AmI 4

J. PAUL GETTY MUSEUM, 17985 Pacific Coast Highway, *Malibu,*
Cal. 90265 V 6

MONTEREY PENINSULA MUSEUM OF ART, 559 Pacific St.,
Monterey, Cal. 93940 V, Am, L 5

NEWPORT HARBOR ART MUSEUM, 400 Main St., *Newport Beach,*
Cal. 92661 AmI; Esk; C 5

THE OAKLAND MUSEUM, Art Division, 1000 Oak St., *Oakland*,
Cal. 94607 L, C 1

PASADENA ART MUSEUM, Colorado and Orange Grove Blvds.,
Pasadena, Cal. 91101 V, C 5

RICHMOND ART CENTER, 25th and Barrett Ave., *Richmond*,
Cal. 94804 V, C 5

FINE ARTS GALLERY OF SAN DIEGO, Balboa Park, *San Diego*, Cal. 92112 V 3

CALIFORNIA PALACE OF THE LEGION OF HONOR, Lincoln Park, *San Francisco*, Cal. 94121 V 2

M. H. DE YOUNG MEMORIAL MUSEUM, Golden Gate Park, *San Francisco*, Cal. 94118 V, Eu, Or, Am, AmI 1

SAN FRANCISCO ART INSTITUTE, 800 Chestnut St., *San Francisco*, Cal. 94133 V, C, L 4

SAN FRANCISCO MUSEUM OF ART, McAllister St. at Van Ness Ave., *San Francisco*, Cal. 94102 CAm & Eu; L 3

ROSICRUCIAN EGYPTIAN MUSEUM AND ART GALLERY, Rosicrucian Park, *San Jose*, Cal. 95114 Eg & Or An; ph 3

HENRY E. HUNTINGTON LIBRARY AND ART GALLERY, *San Marino*, Cal. 91108 V 2

CHARLES W. BOWERS MEMORIAL MUSEUM, 2002 N. Main St., *Santa Ana*, Cal. 92706 CAm 4

SANTA BARBARA MUSEUM OF ART, 1130 State St., *Santa Barbara*, Cal. 93104 V 4

deSAISSET ART GALLERY AND MUSEUM, University of Santa Clara, *Santa Clara*, Cal. 95053 V 3

TRITON MUSEUM OF ART, 1505 Warburton Ave., *Santa Clara*, Cal. 95050 V

VILLA MONTALVO CENTER FOR THE ARTS, Montalvo Association, *Saratoga*, Cal. 95070 V 4

STANFORD UNIVERSITY MUSEUM, *Stanford*, Cal. 94305 V 4

SAN JOAQUIN PIONEER MUSEUM AND HAGGIN ART GALLERIES, Victory Park, 1201 N. Pershing Ave., *Stockton*, Cal. 95203 V 4

COLORADO

GILPIN COUNTY ARTS ASSOCIATION, Eureka St., *Central City*, Colo. 80427 L 4

COLORADO SPRINGS FINE ARTS CENTER, 30 West Dale St., *Colorado Springs*, Colo. 80903 V, AmI 3

THE DENVER ART MUSEUM, 100 W. 14th Ave. Parkway, *Denver*, Colo. 80204 V, AmI, Afr 3

CONNECTICUT

BRUCE MUSEUM, Bruce Park, *Greenwich*, Conn. 06830 V 5

WADSWORTH ATHENEUM, 600 Main St., *Hartford*, Conn. 06103 V 3

DAVISON ART CENTER OF WESLEYAN UNIVERSITY, High St., *Middletown*, Conn. 06457 Eu, Am & Ja pr; C

THE MARINE HISTORICAL ASSOCIATION, INC., *Mystic Seaport*, Conn. 06355 m 2

YALE UNIVERSITY ART GALLERY, 1111 Chapel St., *New Haven*, Conn. 06510 V, An, C 3

LYMAN ALLYN MUSEUM, 100 Mohegan Ave., *New London*, Conn. 06320 V, Am 5

SLATER MEMORIAL MUSEUM, The Norwich Free Academy, Converse Art Bldg., *Norwich*, Conn. 06360 V 5

THE ALDRICH MUSEUM OF CONTEMPORARY ART, 45 Main St., *Ridgefield*, Conn. 06877 C 5

STAMFORD MUSEUM AND NATURE CENTER, High Ridge and Scofieldtown Roads, *Stamford*, Conn. 06903 p; sc; AmI & cr 3

THE WILLIAM BENTON MUSEUM OF ART, Building U-140, *Storrs*, Conn. 06268 Am 5

DELAWARE

WILMINGTON SOCIETY OF THE FINE ARTS, 2301 Kentmere Parkway, *Wilmington*, Del. 19806 V 5

THE HENRY FRANCIS DU PONT WINTERTHUR MUSEUM, *Winterthur*, Del. 19735 V 5

DISTRICT OF COLUMBIA

CORCORAN GALLERY OF ART, 17th St. and New York Ave. N.W., *Washington*, D. C. 20006 V, Am 3

DUMBARTON OAKS RESEARCH LIBRARY AND COLLEC-TIONS, 1703 32nd St., N.W., *Washington*, D. C. 20007 V, By, pC 3

FREER GALLERY OF ART, 12th & Jefferson Dr. S.W., *Washington*, D. C. 20560 V, Ea 3

HOWARD UNIVERSITY, 6th & Fairmont Sts. N.W., *Washington*, D. C. 20001 R; Afr; Am; C 5

MUSEUM OF AFRICAN ART, 316 A St. N.E., *Washington*, D. C. 20002 Afr

MUSEUM OF THE UNITED STATES DEPARTMENT OF THE INTERIOR, C St. between 18th and 19th Sts. N.W., *Washington*, D. C. 20240 Am; Am I; Esk 3

NATIONAL COLLECTION OF FINE ARTS, Eighth & G Sts. N.W., *Washington*, D. C. 20560 Am, C 3

NATIONAL GALLERY OF ART, Constitution Ave. at Sixth St. N.W., *Washington*, D. C. 20565 V 1

NATIONAL MUSEUM OF HISTORY AND TECHNOLOGY, Constitution Ave. between 12th & 14th Sts. N.W., *Washington*, D. C. 20560 pr, ph 1

NATIONAL PORTRAIT GALLERY, Eighth & F Sts. N.W., *Washington*, D. C. 20560 Am 4

THE PHILLIPS COLLECTION, 1600 21st St. N.W., *Washington*, D. C. 20009 Am; Eu; C 4

WASHINGTON GALLERY OF MODERN ART, 1503 21st St. N.W., *Washington*, D. C. 20006 Cp, d, sc & pr 5

FLORIDA

THE LOWE ART MUSEUM OF THE UNIVERSITY OF MIAMI, *Coral Gables*, Fla. 33124 V 4

FORT LAUDERDALE MUSEUM OF THE ARTS, 426 E. Las Olas Blvd., *Fort Lauderdale*, Fla. 33301 Amp & sc; Ja; pr; AmI 5

UNIVERSITY GALLERY, University of Florida, *Gainesville*, Fla. 32601 Eu; Am; Or 5

CUMMER GALLERY OF ART, 829 Riverside Ave., *Jacksonville*, Fla. 32204 Eu & Amp, sc & pr 5

JACKSONVILLE ART MUSEUM, 4160 Boulevard Center Dr., *Jacksonville*, Fla. 32207 pC; C 4

KEY WEST ART AND HISTORICAL SOCIETY, S. Roosevelt Blvd., *Key West*, Fla. 33040 p, wc 5

BASS MUSEUM OF ART, 2100 Collins Ave., *Miami*, Fla. 33139 EuO; M.A. sc 5

MIAMI MUSEUM OF MODERN ART, 381 N.E. 20th St., *Miami*, Fla. 33137 V

VIZCAYA, 3251 S. Miami Ave., *Miami*, Fla. 33129 Euf & p 3

LOCH HAVEN ART CENTER, INC., 2416 North Mills Ave., *Orlando*, Fla. 32803 pr; Amp 4

PENSACOLA ART CENTER, 407 S. Jefferson St., *Pensacola*, Fla. 32501 C 5

CONTEMPORARY ART CENTER OF THE PALM BEACHES, 301 Broadway, *Riviera Beach*, Fla. 33404 C; h3

ST. AUGUSTINE ART ASSOCIATION GALLERY, 22 Marine St., *St. Augustine*, Fla. 32084 L 6

MUSEUM OF FINE ARTS, 255 Beach Drive North, *St. Petersburg*, Fla. 33701 V, Ea 5

JOHN AND MABLE RINGLING MUSEUM OF ART, *Sarasota*, Fla. 33578 Eup, sc & d; B 3

SARASOTA ART ASSOCIATION, 707 N. Tamiami Trail, *Sarasota*, Fla. 33577 C 5

HOUSE OF REFUGE MUSEUM, Hutchinson Island, *Stuart*, Fla. 33494 V 4

FLORIDA CENTER FOR THE ARTS, 4202 E. Fowler Ave., *Tampa*, Fla. 33620 C 3

PALM BEACH ART INSTITUTE, INC. 1451 S. Olive Ave., *West Palm Beach*, Fla. 33401 V 5

GEORGIA

GEORGIA MUSEUM OF ART, The University of Georgia, Jackson St., Main Campus, *Athens*, Ga. 30601 V

THE HIGH MUSEUM OF ART, 1280 Peachtree St. N.E., *Atlanta*, Ga. 30309 V 3

COLUMBUS MUSEUM OF ARTS & CRAFTS, INC., 1251 Wynnton Rd., *Columbus*, Ga. 31906 V 5

HAWAII

HONOLULU ACADEMY OF ARTS, 900 S. Beretania St., *Honolulu*, Hawaii 96814 V, Ch, Ja 3

IDAHO

BOISE GALLERY OF ART, Julia Davis Park, *Boise*, Ida. 83701 V 4

ILLINOIS

UNIVERSITY OF ILLINOIS, Krannert Art Museum, 500 Peabody Dr., *Champaign*, Ill. 61820 V

ART INSTITUTE OF CHICAGO, Michigan Ave. at Adams St., *Chicago*, Ill. 60603 V 1

ROCKFORD ART ASSOCIATION, Burpee Museum of Art, 737 N. Main St., *Rockford*, Ill. 61103 CAm 3

ILLINOIS STATE MUSEUM OF NATURAL HISTORY AND ART, Spring & Edwards Sts., *Springfield*, Ill. 62706 V, L, AmI 3

SPRINGFIELD ART ASSOCIATION, 700 N. Fourth St., *Springfield*, Ill. 62702 Cp 5

INDIANA UNIVERSITY ART MUSEUM, Department of Fine Arts, *Bloomington*, Ind. 47401 V, An, Afr, Oc, pC, Or, Ea 5

EVANSVILLE MUSEUM OF ARTS AND SCIENCE, 411 S.E. Riverside Dr., *Evansville*, Ind. 47713 Am, Eu, Or, AmI 3

MUSEUM OF ART, FORT WAYNE ART INSTITUTE, 1202 W. Wayne St., *Fort Wayne*, Ind. 46804 p, pr, sc 5

THE CLOWES FUND COLLECTION, 3744 Spring Hollow Rd., *Indianapolis*, Ind. 46208 Eu 0

INDIANAPOLIS MUSEUM OF ART, 1200 W. 38th St., *Indianapolis*, Ind. 46208 V 4

BALL STATE UNIVERSITY ART GALLERY, *Muncie*, Ind. 47306 Rp≻ C; pr 4

UNIVERSITY OF NOTRE DAME ART GALLERY, O'Shaughnessy Hall, *Notre Dame*, Ind. 46556 V 5

SLOAN GALLERIES OF AMERICAN PAINTINGS, Valparaiso University, Henry F. Moellering Memorial Library, *Valparaiso*, Ind. 46383 Am

IOWA

DAVENPORT MUNICIPAL ART GALLERY, 1737 W. 12th St., *Davenport*, Ia. 52804 Eu; Me; Am; Ja 4

NORWEGIAN-AMERICAN MUSEUM, 517 W. Water St., *Decorah*, Ia. 52101 No 5

DES MOINES ART CENTER, Greenwood Park, *Des Moines*, Ia. 50312 V, CAm & Eup, pr & d 3

BLANDEN ART GALLERY, 920 Third Ave. S., *Fort Dodge*, Ia. 50501 V, C 5

THE UNIVERSITY OF IOWA MUSEUM OF ART, Riverside Dr., *Iowa City*, Ia. 52240 V 4

CENTRAL IOWA ART ASSOCIATION, INC., Fisher Community Center, *Marshalltown*, Ia. 50158 Im; sc 5

CHARLES H. MacNIDER MUSEUM, 303 Second St. S.E., *Mason City*, Ia. 50401 Am; L5

WATERLOO MUNICIPAL GALLERIES, 225 Cedar St., *Waterloo*, Ia. 50704 CAm 5

KANSAS

UNIVERSITY OF KANSAS MUSEUM OF ART, *Lawrence*, Kans., 66044 V 3

THE BIRGER SANDZEN MEMORIAL GALLERY, Bethany
College Campus, 401 N. First St., *Lindsborg*, Kans. 67456 p, pr,
wa, ce, sc 6

WICHITA ART ASSOCIATION, INC., 9112 E. Central, *Wichita*,
Kans. 67206 pr, d, p, sc, dec 5

WICHITA ART MUSEUM, 619 Stackman Dr., *Wichita*, Kans.
67203 V 4

KENTUCKY

UNIVERSITY OF KENTUCKY ART GALLERY, Fine Arts
Building 105, Rose St., *Lexington*, Ky. 40502 Cpr & d; p 5

J. B. SPEED ART MUSEUM, 2035 S. Third St., *Louisville*, Ky.
40208 V 4

LOUISIANA

HISTORIC NEW ORLEANS COLLECTION, 533 Royal, *New
Orleans*, La. 70130 Lp & pr.

NEW ORLEANS MUSEUM OF ART, City Park, Lelong Ave., *New
Orleans*, La. 70119 V 4

THE R. W. NORTON ART GALLERY, 4700 Block of Creswell
Ave., *Shreveport*, La. 71106 V, Am 5

MAINE

BATH MARINE MUSEUM, *Bath*, Me. 04530 m 5

BOWDOIN COLLEGE MUSEUM OF ART, Walker Art Bldg.,
Brunswick, Me. 04011 V, Am 5

UNIVERSITY OF MAINE ART GALLERY, Carnegie Hall, *Orono*,
Me. 04473 C 5

PORTLAND MUSEUM OF ART, 111 High St., *Portland*, Me.
04101 V, Am 5

WILLIAM A. FARNSWORTH LIBRARY AND ART MUSEUM,
Elm St., *Rockland,* Me. 04841 Am & Eu; L 4

COLBY COLLEGE ART MUSEUM, *Waterville*, Me. 04901 Am

MARYLAND

THE BALTIMORE MUSEUM OF ART, Art Museum Dr., Wyman
Park, *Baltimore*, Md. 21218 V 3

WALTERS ART GALLERY, 600 N. Charles St., *Baltimore*, Md.
21201 V 4

UNIVERSITY OF MARYLAND ART GALLERY, J. Millard
Tawes Fine Arts Center, *College Park*, Md. 20742 Cp, sc & pr 5

WASHINGTON COUNTY MUSEUM OF FINE ARTS, City Park, *Hagerstown*, Md. 21740 Eu; Am; Ch 4

MASSACHUSETTS

ADDISON GALLERY OF AMERICAN ART, Phillips Academy, *Andover*, Mass. 01810 Am 5

ISABELLA STEWART GARDNER MUSEUM, 280 The Fenway, *Boston*, Mass. 02115 V 3

MUSEUM OF FINE ARTS, 465 Huntington Ave., *Boston*, Mass. 02115 V 2

BROCKTON ART CENTER, Fuller Memorial, Oak St. at Upper Porter's Pond, *Brockton*, Mass. 02401 p, sc 5

BUSCH-REISINGER MUSEUM, Kirkland St. & Divinity Ave., *Cambridge*, Mass. 02138 V

WILLIAM HAYES FOGG ART MUSEUM, Harvard University, Quincy St. & Broadway, *Cambridge*, Mass. 02138 V

HAYDEN GALLERY, Massachusetts Institute of Technology, Room 14W-111, *Cambridge*, Mass. 02139 V; m 4

MUSEUM OF THE NATIONAL CENTER OF AFRO-AMERICAN ARTISTS, 122 Elm Hill Ave., *Dorchester*, Mass. 02121 Afr; BL-A

FITCHBURG ART MUSEUM, 25 Merriam Pkwy., *Fitchburg*, Mass. 01420 V 5

HAMMOND MUSEUM, Hesperus Ave., *Gloucester*, Mass. 01931 V 4

HOLYOKE MUSEUM–WISTERIAHURST, 238 Cabot St., *Holyoke*, Mass. 01040 V

DE CORDOVA AND DANA MUSEUM AND PARK, Sandy Pond Rd., *Lincoln*, Mass. 01773 C 5

SMITH COLLEGE MUSEUM OF ART, McConnell Hall, *Northampton*, Mass. 01060 V, Cp 5

BERKSHIRE MUSEUM, 39 South St., *Pittsfield*, Mass. 01201 V 3

CHRYSLER ART MUSEUM, Commercial & Center Sts., *Provincetown*, Mass. 02657 V 4

MOUNT HOLYOKE COLLEGE, Dwight Art Memorial, *South Hadley*, Mass. 01075 V

MUSEUM OF FINE ARTS, 49 Chestnut St., *Springfield*, Mass. 01103 V 4

GEORGE WALTER VINCENT SMITH ART MUSEUM, 222 State St., *Springfield*, Mass. 01103 V, Ch, Ja, Ea 4

ROSE ART MUSEUM, Brandeis University, *Waltham*, Mass. 02154 V 5

STERLING AND FRANCINE CLARK ART INSTITUTE, South St., *Williamstown*, Mass. 01267 V 4

WILLIAMS COLLEGE MUSEUM OF ART, Main St., *Williamstown*, Mass. 01267 V 5

WORCESTER ART MUSEUM, 55 Salisbury St. at Tuckerman St., *Worcester*, Mass. 01608 V, An 3

MICHIGAN

THE UNIVERSITY OF MICHIGAN MUSEUM OF ART, Alumni Memorial Hall, *Ann Arbor*, Mich. 48104 V 4

CRANBROOK ACADEMY OF ART GALLERIES, 500 Lone Pine Rd., *Bloomfield Hills*, Mich. 48013 V 4

THE DETROIT INSTITUTE OF ARTS, 5200 Woodward Ave., *Detroit*, Mich. 48202 V 2

FLINT INSTITUTE OF ARTS, DeWaters Art Center, 1120 E. Kearsley St., *Flint*, Mich. 48503 V 3

GRAND RAPIDS ART MUSEUM, 230 East Fulton, *Grand Rapids*, Mich. 49502 V 4

GENEVIEVE AND DONALD GILMORE ART CENTER, Kalamazoo Institute of Arts, 314 S. Park St., *Kalamazoo*, Mich. 49006 CAm 4

HACKLEY ART GALLERY, 296 W. Webster Ave., *Muskegon*, Mich. 49440 V 5

OAKLAND UNIVERSITY ART GALLERY, *Rochester*, Mich. 48063 pr; C 5

SAGINAW ART MUSEUM, 1126 N. Michigan Ave., *Saginaw*, Mich. 48602 p, wa, pr 5

MINNESOTA

TWEED MUSEUM OF ART, University of Minnesota, *Duluth*, Minn. 55812 Fr; Cpr 5

AMERICAN SWEDISH INSTITUTE, 2600 Park Ave., *Minneapolis*, Minn. 55407 Sw5

MINNEAPOLIS INSTITUTE OF ARTS, 201 E. 24th St., *Minneapolis*, Minn. 55404 V, Ch, pC

UNIVERSITY OF MINNESOTA UNIVERSITY GALLERY, Northrop Memorial Auditorium, *Minneapolis*, Minn. 55455 CAm 4

WALKER ART CENTER, 807 Hennepin Ave., *Minneapolis*, Minn. 55403 V, C 3

MINNESOTA HISTORICAL SOCIETY, Cedar & Central Ave., *St. Paul*, Minn. 55101 p, ph, pr; AmI 3

MINNESOTA MUSEUM OF ART, 30 East 10th St., *St. Paul*, Minn. 55101 V 3

MISSISSIPPI

MISSISSIPPI ART ASSOCIATION, *Jackson*, Miss. 39205 p, pr, sc 5

LAUREL ROGERS LIBRARY AND MUSEUM OF ART, Fifth Ave. at Seventh St., *Laurel*, Miss. 39440 Eu & Amp; Ja pr 6

MISSOURI

SPIVA ART CENTER, INC., Newman & Duquesne Roads, Missouri Southern Fine Arts Building, *Joplin*, Mo. 64801 V 6

ART RESEARCH CENTER, 1609 Washington, *Kansas City*, Mo. 64108 C 6

CHARLOTTE CROSBY KEMPER GALLERY, 4415 Warwick, *Kansas City*, Mo. 64111 C 5

WILLIAM ROCKHILL NELSON GALLERY OF ART, Atkins Museum of Fine Arts, 4525 Oak St., *Kansas City*, Mo. 64111 V 3

ALBRECHT GALLERY OF ART, 2818 Frederick Blvd., *St. Joseph*, Mo. 64506 Am & Eu 5

ST. JOSEPH MUSEUM, 11th & Charles Sts., *St. Joseph*, Mo. 64501 AmI 5

ST. LOUIS ART MUSEUM, Forest Park, *St. Louis*, Mo. 63110 V 2

ST. LOUIS ARTISTS GUILD, 812 Union Blvd., Webster Groves, *St. Louis*, Mo. 63108 pr, d, cr

WASHINGTON UNIVERSITY GALLERY OF ART, Steinberg Hall, *St. Louis*, Mo. 63130 V 3

SPRINGFIELD ART MUSEUM, 1111 E. Brookside Dr., *Springfield*, Mo. 65804 Am 3

MONTANA

MUSEUM OF THE PLAINS INDIAN AND CRAFTS CENTER, *Browning*, Mont. 59417 AmI 4

C.M. RUSSELL GALLERY AND ORIGINAL STUDIO, 1201 Fourth Ave. N., *Great Falls*, Mont. 59401 AmW 5

ARCHIE BRAY FOUNDATION, Route 2, *Helena*, Mont. 59601
ce 6

MONTANA HISTORICAL SOCIETY, 225 N. Roberts St., *Helena*,
Mont. 59601 AmW 3

NEBRASKA

SHELDON MEMORIAL ART GALLERY, University of Nebraska,
Lincoln, Neb. 68508 Am 4

NEBRASKA STATE HISTORICAL SOCIETY, 1500 R St.,
Lincoln, Neb. 68508 AmI 3

UNIVERSITY OF NEBRASKA ART GALLERIES, Sheldon
Memorial Art Gallery, *Lincoln*, Neb. 68508 C; Am

JOSLYN ART MUSEUM, 2218 Dodge St., *Omaha*, Neb. 68102
V 3

NEVADA

NORTHEASTERN NEVADA MUSEUM, 1515 Idaho St., *Elko*, Nev.
89801 AmI; L 5

UNIVERSITY OF NEVADA, LAS VEGAS, ART GALLERY,
4505 Maryland Parkway, *Las Vegas*, Nev. 89109 pr, p, sc; Or 6

NEW HAMPSHIRE

DARTMOUTH COLLEGE, Hopkins Center Art Galleries,
Hanover, N. H. 03755 V 4

THORNE ART GALLERY, Keene State College, *Keene*, N. H.
03431 L 5

CURRIER GALLERY OF ART, 192 Orange St., *Manchester*,
N. H. 03104 Am & Eu 5

MANCHESTER HISTORIC ASSOCIATION, 129 Amherst St.,
Manchester, N. H. 03104 V, AmI 6

ARTS AND SCIENCE CENTER, *Nashua*, N. H. 03060

NEW JERSEY

MONTCLAIR ART MUSEUM, 3 S. Mountain Ave., *Montclair*,
N. J. 07042 V, Am 5

NEWARK MUSEUM ASSOCIATION, 43-49 Washington St.,
Newark, N. J. 07101 V 3

**RUTGERS UNIVERSITY, THE STATE UNIVERSITY OF NEW
JERSEY**, University Art Gallery, *New Brunswick*, N. J. 08903
Eu & Amp

PRINCETON UNIVERSITY, The Art Museum, *Princeton*, N. J. 08540 V

SETON HALL UNIVERSITY STUDENT CENTER ART GALLERY, S. Orange Ave., *South Orange*, N. J. 07079 C 5

NEW JERSEY STATE MUSEUM, Cultural Center, 205 West State St., *Trenton*, N. J. 08625 L; Am 2

NEW MEXICO

UNIVERSITY OF NEW MEXICO, University Art Museum, Fine Arts Center, *Albuquerque*, N. Mex. 87106 V 5

ROSWELL MUSEUM AND ART CENTER, 11th and Main Sts., *Roswell*, N. Mex. 88201 V 4

MUSEUM OF NAVAHO CEREMONIAL ART, INC., 704 Camino Lejo, *Santa Fe*, N. Mex. 87501 AmI 5

MUSEUM OF NEW MEXICO, Fine Arts Bldg., 107 W. Palace Ave., *Santa Fe*, N. Mex. 87501 AmW & AmI

NEW YORK

ALBANY INSTITUTE OF HISTORY AND ART, 125 Washington Ave., *Albany*, N. Y. 12210 V, L 4

UNIVERSITY ART GALLERY, State University of New York at Binghamton, *Binghamton*, N. Y. 13901 V

ALBRIGHT-KNOX ART GALLERY, 1285 Elmwood Ave., *Buffalo*, N. Y. 14222 V, Am & EuC 3

NEW YORK STATE HISTORICAL ASSOCIATION, Fenimore House-Central Quarters, *Cooperstown*, N. Y. 13326 Am; L 3

CORNING GLASS CENTER, *Corning*, N. Y. 14830 gl 2

GUILD HALL OF EAST HAMPTON, 158 Main St., *East Hampton*, N. Y. 11937 L 4

ARNOT ART GALLERY, 235 Lake St., *Elmira*, N. Y. 14901 Am & Eu 5

ART GALLERY OF STATE UNIVERSITY COLLEGE AT FREDONIA, *Fredonia*, N. Y. 14063 pr, sc, p 5

THE HYDE COLLECTION, 161 Warren St., *Glens Falls*, N. Y. 12801 V 5

HECKSCHER MUSEUM, Heckscher Park, Prime Ave., *Huntington*, N. Y. 11743 Eu & Am 4

HERBERT F. JOHNSON MUSEUM OF ART, Cornell University, 27 East Ave., *Ithaca*, N. Y. 14850 Eu & Am 5

ITHACA COLLEGE MUSEUM OF ART, 120 E. Buffalo St., *Ithaca*, N. Y. 14850 Afr; Oc; C 5

THE COLLEGE ART GALLERY, State University College, *New Paltz*, N. Y. 12561 V

AMERICAN ACADEMY OF ARTS AND LETTERS, 633 W. 155th St., *New York*, N. Y. 10032 sc, p, d

ASIA HOUSE GALLERY, 112 E. 64th St., *New York*, N. Y. 10021 Ea 5

THE BROOKLYN MUSEUM, Eastern Pkwy, & Washington Ave., *Brooklyn*, N. Y. 11238 V 3

CENTER FOR INTER-AMERICAN RELATIONS ART GALLERY, 680 Park Ave., *New York*, N. Y. 10021 La; pC 5

CONTEMPORARY ARTS, INC. 40 W. 56th St., *New York*, N. Y. 10019 CAm

COOPER-HEWITT MUSEUM OF DECORATIVE ARTS AND DESIGN, 2 E. 91st St., *New York*, N. Y. 10028 ce, dec, d, pr

FINCH COLLEGE MUSEUM OF ART, Contemporary Wing, 62 E. 78th St., *New York*, N. Y. 10021 CAm 5

FRICK COLLECTION, 1 E. 70th St., *New York*, N. Y. 10021 Eu; Ch 3

SOLOMON R. GUGGENHEIM MUSEUM, 1071 Fifth Ave., *New York*, N. Y. 10028 CAm & Eu 2

THE HISPANIC SOCIETY OF AMERICA, Broadway, between 155th & 156th Sts., *New York*, N. Y. 10032 Sp 5

THE JEWISH MUSEUM, 1109 Fifth Ave., *New York*, N. Y. 10028 Je 3

THE METROPOLITAN MUSEUM OF ART, Fifth Avenue at 82nd St., *New York*, N. Y. 10028 V 1

THE CLOISTERS (part of the Metropolitan Museum of Art) Fort Tryon Park, *New York*, N. Y. 10040 M.A.

PIERPONT MORGAN LIBRARY, 29 E. 36th St., *New York*, N. Y. 10016 V, ill.mss.

MUSEUM OF THE AMERICAN INDIAN, Heye Foundation, Broadway at 155th St., *New York*, N. Y. 10032 AmI; pC; Esk 4

THE MUSEUM OF MODERN ART, 11 W. 53rd St., *New York*, N. Y. 10019 C 1

MUSEUM OF CONTEMPORARY CRAFTS OF THE AMERICAN CRAFTS COUNCIL, 29 W. 53rd St., *New York*, N. Y. 10019 Acr 4

THE MUSEUM OF GRAPHIC ART, 245 W. 19th St., *New York*, N. Y. 10011 pr

THE MUSEUM OF PRIMITIVE ART, 15 W. 54th St., *New York*, N. Y. 10019 La; Afr; Oc 5

NEW YORK CULTURAL CENTER, 2 Columbus Circle, *New York*, N. Y. 10019 CAm & Eu

NEW YORK HISTORICAL SOCIETY, 170 Central Park West (77th St.), *New York*, N. Y. 10024 Am; EuO; L 3

NEW YORK PUBLIC LIBRARY, Prints Div.-Rm. 308, Fifth Ave. & 42nd St., *New York*, N. Y. 10018 Apr, d

NEW YORK UNIVERSITY ART COLLECTION, 1 Washington Square Village, *New York*, N. Y. 10012 p, sc, d, pr, ph

RIVERSIDE MUSEUM, 310 Riverside Drive at 103rd St., *New York*, N. Y. 10025 Am, Ea, Ja 5

WHITNEY MUSEUM OF AMERICAN ART, 945 Madison Avenue, *New York* N. Y. 10021 Cp, sc, d & pr 3

FREDERICK REMINGTON MUSEUM, 303 Washington St., *Ogdensburg*, N. Y. 13669 p, br, d 4

VASSAR COLLEGE ART GALLERY, Taylor Hall, *Poughkeepsie*, N. Y. 12601 V Classical Museum, Avery Hall Gr, Eg, Rogl

GEORGE EASTMAN HOUSE, 900 East Ave., *Rochester*, N. Y. 14607 ph, EuO 3

MEMORIAL ART GALLERY, The University of Rochester, 490 University Ave., *Rochester*, N. Y. 14607 V 3

SKIDMORE COLLEGE ART GALLERY, Hathorn Studio, *Saratoga Springs*, N. Y. 12866 pr, p, sc, ce, ph 6

SCHENECTADY MUSEUM, Nott Terrace Heights, *Schenectady*, N. Y. 12308 V 4

PARRISH ART MUSEUM, 25 Jobs Lane, *Southampton*, N. Y. 11968 R; Am

STATEN ISLAND INSTITUTE OF ARTS AND SCIENCES, 75 Stuyvesant Place, St. George, *Staten Island*, N. Y. 10301 V, CAm 3

SUFFOLK MUSEUM & CARRIAGE HOUSE AT STONY BROOK, *Stony Brook*, N. Y. 11790 L; Am 3

EVERSON MUSEUM OF ART 401 Harrison St., *Syracuse*, N. Y. 13202 V, CAm 3

JOE & EMILY LOWE ART CENTER, Syracuse University, 309 University Pl., *Syracuse*, N. Y. 13210 V, C

MUNSON-WILLIAMS-PROCTOR INSTITUTE, 310 Genesee St., *Utica*, N. Y. 13502 Am; C; L; dec, pr

WEST POINT MUSEUM, United States Military Academy, *West Point*, N. Y. 10996 Am 3

HUDSON RIVER MUSEUM, 511 Warburton Ave., Trevor Park, *Yonkers*, N. Y. 10701 Am; Hu; AmI; L 4

NORTH CAROLINA

ASHEVILLE ART MUSEUM, 152 Pearson Dr., *Asheville*, N. C. 28801 p, pr 5

WILLIAM HAYES ACKLAND MEMORIAL ART CENTER, University of North Carolina, *Chapel Hill*, N. C. 27514 p, pr, d, sc 5

THE MINT MUSEUM OF ART, 501 Hempstead Place, *Charlotte*, N. C. 28207 ce, coins 3

DUKE UNIVERSITY ART MUSEUM, 6877 College Station, *Durham*, N. C. 27708 M.A.; Rsc & dec; pr

WEATHERSPOON ART GALLERY, University of North Carolina at Greensboro, McIver Building, *Greensboro*, N. C. 27412 Cp, sc, pr & d

HICKORY MUSEUM OF ART, Third St. & First Ave. N. W., *Hickory*, N. C. 28601 Am & Eup; Ch 5

TRYON PALACE, 613 Pollock St., *New Bern*, N. C. 28560 Enp 5

NORTH CAROLINA MUSEUM OF ART, 107 E. Morgan St., *Raleigh*, N. C. 27601 EuO; Cl 3

MUSEUM OF EARLY SOUTHERN DECORATIVE ARTS, 924 S. Main St., *Winston-Salem,* N. C. 27101 f, ce, pr; Lp 5

OHIO

AKRON ART INSTITUTE, 69 E. Market St., *Akron*, O. 44308 V 4

THE CANTON ART INSTITUTE, 1001 Market Ave. N., *Canton*, O. 44702 V 4

CINCINNATI ART MUSEUM, Eden Park, *Cincinnati*, O. 45202 V

THE CONTEMPORARY ARTS CENTER, 113 W. Fourth St., *Cincinnati*, O. 45202 Cp, sc, d & pr

HEBREW UNION COLLEGE MUSEUM, 3101 Clifton Ave., *Cincinnati*, O. 45220 Je

TAFT MUSEUM, 316 Pike St., *Cincinnati*, O. 45202 V, EuO 5

CLEVELAND MUSEUM OF ART, 11150 East Boulevard, *Cleveland*, O. 44106 V 2

THE SALVADOR DALI MUSEUM, 24050 Commerce Park Road, *Cleveland*, O. 44122 by appointment

THE WESTERN RESERVE HISTORICAL SOCIETY, 10825 East Boulevard, *Cleveland*, O. 44106 L; AmI; ce, gl, di 2

THE COLUMBUS GALLERY OF FINE ARTS, 480 East Broad St., *Columbus*, O. 43215 CAm & Fr; R; B 3

JOHNSON-HUMRICKHOUSE MEMORIAL MUSEUM, Sycamore & 3rd Sts., *Coshocton*, O. 43812 AmI; Esk; Ch; Ja

DAYTON ART INSTITUTE, Forest & Riverview Ave., *Dayton*, O. 45405 AmW; Ea; MED; pC 3

OHIO WESLEYAN UNIVERSITY, Memorial Union Bldg., *Delaware*, O. 43015 V

DUDLEY PETER ALLEN MEMORIAL ART MUSEUM, Oberlin College, *Oberlin*, O. 44074 V 5

THE TOLEDO MUSEUM OF ART, Monroe St. at Scottwood Ave., *Toledo*, 0. 43601 V 3

GREAT LAKES HISTORICAL SOCIETY, 480 N. Main St., *Vermilion*, O. 44089 m 5

COLLEGE OF WOOSTER ART CENTER, College Art Museum, *Wooster*, O. 44691 V

THE BUTLER INSTITUTE OF AMERICAN ART, 524 Wick Ave., *Youngstown*, O. 44502 Am, AmI 4

ART INSTITUTE OF ZANESVILLE, Maple at Adair Aves., *Zanesville*, O. 43701 V 5

OKLAHOMA

EAST CENTRAL STATE COLLEGE MUSEUM, *Ada*, Okla. 74820 V, Cpr & d 5

SOUTHERN PLAINS INDIAN MUSEUM AND CRAFTS CENTER, *Anadarko*, Okla. 73005 AmI 5

WOOLAROC MUSEUM, *Bartlesville*, Okla. 74003 AmI, AmW 3

MUSEUM OF THE GREAT PLAINS, Elmer Thomas Park, *Lawton*, Okla. 73501 AmI 3

UNIVERSITY OF OKLAHOMA MUSEUM OF ART, *Norman*, Okla. 73069 V 3

OKLAHOMA ART CENTER, Plaza Circle-Fair Park, Pershing Blvd., *Oklahoma City*, Okla. 73107 CAm 3

THE OKLAHOMA MUSEUM OF ART, 5500 N. Lincoln Blvd., *Oklahoma City*, Okla. 73105

PONCA CITY CULTURAL CENTER AND INDIAN MUSEUM, 1000 E. Grand, *Ponca City*, Okla. 74601 AmIcr 5

THOMAS GILCREASE INSTITUTE OF AMERICAN HISTORY AND ART, 2500 W. Newton St., *Tulsa*, Okla. 74127 AmI, AmW 4

PHILBROOK ART CENTER, 2727 S. Rockford Rd., *Tulsa*, Okla. 74114 V 4

ELOISE J. SCHELLSTREDE GALLERY OF FINE ARTS, 1307 S. Main, *Tulsa*, Okla. 74119 Lp & sc

OREGON

MEMORIAL UNION ART GALLERY, Oregon State University, *Corvallis*, Ore. 97331 V 4

UNIVERSITY OF OREGON MUSEUM OF ART, *Eugene*, Ore. 97403 V 6

KLAMATH COUNTY MUSEUM, 1451 Main St., *Klamath Falls*, Ore. 97601 AmW; L 5

ROGUE VALLEY ART GALLERY, 40 S. Bartlett, *Medford*, Ore. 97501 C 6

OREGON HISTORICAL SOCIETY, INC. 1230 S.W. Park Ave., *Portland*, Ore. 97205 AmW 4

PORTLAND ART MUSEUM, S. W. Park & Madison, *Portland*, Ore. 97205 V 3

SALEM ART ASSOCIATION, Bush Barn Art Center, 600 Mission St., *Salem*, Ore. 97301 V 5

PENNSYLVANIA

ALLENTOWN ART MUSEUM, Fifth & Court Sts., *Allentown*, Pa. 18105 EuO; Am pr 5

LEHIGH ART GALLERIES, Lehigh University, *Bethlehem*, Pa. 18015 V 6

THE BRANDYWINE RIVER MUSEUM, *Chadds Ford*, Pa. 19317 (Where U.S.I. crosses the Brandywine) Am

ERIE ART CENTER, 338 W. Sixth St., *Erie*, Pa. 16507 Amp, pr & sc 5

WESTMORELAND COUNTY MUSEUM OF ART, 221 N. Main St., *Greensburg*, Pa. 15601 Amp, sc, pr, d, f & dec 4

PENNSYLVANIA HISTORICAL AND MUSEUM COMMISSION, William Penn Memorial Museum & Archives Building, *Harrisburg*, Pa. 17108 V, p, cr, f

BARNES FOUNDATION COLLECTION, Merion Station, *Montgomery County*, Pa. 19066 Im

AMERICAN SWEDISH HISTORICAL MUSEUM, 1900 Pattison Ave., *Philadelphia*, Pa. 19145 Sw 6

CIVIC CENTER MUSEUM, Civic Center Blvd. & 34th St., *Philadelphia*, Pa. 19104 Or, Afr & Lacr

DREXEL UNIVERSITY ART GALLERY AND MUSEUM COLLECTION, Chestnut & 32nd Sts., *Philadelphia*, Pa. 19104 In, Ch, Ja & Eudec; ce

FREE LIBRARY OF PHILADELPHIA, Print and Picture Dept.-Rm 211, Logan Sq., *Philadelphia*, Pa. 19103 Am & Lpr, ph & d

171

HISTORICAL SOCIETY OF PENNSYLVANIA, 1300 Locust St., *Philadelphia*, Pa. 19107 Amp

INDEPENDENCE NATIONAL HISTORICAL PARK, 311 Walnut St., *Philadelphia*, Pa. 19106 Am 1

MUSEUM OF THE PHILADELPHIA CIVIC CENTER, Civic Center Blvd. at 34th St., *Philadelphia*, Pa. 19104 V 2

PENNSYLVANIA ACADEMY OF THE FINE ARTS, Broad & Cherry Sts., *Philadelphia*, Pa. 19102 Amp, sc, d, & pr 4

PHILADELPHIA ART ALLIANCE, 251 S. 18th St., *Philadelphia*, Pa. 19103 p, sc, pr 3

PHILADELPHIA MUSEUM OF ART, Parkway at 26th St., *Philadelphia*, Pa. 19101 V 2

RODIN MUSEUM, Parkway at 22nd St., *Philadelphia*, Pa. 19131 sc, d, wa

THE UNIVERSITY MUSEUM, University of Pennsylvania, 33rd and Spruce St., *Philadelphia*, Pa. 19104 Ea; AmI; Oc; Afr, Ne 3

THE WOODMERE ART GALLERY, 9201 Germantown Ave., *Philadelphia*, Pa. 19118 V 5

ARTS AND CRAFTS CENTER OF PITTSBURGH, Mellon Park, Fifth & Shady Aves., *Pittsburgh*, Pa. 15232 cr 4

HENRY CLAY FRICK FINE ARTS BUILDING, University of Pittsburgh, Schenley Plaza, *Pittsburgh*, Pa. 15213 C; Or 6

MUSEUM OF ART, CARNEGIE INSTITUTE, 4400 Forbes Ave., *Pittsburgh*, Pa. 15213 V 1

READING PUBLIC MUSEUM AND ART GALLERY, 500 Museum Road, *Reading*, Pa. 19602 V 3

EVERHART MUSEUM, Nay Aug Park, *Scranton*, Pa. 18510 V 3

FRIENDS HISTORICAL LIBRARY, Swarthmore College, *Swarthmore*, Pa. 19081 Q 6

THE HISTORICAL SOCIETY OF YORK COUNTY, 250 E. Market St., *York*, Pa. 17403 Lp & sc 5

RHODE ISLAND

NEWPORT HISTORICAL SOCIETY, 82 Touro St., *Newport*, R. I. 02840 m, gl, f, **L**

ALBERTA AND VERA LIST ART BLDG., Brown Univ., Prospect, *Providence*, R. I. 02912

MUSEUM OF ART, Rhode Island School of Design, 224 Benefit St., *Providence*, R. I. 02903 V 4

SOUTH CAROLINA

GIBBES ART GALLERY, 135 Meeting St., *Charleston*, S. C. 29401 Amp, sc, pr & dec; L 5

RUDOLPH LEE GALLERY, College of Architecture, Clemson University, *Clemson*, S. C. 29631 Du & Flp; CAmp & pr 5

COLUMBIA MUSEUM OF ART, Senate & Bull Sts., *Columbia*, S. C. 29201 V 3

FLORENCE MUSEUM, Spruce at Graham St., *Florence*, S. C. 29501 ce; AmI; Or; Am & Eup 5

GREENVILLE COUNTY MUSEUM OF ART, *Greenville*, S. C. 29607 CAmp & sc 4

BOB JONES UNIVERSITY MUSEUM AND ART GALLERY, *Greenville*, S. C. 29614 r, EuO 5

THE MUSEUM, Phoenix St., *Greenwood*, S. C. 29646 L 5

BROOKGREEN GARDENS, *Murrells Inlet*, S. C. 29576 Amsc 3

THE ARTS COUNCIL OF SPARTANBURG COUNTY, INC., 151 N. Fairview Ave., *Spartanburg*, S. C. 29302 L 5

THE GALLERY, 327 E. Kennedy St., *Spartanburg*, S. C. 29302 L 6

SOUTH DAKOTA

SOUTH DAKOTA MEMORIAL ART CENTER, South Dakota State University, Medary at Tenth St., *Brookings*, S. D. 57006 L; CAmp, sc & pr

SIOUX INDIAN MUSEUM AND CRAFTS CENTER, *Rapid City*, S. D. 57701 AmI 3

CIVIC FINE ARTS ASSOCIATION, 318 S. Main St., *Sioux Falls*, S. D. 57102 Cd, pr, p & sc 5

TENNESSEE

GEORGE T. HUNTER GALLERY, 10 Bluff View, *Chattanooga*, Tenn. 37403 Am; Or 5

HOUSTON ANTIQUE MUSEUM, 201 High St., *Chattanooga*, Tenn. 37403 gl 5

EAST TENNESSEE STATE UNIVERSITY, Carroll Reece Museum, *Johnson City*, Tenn. 37601 L; Cp; cr 4

DULIN GALLERY OF ART, 3100 Kingston Pike, *Knoxville*, Tenn. 37919 C 5

BROOKS MEMORIAL ART GALLERY, Overton Park, *Memphis*, Tenn. 38112 V 3

TENNESSEE FINE ARTS CENTER, Cheekwood, *Nashville*, Tenn. 37205 p, sc, pr, ce, en 4

TENNESSEE STATE MUSEUM, War Memorial Building, *Nashville*, Tenn. 37219 L; AmIcr 3

TEXAS

ABILENE FINE ARTS MUSEUM, Oscar Rose Park, *Abilene*, Tex. 79604

PANHANDLE-PLAINS HISTORICAL MUSEUM, 2401 Fourth Ave., *Canyon*, Tex. 79015 Amp 3

ART MUSEUM OF SOUTH TEXAS, 1902 Park Ave., *Corpus Christi*, Tex. 78401 p 5

DALLAS MUSEUM OF FINE ARTS, Fair Park, *Dallas*, Tex. 75226 V 3

POLLOCK GALLERIES, Owen Arts Center, Southern Methodist University, *Dallas*, Tex. 75222 CAm & Eu 3

EL PASO MUSEUM OF ART, 1211 Montana Ave., *El Paso*, Tex. 79902 V 4

AMON CARTER MUSEUM OF WESTERN ART, 3501 Camp Bowie Blvd., *Fort Worth*, Tex. 76101 AmW 4

FORT WORTH ART CENTER MUSEUM, 1309 Montgomery St., *Fort Worth*, Tex. 76107 C; pr, p, d, sc 4

KIMBELL ART MUSEUM, Will Rogers Road W., *Fort Worth*, Tex. 76107 V

CONTEMPORARY ARTS MUSEUM, 5216 Montrose, *Houston*, Tex. 77006 C

INSTITUTE FOR THE ARTS, Rice University, *Houston*, Tex. 77001 pr, ph, p, sc 4

THE MUSEUM OF FINE ARTS, 1001 Bissonnet St., *Houston*, Tex. 77005 V 3

PRESIDENTIAL MUSEUM, 622 N. Lee, *Odessa*, Tex. 79760 V, p, mo 5

MARION KOOGLER McNAY ART INSTITUTE, 6000 N. New Braunfels St., *San Antonio*, Tex. 78209 V, Im 3

WITTE MEMORIAL MUSEUM, Art Museum, Brackenridge Park, 3801 Broadway, *San Antonio*, Tex. 78209 Am; L; r; sc, d, pr, dec

UTAH

TERRITORIAL STATEHOUSE, Capitol Ave., *Fillmore*, Ut. 84631 p, sc, d, pr, ph

BRIGHAM YOUNG UNIVERSITY, Harris Fine Arts Center, B. F. Larsen Gallery, *Provo*, Ut. 84601 pr; L; Amp 3

SALT LAKE ART CENTER, 54 Finch Lane, Reservoir Park, *Salt Lake City*, Ut. 84102 L 5

UTAH MUSEUM OF FINE ARTS, Art & Architecture Center, University of Utah, *Salt Lake City*, Ut. 84112 V 5

SPRINGVILLE MUSEUM OF ART, 126 E. 400 S., *Springville*, Ut., 84663 p, sc 6

VERMONT

BENNINGTON MUSEUM, INC., W. Main St., *Bennington*, Vt. 05201 V, gl, L 4

UNIVERSITY OF VERMONT, Robert Hull Fleming Museum, *Burlington*, Vt. 05401 V 5

WALKER MUSEUM, Route 5, *Fairlee*, Vt. 05044 V 6

SOUTHERN VERMONT ART CENTER, *Manchester*, Vt. 05254 CAmp 5

ST. JOHNSBURY ATHENAEUM, 30 Main St., *St. Johnsbury*, Vt. 05819 Am & Eup 6

SHELBURNE MUSEUM, *Shelburne*, Vt. 05482 V 4

BUNDY ART GALLERY, *Waitsfield*, Vt. 05673 Cp & sc 6

VIRGINIA

THOMAS JEFFERSON MEMORIAL FOUNDATION, *Monticello*, Va. 22902 f

HAMPTON INSTITUTE COLLEGE MUSEUM, *Hampton*, Va. 23368 Afr; Oc; AmI; C 6

MOUNT VERNON, HOME OF GEORGE WASHINGTON, *Mount Vernon*, Va. 22121 f, p, pr 1

THE MARINERS MUSEUM, Rt. 60 & J. Clyde Morris Blvd., *Mount Vernon*, Va. 23606 m 3

THE HERMITAGE FOUNDATION, 7637 North Shore Rd., Lochhaven, *Norfolk*, Va. 23505 V 5

NORFOLK MUSEUM OF ARTS AND SCIENCES, Mowbray Arch and Olney Rd., *Norfolk*, Va. 23510 V 3

VIRGINIA HISTORICAL SOCIETY, Battle Abbey, 428 North Blvd., *Richmond*, Va. 23221 p 5

VIRGINIA MUSEUM OF FINE ARTS, Boulevard & Grove, *Richmond*, Va. 23221 V 2

ROANOKE FINE ARTS CENTER, Cherry Hill, 301 23rd St. S.W., *Roanoke*, Va. 24014 p, wa, sc, pr 5

COLONIAL WILLIAMSBURG, *Williamsburg*, Va. 23185 V 1
ABBY ALDRICH ROCKEFELLER FOLK ART COLLECTION, *Williamsburg*, Va. 23185 Amp & sc 3

WASHINGTON

PACIFIC NORTHWEST ARTS AND CRAFTS ASSOCIATION, 250 Bellevue Square, *Bellevue*, Wash. 98004 AmW & Lcr 3
WHATCOM MUSEUM OF HISTORY AND ART, 121 Prospect St., *Bellingham*, Wash. 98225 AmW; L; C
MARYHILL MUSEUM OF FINE ARTS, *Maryhill*, Wash. 98620 V 4
STATE CAPITOL MUSEUM, 211 W. 21st Ave., *Olympia*, Wash. 98501 AmW, AmI 4
CHARLES AND EMMA FRYE ART MUSEUM, 704 Terry Ave., *Seattle*, Wash. 98114 Eu & Amp, C 4
SEATTLE ART MUSEUM, Volunteer Park, *Seattle*, Wash. 98102 V 3
SEATTLE ART MUSEUM PAVILION, Seattle Center, 2nd N. & Thomas St., *Seattle*, Wash. 98109 C
UNIVERSITY OF WASHINGTON, Henry Art Gallery, *Seattle*, Wash. 98105 Am & Eup; C 4
EASTERN WASHINGTON STATE HISTORICAL SOCIETY, 2316 W. First Ave., *Spokane*, Wash. 99204 AmW & AmI
TACOMA ART MUSEUM, 12th and Pacific, *Tacoma*, Wash. 98402 Am & Eu 4
WASHINGTON STATE HISTORICAL SOCIETY, 315 N. Stadium Way, *Tacoma*, Wash. 98403 AmI; Esk; Or; AmW 3

WEST VIRGINIA

THE CHARLESTON ART GALLERY OF SUNRISE, 755 Myrtle Rd., *Charleston*, W. Va. 25314 C 4
HUNTINGTON GALLERIES, Park Hills, *Huntington*, W. Va. 25701 Am; Eu; Ea; pC 4

WISCONSIN

THEODORE LYMAN WRIGHT ART CENTER, Beloit College, *Beloit*, Wis. 53511 Or; C; pr, ph
NEVILLE PUBLIC MUSEUM, 129 S. Jefferson St., *Green Bay*, Wis. 54301 V 4
KENOSHA PUBLIC MUSEUM, Civic Center, *Kenosha*, Wis. 53140 AmI; Or; p, cr 4

176

ELVEHJEM ART CENTER, University of Wisconsin, 800 University Ave., *Madison*, Wis. 53706 V

MADISON ART CENTER, INC., 720 E. Gorham St., *Madison*, Wis. 53703 pr, d, p, sc 4

STATE HISTORICAL SOCIETY OF WISCONSIN, 816 State St., *Madison*, Wis. 53706 L; f, gl, cr, ph 3

UNIVERSITY OF WISCONSIN, Wisconsin Union, 800 Langdon St., *Madison*, Wis. 53706 C 3

RAHR CIVIC CENTER AND PUBLIC MUSEUM, 610 N. 8th St., *Manitowoc*, Wis. 54220 Am; Eu; Ja 5

MARQUETTE UNIVERSITY GALLERY, *Milwaukee*, Wis. 53233 R, r 5

MILWAUKEE ART CENTER, 750 North Lincoln Memorial Dr., *Milwaukee*, Wis. 53202 Am & Eup, sc, d, pr 3

CHARLES ALLIS ART LIBRARY, 1630 E. Royall Place, *Milwaukee*, Wis. 53202 V, Eup & pr 5

MILWAUKEE PUBLIC MUSEUM, 800 W. Wells St., *Milwaukee*, Wis. 53233 V, Sp, AmI, Euf, di 1

BERGSTROM ART CENTER AND MUSEUM, *Neehah*, Wis. 54956 gl, p, d 5

OSHKOSH PUBLIC MUSEUM, 1331 Algoma Blvd., *Oshkosh*, Wis. 54901 Am; Eu; AmI 4

PAINE ART CENTER AND ARBORETUM, 1410 Algoma Blvd., *Oshkosh*, Wis. 54902 Eup, Enf 5

CHARLES A. WUSTUM MUSEUM OF FINE ARTS, 2519 Northwestern Ave., *Racine*, Wis. 53404 L 4

WYOMING

BRADFORD BRINTON MEMORIAL RANCH MUSEUM, *Big Horn*, Wyo. 82833 Am 5

WHITNEY GALLERY OF WESTERN ART, *Cody*, Wyo. 82414 AmW 3

UNIVERSITY OF WYOMING ART MUSEUM, *Laramie*, Wyo. 82070 Am; Eu; Or 6

PUERTO RICO

MUSEO DE ARTE DE PONCE (Ponce Art Museum) Avenida de las Americas, Apartado 1492, *Ponce*, P. R. 00731 Eu & Lp

INSTITUTO DE CULTURAL PUERTORRIQUENA (Institute of Puerto Rican Culture) Apartado 4184, *San Juan*, P. R. 00905 L

Selected List of
ART MUSEUMS IN CANADA

Arranged Alphabetically by Province

ALBERTA

GLENBOW-ALBERTA ART GALLERY, 902 11th Ave. S. W.,
Calgary, Alta. Lp & pr
THE EDMONTON ART GALLERY, 2 Sir Winston Churchill
Square, *Edmonton*, Alta. Cap, sc & pr 3
UNIVERSITY ART GALLERY AND MUSEUM, University of
Alberta, *Edmonton*, Alta. p, sc, pr 6

BRITISH COLUMBIA

MUSEUM OF NORTHERN BRITISH COLUMBIA, McBride St.
& First Ave. E., *Prince Rupert*, B. C. t; CaI; m; Esk 5
FINE ARTS GALLERY, University of British Columbia, 8.,
Vancouver, B. C. V 4
MARITIME MUSEUM, 1100 Chestnut St., 9., *Vancouver*, B. C.
m 3
THE VANCOUVER ART GALLERY, 1145 W. Georgia St., 5.,
Vancouver, B. C. Eu, Am & Ca 3
ART GALLERY OF GREATER VICTORIA, 1040 Moss St.,
Victoria, B. C. V 5
MALTWOOD MEMORIAL MUSEUM OF HISTORIC ART, 2509
W. Saanich Rd., *Victoria*, B. C. V 6

MANITOBA

UNIVERSITY OF MANITOBA GALLERY III, School of Art, 19.,
Winnipeg, Man. CCa & Am 5
WINNIPEG ART GALLERY, Civic Auditorium Building 1,
Winnipeg, Man. p, sc, pr 4

NEW BRUNSWICK

BEAVERBROOK ART GALLERY, Queen St., *Fredericton*, N. B.
En & Cap 4
NEW BRUNSWICK MUSEUM, 277 Douglas Ave., *Saint John*,
N. B. Cap; Eu; Or 4

178

NEWFOUNDLAND

MEMORIAL UNIVERSITY ART GALLERY, Arts & Culture Centre, Prince Philip Dr., *St. John's*, Nfld. CCap & sc 3

NOVA SCOTIA

PUBLIC ARCHIVES OF NOVA SCOTIA, Coburg Rd., *Halifax, N. S.* L; m; ph, p

ONTARIO

ART GALLERY OF HAMILTON, Main W. at Forsythe St., *Hamilton*, Ont. Ca, Eu & Amp

AGNES ETHERINGTON ART CENTRE, Queen's University, University Ave., *Kingston*, Ont. Ca & Eu 4

McMICHAEL CONSERVATION COLLECTION OF ART, *Kleinburg*, Ont. Ca 4

LONDON PUBLIC LIBRARY AND ART MUSEUM, 305 Queens Ave, 14., *London*, Ont. V, Ca 4

McINTOSH MEMORIAL ART GALLERY, University of Western Ontario, 72., *London*, Ont. p, d, pr

THE ROBERT McLAUGHLIN GALLERY, Civic Centre, *Oshawa*, Ont. p 4

THE NATIONAL GALLERY OF CANADA, Elgin St., 4., *Ottawa*, Ont. Ca; Eu; CAm 3

THE ST. CATHERINES AND DISTRICT ARTS COUNCIL, 109 St. Paul Crescent, *Ottawa*, Ont. CCa 5

SARNIA PUBLIC LIBRARY AND ART GALLERY, *Ottawa*, Ont. Ca

ROTHMANS ART GALLERY OF STRATFORD, 54 Romeo St. N., *Stratford*, Ont. p, sc 5

ART GALLERY OF ONTARIO, Grange Park, 133., *Toronto*, Ont. Eu; Ca; Am 3

HART HOUSE, University of Toronto, 5., *Toronto*, Ont. Cap

METROPOLITAN TORONTO CENTRAL LIBRARY, 214 College St., 130., *Toronto*, Ont. Capr, d, p & ph

ROYAL ONTARIO MUSEUM, 100 Queen's Park, 5., *Toronto*, Ont. V, Ch, R 1

THE ART GALLERY OF WINDSOR, Willistead Park, 15., *Windsor*, Ont. Cap, pr, dec & sc 4

QUEBEC

CHATEAU DE RAMEZAY, Antiquarian and Numismatic Society of Montreal, 290 Notre-Dame St. E., *Montreal*, Que. p, wc, cr, f 5

MONTREAL MUSEUM OF FINE ARTS, 1379 Sherbrooke St. West, 109., *Montreal*, Que. V 3

MUSÉE D'ART CONTEMPORAIN, Cité du Havre, 103., *Montreal*, Que. CCa; Eu; Am 3

SIR GEORGE WILLIAMS UNIVERSITY COLLECTION OF ART, 1435 Maisonneuve Blvd., 107., *Montreal*, Que. Cap, pr, sc & mix 3

MUSÉE DU QUEBEC, Battlefields Park, 4., *Quebec*, Que. Lp, sc & f 3

MUSÉE DU SEMINAIRE DE QUEBEC, 6., rue de l'Université, *Quebec*, Que. Ca & Eup

CENTRE CULTUREL DE L'UNIVERSITÉ DE SHERBROOKE, (University of Sherbrooke Cultural Center) Cité Universitaire, *Sherbrooke*, Que. Capr, p, & sc 3

SASKATCHEWAN

NORMAN MACKENZIE ART GALLERY, University of Saskatchewan, Regina Campus, *Regina*, Sask. p; EuOd; sc 5

REGINA PUBLIC LIBRARY, 2311 12th Ave., *Regina*, Sask. V

MENDEL ART GALLERY AND CIVIC CONSERVATORY, 950 Spadina Crescent E., *Saskatoon*, Sask. Ca & Eup, sc & pr; Esk 3

180

Selected List of
ART MUSEUMS IN EUROPE

Arranged Alphabetically by Country

ALBANIA

ARCHAELOGICAL MUSEUM, *Tirana,* Alb. Gr & RoAn

AUSTRIA

NEUE GALERIE DER STADT LINZ (New City Gallery)
Hauptplatz 8, *Linz,* Aus. Eu 5

SALZBURGER MUSEUM CAROLINO-AUGUSTEUM (Salzburg
Museum) Museumsplatz 6. Postfach 525, A-5010, *Salzburg,*
Aus. M.A., B; C

**GEMÄLDEGALERIE DER AKADEMIE DER BILDENDEN
KÜNSTE** (Art Gallery of the Academy of Fine Arts) A1010
Schillerplatz 3, 1 *Vienna,* Aus. V, Eup 5

GRAPHISCHE SAMMLUNG ALBERTINA (Albertina Graphic
Art Collection) Augustinerstrasse 1 *Vienna,* Aus. d, wa, pr 4

KUNSTHISTORISCHES MUSEUM (Museum of Fine Arts) 1
Burgring 5, *Vienna,* Aus. V, Eg & Or

**KUPFERSTICHKABINETT DER AKADEMIE DER BILDENDEN
KÜNSTE** (Graphic Art Collection of the Academy of Fine Arts)
Vienna I, Schillerplatz 3, Aus. d, pr, ph

MUSEUM DES 20. JAHRHUNDERTS (Museum of the 20th
Century) *Vienna* III, Schweizergarten, Aus. C

ÖSTERREICHISCHE GALERIE (Austrian Gallery) Prinz
Eugen-Str. 27, Oberes Belvedere, A 1030, *Vienna,* Aus. Aus 3

BELGIUM

KONINKLIJK MUSEUM VOOR SCHONE KUNSTEN (Royal
Museum of Fine Arts) Plaatsnijdersstraat 2, *Antwerp,* Bel. EuO,
Fl 4

MUSEUM MAYER VAN DEN BERGH (Mayor van den Bergh
Museum) Lange Gasthuisstraat 19, 2000, *Antwerp,* Bel. An

MUSEUM PLANTIN-MORETUS (Plantin-Moretus Museum)
Vrijdagmarkt 22, *Antwerp,* Bel. Bel pr

OPENLUCHTMUSEUM VOOR BEELDHOUWKUNST (MIDDELHEIM) (Open air Museum for Sculpture Middelheim) Middelheimlaan 61, 2020, *Antwerp*, Bel. Csc

STEDELIJK PRENTENKABINET (Municipal Gallery of Graphic Arts) Vrijdagmarkt 23, *Antwerp*, Bel. d, p

GROENINGEMUSEUM (City Gallery of Art) Dyver, 12, *Bruges*, Bel. EuO 4

MEMLING MUSEUM, St. John's Hospital, Mariastraat 38, *Bruges*, Bel. p

MUSÉES COMMUNAUX BEAUX-ARTS (Community Museum: Fine Arts) rue Renier, 17, *Brussels*, Bel. V

MUSÉES ROYAUX D'ART ET D'HISTOIRE (Royal Museums of Art & History) 10 Parc du Cinquantenaire, 1040, *Brussels*, Bel. V 4

MUSÉES ROYAUX DES BEAUX-ARTS DE BELGIQUE (Royal Museums of Fine Arts of Belgium) rue du Musée 9, *Brussels*, Bel. p, d, sc

　Musée d'Art Ancien, rue de la Regence 3 p, d, sc
　Musée d'Art Moderne, place Royale 1 Cp, d & sc
　Musée Wiertz, rue Vautier 62 p

MUSÉE DES BEAUX-ARTS, Citadelpark, *Ghent*, Bel. An&Cp, sc, d&pr

MUSÉES D'ARCHEOLOGIE ET D'ARTS DECORATIFS (Liege Museum of Archeology and Decorative Arts) 13, Quai de Maastricht, *Liege*, Bel. dec, gl

BULGARIA

NATIONAL ART GALLERY, *Sofia*, 6 Moskowska St., Bul. Eu

CYPRUS

CYPRUS MUSEUM, Museum Ave., *Nicosia*, Cyp. ce, sc, br

CZECHOSLOVAKIA

SLOVENSKÁ NÁRODNÁ GALÉRIA (National Gallery Slovakian) Rázusovo nábr. 2, *Bratislava*, Czech. Czech; Eu; In

STÁTNÍ ZIDOVSKÉ MUSEUM (State Jewish Museum) Jáchymova 3, *Prague*, Czech. Je 3

DENMARK

NORDJYLLANDS KUNSTMUSEUM (North Jutland Art Museum and Art Documentation Center) 50 Kong Christians Allé, *Aalborg*, Den. CDanp, sc&pr

182

AARHUS KUNSTMUSEUM (Aarhus Art Museum) Vennelyst-parken, Dr 8000, *Aarhus*, Den. Dan; Eupr 4

NY CARLSBERG GLYPTOTHEK (The Carlsberg Gallery) Dantes Plads, 1556, *Copenhagen*, Den. Eg & Grsc; Dan & Frp & sc 3

DET DANSKE KUNSTINDUSTRIMUSEUM (Museum of Decorative Art) Bredgade 68, 1260, *Copenhagen*, Den. Eudec; f; Ch & Ja

LOUISIANA, Gl. Strandvej 13, 3050 Humlebaek, *Copenhagen*, Den. C

STATENS MUSEUM FOR KUNST (The Royal Museum of Fine Arts) Sølvgade, DK-1307 *Copenhagen*, Den. Danp≻CFr; EuO

THORVALDSENS MUSEUM, Porthusgade 2, 1213 *Copenhagen* K, Den. Dansc&d; CEup, d≺ An

SILKEBORG KUNSTMUSEUM, Hostrupsgade, *Silkeborg*, Den. CDanp&sc

FINLAND

TURUN TAIDEMUSEO (Turku Art Association and Museum) Puolalanpuisto, *Turku*, Fin. CFin; pr 5

FRANCE

MUSÉE GRANET, place St. Jean de Malte, *Aix-en-Provence*, Fr. CEup, sc, f

MUSÉE DES BEAUX-ARTS, place de la Sainte-Chapelle, *Dijon* (Côte-d'Or) Fr. Swiss; Fr; pr, sc, d

MUSÉE DES BEAUX ARTS, PALAIS ST. PIERRE (Museum of Fine Arts) 20 place des Terreaux, 69, 1er, *Lyons*, Fr. V

MUSÉE DES BEAUX-ARTS, Palais de Longchamp, *Marseille* (Bouches-du-Rhône) Fr. p, murals, dr, sc, pr

MUSÉE COGNACQ-JAY (Cognacq-Jay Museum) 25 Boulevard des Capucines, 2 ème, 75, *Paris*, Fr. p, d, f, ce sc, ph

MUSÉE DES ARTS DÉCORATIFS, Palais du Pavillon Louvre, de Marsan, 107 rue de Rivoli, *Paris* 1er, Fr. f, ce, sc, p, gl, W, Or

MUSÉE D'ART MODERNE DE LA VILLE DE PARIS (Museum of Modern Art) 8 rue de la Manutention, 16, *Paris*, Fr. Cp & sc

MUSÉE DE CLUNY (Cluny Museum) 6 Place Paul Painlevé (V), *Paris*, Fr. M.A.

MUSÉE DE L'OEUVRE NOTRE DAME (Cathedral Museum) 3 Place du Château, *Paris*, Fr. V

MUSÉE DES BEAUX-ARTS (Museum of Fine Arts) 2 Place du Château, *Paris*, Fr. p; EuO; Im; C

MUSÉE DU JEU DE PAUME (Gallery of Impressionists) Place de la Concorde, *Paris*, Fr. V 1

MUSÉE DU LOUVRE (The Louvre Museum) Palais du Louvre, *Paris*, Fr. V 1

MUSÉE GUIMET (Asiatic Dept. of Musée du Louvre) 6 place d'Iéna, *Paris* 16e, Fr. Ch, In, Ja

MUSÉE NATIONAL DES MONUMENTS FRANCAIS (National Museum of French Sculpture) Palais de Chaillot, 16, *Paris*, Fr. sc, ph, murals

MUSÉE NATIONAL DU CHATEAU DE FONTAINEBLEAU (National Museum of Fontainebleau) 77 Fontainebleau, *Paris*, Fr. f, ph

MUSÉE DU PETIT PALAIS (Municipal Museum) Av. Alexandre III, *Paris*, Fr. V

MUSÉE RODIN, Hôtel Biron, 77 rue de Varenne, *Paris* 7e, Fr. sc, d

MUSÉE SAINT-REMI, 53 rue Simon, *Rheims* (Marne) Fr. Ro&GoAn &sc

FONDATION MAEGHT, *St.-Paul-de-Vence*, Fr. Cp & sc

MUSÉE DES BEAUX-ARTS, place Francois-Sicard, *Tours* (Indre-et-Loire) Fr. Eup≻ f

GERMANY – FEDERAL REPUBLIC OF GERMANY

STAATLICHE MUSEEN PREUSSISCHER KULTURBESITZ (State Museum, Institute of Prussian Culture) Stauffenbergstr. 41, 30, *Berlin*, Ger. V 2

Collections in Dahlem (1 Berlin 33, Arnimallee 23/27) EuO; se, pr

MUSEUM STÄDTISCHE KUNSTSAMMLUNGEN BONN (Bonn Art Collection) Rathausgasse 7, 53, *Bonn*, Ger. C; pr

KUNSTHALLE BREMEN (Bremen Art Association Gallery) 28 Bremen, Am Wall 207, *Bremen*, Ger. Eup; d, pr

KUNSTGEWERBEMUSEUM (Arts and Crafts Museum) Eigelsteintorburg, *Cologne*, Ger. cr 5

KUNSTHALLE KÖLN (Cologne Art Gallery) Josef-Haubrich-Hof 1., *Cologne*, Ger. V 3

MUSEUM FUR OSTASIATISCHE KUNST (East Asian Art) Kattenbug 18-24, *Cologne*, Ger. Ea 5

RAUTENSTRAUCH-JOEST MUSEUM, Ubierring 45, *Cologne,* Ger. Eu 4

RÖMISCH-GERMANISCHES MUSEUM, Roncalliplatz, *Cologne,* Ger. Ro 3

SCHNÜTGEN MUSEUM, Cäcilienstrasse 29 (Cäcilienkirche) *Cologne*, Ger. r

WALLRAF-RICHARTZ MUSEUM, An der Rechtschule, *Cologne*, Ger. p, sc, pr 3

MUSEUM FOLKWANG, Bismarckstr. 64, *Essen*, Ger. C

STAEDELSCHES KUNSTINSTITUT, Schaumainkai 63, *Frankfurt*, Ger. Csc; Eup, d & pr 4

HAMBURGER KUNSTHALLE (Hamburg Hall of Arts) Glockengiesserwall, *Hamburg*, Ger. Eup & sc 3

STAATLICHE KUNSTHALLE, Hans-Thoma-Strasse 2, *Karlsruhe*, Ger. Eup&pr

STAATLICHE KUNSTSAMMLUNGEN KASSEL (Federal Collection of Art) Brüder-Grimm-Platz 5, *Kassel*, Ger. Gr&Ro; p, pr, sc, cr

ALTE PINAKOTHEK (Old Picture Gallery) Barerstrasse 27, *Munich*, Ger.　EuO

BAYERISCHES NATIONALMUSEUM (Bavarian National Museum) Prinzregentenstrasse 3, *Munich*, Ger. br, ce, gl; L

NEUE PINAKOTHEK AND NEUE STAATSGALERIE (New Picture Gallery) Prinzregenstrasse 1, *Munich*, Ger. C

SCHACKGALERIE, Prinzregentenstrasse 9, *Munich*, Ger. Ger

STÄDTISCHE GALERIE IM LENBACHHAUS, Luisenstr 33, *Munich*, Ger. CEu

GERMANISCHES NATIONAL MUSEUM (Germanic National Museum) Kartausergasse 1, *Nuremberg*, Ger. p, pr, sc, f 3

GERMAN DEMOCRATIC REPUBLIC

NATIONAL-GALERIE, 102, Bodestrasse 1/**3**, *Berlin*, Ger. p&d

GEMÄLDEGALERIE ALTE MEISTER, 801 Dresden, Semperbau Zwinger, *Dresden*, Ger. EuO

GEMÄLDEGALERIE NEUE MEISTER, 801 Dresden, Georg-Treu-Platz Albertinum, *Dresden*, Ger. Eu

KUPFERSTICHKABINETT, 8019 *Dresden*, Güntzstrasse 34, Ger.

SKULPTURENSAMMLUNG, 801 Dresden, Georg-Treu-Platz 2, *Dresden*, Ger. sc

MUSEUM DER BILDENDEN KÜNSTE, 701 *Leipzig*, Georgi-Dimitroff-Platz 1, Ger. p&sc

GREAT BRITAIN

AMERICAN MUSEUM IN BRITAIN, Claverton Manor, *Bath*, Eng. Amdec 4

BIRMINGHAM CITY MUSEUM AND ART GALLERY, Gongreve St., *Birmingham*, B3 3DH, Eng. V

BRIGHTON ART GALLERY AND MUSEUM, Church St., *Brighton*, Sussex, Eng. p, wa, pr&d

CITY ART GALLERY, Queen's Rd., BS8 IRL., *Bristol*, Eng. V

BRITISH MUSEUM, Great Russell St., WCIB 3DG, *London*, Eng. V 1

COURTAULD INSTITUTE GALLERIES, University of London, Woburn Square, *London*, W.C.1, Eng. EuO; Im; d

FITZWILLIAM MUSEUM, Trumpington St. 2 1RB, *London*, Eng. V 4

NATIONAL GALLERY, Trafalgar Square, W.C.2, *London*, Eng. Eup 1

THE TATE GALLERY, Millbank, S.W. 1, *London*, Eng. En & Eup; Csc 2

VICTORIA AND ALBERT MUSEUM, Cromwell Road, S.W. 7, *London*, Eng. V 1

THE WALLACE COLLECTION, Manchester Square W.1., *London*, Eng. V, EuO 3

UNIVERSITY OF MANCHESTER, Whitworth Art Gallery, Whitworth Park, m15 6ER., *Manchester*, Eng. Enwa & d; EuO; Japr; C

ASHMOLEAN MUSEUM, *Oxford*, Eng. V

CITY MUSEUM AND ART GALLERY, Drake Circus, *Plymouth*, Eng. V 3

SHEFFIELD CITY ART GALLERIES, Surrey St., S1, IXZ, *Sheffield*, Eng. V 3

SCOTLAND

THE ROYAL SCOTTISH MUSEUM, Chambers St., EH1, 1 JF, *Edinburgh*, Scot. dec 2

NATIONAL GALLERY OF SCOTLAND, The Mound, *Edinburgh*, EH2 2EL, Scot. Eup, d&pr

GLASGOW ART GALLERIES AND MUSEUM, Kelvingrove, *Glasgow*, Scot. EuO; En; CFr; sc, ce, f

WALES

NATIONAL MUSEUM OF WALES, Cathays Park, *Cardiff*, Wales We; Fr 3

WELSH FOLK MUSEUM, near Cardiff, *St. Fagans*, Wales Lcr 3

GREECE

ACROPOLIS OF ATHENS AND ACROPOLIS MUSEUM, *Athens*, Grc. Grsc

BENAKI MUSEUM, I odos Koumbari, *Athens*, Grc. V

BYZANTINE MUSEUM, Hotel de la Duchesse de Plaisance, Leoforos Vasilissis Sophias 22, *Athens*, Grc. B

NATIONAL ARCHEOLOGICAL MUSEUM, Odos Patission 144, *Athens*, Grc. Gr & RoAn

ARCHAEOLOGICAL MUSEUM, *Olympia*, Grc. Grbr & sc

ARCHAEOLOGICAL MUSEUM, *Delphi*, Grc. An

ARCHAEOLOGICAL MUSEUM, Herakleion, *Crete*, Grc. An

HUNGARY

MAGYAR NEMZETI GALERIA (Hungarian National Gallery) Kossuth Lajos tér 12, 5, *Budapest*, Hung. Hungp, sc & pr 2

ICELAND

LISTASAIN EINARS JÓNSSONAR (The Einar Jónsson Art Gallery) *Revkjavik*, Ice. sc

THJODMINJASAFN (National Museum of Iceland) Sudurgata, *Reykjavik*, Ice. V, Ice 5

IRELAND

MUNICIPAL GALLERY OF MODERN ART, Charlemont House, Parnell Square 1, *Dublin*, Ire. Cp 3

NATIONAL GALLERY OF IRELAND, Merrian Square West, 2, *Dublin*, Ire. Eu & Am 3

NATIONAL MUSEUM OF IRELAND, Kildare St., *Dublin*, Ire. V

ITALY

GALLERIA DEGLI UFFIZI (Uffizi Gallery) Piazzale Uffizi, *Florence*, It. Rp & sc; d 1

GALLERIA PALATINA, PALAZZO PITTI, MUSEI (Palatine Gallery) Piazza Pitti, n.1., 50125 *Florence*, It. V 1

GALLERIA DI PALAZZO BIANCO (White Palace Gallery) via Garibaldi 11, *Genoa*, It. L & F1p & sc

MUSEO NAZIONALE DI VILLA GUINIGI, via della Quarquonia, *Lucca*, It. L; EuO; sc

MUSEO D'ARTE ANTICA (Museum of Ancient Art) Castello Sforzesco, *Milan*, It. V

MUSEO POLDI PEZZOLI (Poldi Pezzoli Museum) Via Manzoni, 12, 20120 *Milan*, It. V

PINACOTECA DE BRERA (Brera Picture Gallery) Via Brera 28, *Milan*, It. p & d 3

MUSEO E GALLERIE NAZIONALI DI CAPODIMONTE (Mt. Capodi National Museum & Gallery) Palazzo di Capodimonte, *Naples*, It. V 4

MUSEO NAZIONALE (National Museum) *Naples*, It. An; br; mo; murals

GALLERIA NAZIONALE DELL'UMBRIA (Umbrian National Gallery) Palazzo Dei Priori, Corso Vannucci, *Perugia*, It. V, R 5

MUSEO NAZIONALE E MUSEO CIVICO DI SAN MATTEO (St. Matteo National Museum) Piazza S. Matteo in Soarta, *Pisa*, It. EuO; sc, illmss, pr, ph

CAPITOLINE MUSEUM AND PALAZZO DEI CONSERVATORI (Museum of Sculpture) *Rome*, It. Ansc; p; ce; br 3

GALLERIA DORIA PAMPHILJ (Dorian Gallery) Piazza del Collegio Romano 1/A 00186, *Rome*, It. It

GALLERIA NAZIONALE D'ARTE ANTICA (Gallery Corsini) 10 Via della Lungara, *Rome*, It. It

MUSEO GALLERIA BORGHESE (Borghese Gallery) Villa Borghese, 00197 *Rome*, It. Itp & sc

MUSEO ARCHEOLOGICO NAZIONALE, Piazza del Duomo 14, *Syracuse*, It. Gr & RoAn

CIVICO MUSEO REVOLTELLA-GALLERIA D'ARTE MODER-NA (Revoltella Civic Museum-Gallery of Modern Art) *Trieste,* It. Itp & sc, Eu

MUSEI E GALLERIE PONTIFICIE (Vatican Museums and Galeries) *Vatican City*, It. V 1

MUSEO DI CASTELVECCHIO, Corse Cavour, *Verona*, It. ItR & B

MUSEO CIVICO, Palazzo Chiericati, *Vicenza*, It. ItR & B

LUXEMBOURG

 MUSÉES DE L'ETAT (State Museum), Marché aux Poissons, Luxembourg

NETHERLANDS

 STEDELIJK MUSEUM ALKMAAR (Alkmaar Municipal Museum) Doelenstraat 3, *Alkmaar*, Neth. L

 RIJKSMUSEUM (State Museum) Stadhouderskade 42, *Amsterdam*, Neth. V, Du 2

RIJKSMUSEUM VINCENT VAN GOGH (Vincent van Gogh National Museum) Honthorststraat 16, *Amsterdam*, Neth. p, dr; En&Japr

STEDELIKJ MUSEUM (Municipal Museum) Paulus Potterstraat 13, *Amsterdam*, Neth. C; Im; Exp; pr, ph, sc 3

MUNICIPAL VAN ABBEMUSEUM (Eindhoven Municipal Museum) Bilderdijklaan 10, *Eindhoven*, Neth. C 4

GRONINGER MUSEUM VOOR STAD EN LANDE (Groningen Museum) Praediniussingel 59, *Groningen*, Neth. Or & Euce; Dup & d 5

FRANS HALS MUSEUM, Groot Heiligland 62, *Haarlem*, Neth. V, Du 4

KUNSTVERSAMELINGEN (Teylers Museum) 21 Damstraat, *Haarlem*, Neth. It, Du & Frd; Cp

GEMEENTEMUSEUM (Municipal Museum of the Hague) Stadhouderslaan 41, *The Hague*, Neth. V 3

KENINKLIJK KABINET VAN SCHILDERIJEN (MAURITSHUIS) (Royal Picture Gallery) Korte Vijverberg 8, *The Hague*, Neth. Du & Fl

MUSEUM BREDIUS, Prinsegracht 6, *The Hague*, Neth. Dup & d 6

STEDELIJK MUSEUM DE LAKENHAL (Leyden Municipal Museum) Oude Singel 28-32, *Leyden*, Neth. Lp & sc 5

RIJKSMUSEUM KROLLER-MULLER (Kroller-Muller State Museum) National Park, *Otterlo*, Neth. Eup & sc

MUSEUM BOYMANS-VAN BEUNINGEN, Mathenesserlaan 18, *Rotterdam*, Neth. V 3

NORWAY

VESTLANDSKE KUNSTINDUSTRIMUSEUM (Western Norway Museum of Applied Art) Nordal Brunsgate 9, 5000, *Bergen*, Nor. V, No 5

NASJONALGALLERIET (National Gallery) Universitetsgaten 13, *Oslo*, Nor. V, Nop & sc

NORSK FOLKEMUSEUM (Norwegian Folk Museum) Bygdöy, 2, *Oslo*, Nor. V 3

NORSK SJOFARTSMUSEUM (Norwegian Maritime Museum) Bygdöy-Oslo (2), *Oslo*, Nor. m 5

UNIVERSITETETS OLDSAKSAMLING (University Museum of National Antiquities) Fredriks Gate 2, 1, *Oslo*, Nor. An

GALERIA POLSKIEGO MARLARSTWA (Gallery of Polish Painting and Sculpture of the 14th-18th Centuries) i.Rzezby od 14 do 18 wieku, pl. Szczepanski 9, Kamienica Szolayskich, *Cracow*, Pol. Pop & sc

GALERIA MALARSTWA POLSKIEGO w. XIX (Gallery of Polish Painting and Sculpture of the 19th Century) Rynek Glówny, Sukiennice, *Cracow*, Pol. Pop

GALERIA SZTUKI POLSKIEJ w.XX (Gallery of Polish Painting and Sculpture of the 20th Century) al. Trzeciego Maja 1, *Cracow*, Pol. CPop & sc

ZBIORY CZARTORYSKICH (The Czartoryski Collection) ul. Pijarska 15, *Cracow*, Pol. V

PANSTWOWE ZBIORY SZTUKI NA WAWELU (State Collections of Art in the Wawel) Wawel 5, *Cracow*, Pol. V, Po

NATIONAL MUSEUM, Al. Marcinkowskiego 9, *Poznań*, Pol. V

NATIONAL MUSEUM, Al. Jerozolimskie 3, *Warsaw*, Pol. V

PORTUGAL

MUSEU NACIONAL DE ARTE ANTIGA (National Museum of Ancient Art) Largo 9 de Abril, *Lisbon*, Port. V, Port.

MUSEU NACIONAL DE ARTE CONTEMPORANEA (National Museum of Contemporary Art) Rua Serpa Pinto 6, *Lisbon*, Port. Cp & sc

ROMANIA

ARAD REGIONAL MUSEUM, *Arad*, Piata Enescu 1, Rom. Eu

ART MUSEUM OF S.R.R., *Bucharest*, Stirbei Voda 1, Rom. V

ELENA AND DR. L. N. DONA COLLECTION, *Bucharest*, Str. General Dona 12, Rom. Eu

CLUJ ART MUSEUM, *Cluj*, 30 Piata Libertătii, Rom. Eu

BRUCKENTHAL MUSEUM, *Sibiu*, Piata Republicii 4, Rom. Eu

SPAIN

MUSEO DE ARTE CATALUNA (Museum of Ancient Art) Palacio Nacional, Parque de Montjuich, *Barcelona*, Sp. Gop & sc, R & Bp

MUSEO DE ARTE MODERNO (Museum of Modern Art) Palacio de la Ciudadela, *Barcelona*, Sp. C

MUSEO NACIONAL DEL PRADO (National Museum of Paintings and Sculpture) Calle de Felipe IV, *Madrid*, Sp. V

MUSEO ROMANTICO (Museum of the Romantic Epoch) San
Mateo 13 (4), *Madrid*, Sp. p, f, dec 5
CASA Y MUSEO DEL GRECO (El Greco's House & Museum)
Calle de Samuel Levi, *Toledo*, Sp. f, p 3

SWEDEN

GOTEBORGS KONTSMUSEUM (Gothenburg Art Gallery)
Götaplatsen, *Gothenburg*, Swe. Scand; EuO; Im 2
RÖHSSKA KONSTSLÖJDMUSEET (The Roehss Museum of
Arts and Crafts) Vasagatan 37-39, *Gothenburg*, Swe. V, Sw
NATIONALMUSEUM BIBLIOTEKET, *Stockholm*, Swe. V 3
NORDISKA MUSEET (Swedish Museum) Djurgarden, *Stockholm*,
Swe. Swcr & f 3
**STATENS HISTORISKA MUSEUM OCH KUNGL MYNTKABI-
NETTET** (Museum of National Antiquities and the Royal Coin
Cabinet) Storgatan 41, *Stockholm*, Swe. V 4

SWITZERLAND

**MUSEUM FÜR VÖLKERKUNDE UND SCHWEIZERISCHES
MUSEUM FÜR VOLKSKUNDE BASEL** (Museum of Ethnolo-
gical Collections and Folklore) Augustinergasse 2, *Basel*,
Switz. V 4
ÖFFENTLICHE KUNSTSAMMLUNG (Museum of Fine Arts) St.
Albangraben 16, *Basel*, Switz. Eup 3
KUNSTMUSEUM BERN (Berne Museum of Fine Arts) Hodler-
strasse 12, *Berne*, Switz. Eup
MUSEE D'ART ET D'HISTOIRE (Museum of Art and History)
rue Charles-Galland, *Geneva*, Switz. p, pr, dec
PETIT PALAIS (House of Arts) 2, Terrasse Saint-Victor, 1206,
Geneva, Switz. Cp
CASTELLO VISCONTI, *Lugano*, Switz. C
MUSEO CIVICO DI BELLE ARTI, Villa Ciani, *Lugano*, Switz. Swiss,
Fr&It
MUSEUM ZU ALLERHEILIGEN (All Saints' Museum) Kloster-
platz, *Schaffhausen*, Switz. An; Ro; Eu
KUNSTMUSEUM WINTERTHUR (Art Museum) Museumstrasse
52, CH-8400, *Winterthur*, Switz. Swissp & sc; Eup & sc 5
KUNSTHAUS ZÜRICH (Art Gallery) Heimplatz 1, *Zürich*, Switz.
Swiss & Eu 3
MUSEUM RIETBERG ZÜRICH, Gablerstrasse 15, 8002,
Zürich, Switz. Am; La; Ea 5

SCHWEIZERISCHES LANDESMUSEUM (Swiss National Museum) Museumstrasse 2, CH-8023, *Zurich*, Switz. V 3

UNION OF SOVIET SOCIALIST REPUBLICS

KIEV STATE MUSEUM OF WESTERN AND ORIENTAL ART, Ul.Repina 15, *Kiev*, Ukrainian S.S.R. V

STATE HERMITAGE MUSEUM, M. Dvortsovaya Naberezhnaya 34, *Leningrad*, USSR. V, Ea, Gr & RoAn, EuO

STATE PUSHKIN MUSEUM OF FINE ARTS, Volkhonka 12, *Moscow*, USSR. Ea, Gr & RoAn; M.A.; Eu

ODESSA STATE MUSEUM OF WESTERN AND EASTERN ART, Ul. Pushkinskaya 9, *Odessa*, Ukrainian S.S.R.

YUGOSLAVIA

NARODNI MUZEJ (National Museum) *Belgrade*, Yugo. V

NARODNA GALERIJA (National Art Gallery) Prežihova ulica 1, *Ljubljana*, Yugo. Slovp, sc & pr

ARHEOLOSKI MUZEJ (Archaeological Museum), Zrinjsko-Frankopanska 25, *Split*, Yugo. Gr & RoAn

GALERIJA MESTROVIĆ (Meštrović Gallery), Moše Pijade 44, *Split*, Yugo.

ARHEOLOSKI MUZEJ (Archaeological Museum) Zrinjski trg. 19, *Zagreb*, Yugo. An

ART MUSEUMS IN OTHER COUNTRIES

Arranged Alphabetically by Country

ALGERIA

MUSÉE NATIONAL DES ANTIQUITÉS, Parc de la Liberté, *Algiers*, Alg. An; Is

MUSÉE NATIONAL DES BEAUX ARTS D'ALGER (National Museum of Algiers) Jardin d'Essai, *Algiers*, Alg. br, d, p, pr

ARGENTINA

MUSEO NACIONAL DE ARTE DECORATIVO (National Museum of Decorative Art) Av. del Libertador 1902, *Buenos Aires*, Arg. f, sc; Eu & S. A.

MUSEO NACIONAL DE BELLAS ARTES (National Museum of Fine Arts) Avda. Libertador 1473, *Buenos Aires*, Arg. Ar; Am; Eu; Cl

MUSEO DE ARTE MODERNO, Teatro General San Martin, Corrientes 1530, *Buenos Aires*, Arg.

MUSEO DE BELLAS ARTES DE LA BOCA, Pedro Mendoza 1835, *Buenos Aires*, Arg. p, sc, gr, m

MUSEO MUNICIPAL DE BELLAS ARTES Y ARTE NACIONAL (Municipal Museum of Fine Arts and National Art) Av. Alvear 3273, *Buenos Aires*, Arg.

MUSEO MUNICIPAL DE ARTE DECORATIVO "FIRMA Y ODILO ESTEVEZ", Santa Fé 748, *Rosario*, Arg. p, gl, ce, f

MUSEO MUNICIPAL DE BELLAS ARTES JUAN B. CASTAGNINO (Municipal Museum of Fine Arts) Avda. Pellegrini, 2202 Parque Independencia, *Rosario*, Arg. Eu & Amp & sc 4

AUSTRALIA

THE ART GALLERY OF SOUTH AUSTRALIA, North Terrace, *Adelaide*, Austl. 5000 p, d, sc, pr, f, ce 3

QUEENSLAND ART GALLERY, Gregory Terrace, *Brisbane*, Austl. Austl, Eu & Ea

TASMANIAN MUSEUM AND ART GALLERY, 5 Argyle St., *Hobart*, Austl. Tas; Austl; Eu; Am

NATIONAL GALLERY OF VICTORIA, Victorian Arts Centre, 180 St. Kilda Rd., *Melbourne*, Austl. 3004 V 3

THE WESTERN AUSTRALIAN ART GALLERY, Beaufort St., *Perth*, Austl. 6000 V 4

ART GALLERY OF NEW SOUTH WALES, Art Gallery Road, Domain, *Sydney*, Austl. 2000 V, Austl 3

NICHOLSON MUSEUM OF ANTIQUITIES, Univ. of Sydney, *Sydney*, Austl. Eg, Ea, Eu; Gr&RoAn

BOLIVIA

MUSEO NACIONAL DE ARQUEOLOGIA (National Museum) Calle Tihuanacu 93 Casilla official 64, *LaPaz*, Bol. V, Lcr 6

BRAZIL

MUSEU DA INCONFIDENCIA (History of Democratic Ideals and Culture in Minas Gerais) Praca Tiracentes, *Ouro Preto*, Braz. V, wc, f, p, d

MUSEU DE ART MODERNA (Museum of Modern Art) Avenida Beira-Mar Caixa Postal ZC 00, *Rio De Janeiro*, Braz. CL, Eu & Am

MUSEU NACIONAL DE BELLAS ARTES (National Museum of Fine Arts) Av. Rio Branco 199, *Rio De Janeiro*, Braz. V

MUSEU DE ARTE (Sao Paulo Art Museum) Av. Paulista 157-8, *Sao Paulo*, Braz. Braz; EuO; CAm

CHILE

MUSEO DE ARTE CONTEMPORÁNEO (Contemporary Art Museum) Universidad de Chile, Quinta Normal, Casilla 5627, *Santiago*, Chl.

MUSEU NACIONAL DE BELLAS ARTES (National Museum of Fine Arts) Parque Forestal, *Santiago*, Chl. p, sc, pr

CHINA

IMPERIAL MUSEUM, Imperial Palace, *Peking*, Chn. Ch

SHANGHAI MUSEUM, *Shanghai*, Chn.

CANTON MUSEUM, *Canton*, Chn.

CHINGTEHCHEN CERAMICS MUSEUM, *Chingtehchen*, Chn. cr, dec

NANKING MUSEUM OF HISTORICAL ARTS, *Nanking*, Chn.

COLOMBIA

MUSEO DE ARTE COLONIAL (Museum of Colonial Art)
Carrera 6 N09-77, *Bogotá*, Col. p, sc, f; Sp

MUSEO NACIONAL (National Museum) Carrera 7a, No. 28-66,
Bogatá, Col. L, Sp

CUBA

MUSEO NACIONAL (National Museum), Palacio de Bellas Artes,
Animas entre Zulueta y Monserrate, *Havana*. Cuba. V

MUSEO NAPOLEONICO, San Miguel y Ronda, *Havana*, Cuba.
f, br, ce; Fr

DOMINICAN REPUBLIC

GALERIA NACIONAL DE BELLAS ARTES (National Fine Arts
Gallery) *Santo Domingo*, Dom. Rep. p, sc

MUSEO NACIONAL (National Museum) Centro de los Héroes,
Santo Domingo, Dom. Rep. pC; Cp, d&ph

ECUADOR

MUSEO DE ARTE E HISTORIA DE LA CIUDAD (Civic Museum
of Arts and History) Calle Espejo 1147, Apdo. 399, *Quito*, Ec.
p, sc

MUSEO NACIONAL DE ARTE COLONIAL, Calles Cuenca 915 y
Mejfa, *Quinto*, Ec. L, C

EGYPT

GRECO-ROMAN MUSEUM, Museum St., *Alexandria*, Eg. Co; Ro; Gr

ANDERSON MUSEUM, Beit el-Kretlia, *Cairo*, Eg. Or

COPTIC MUSEUM, St. George St., Old Cairo, *Cairo*, Eg. sc, ce, gl

EGYPTIAN NATIONAL MUSEUM, Midan-el-Tahrir, Kasr El-Nil,
Cairo, Eg. An

MUSEUM OF ISLAMIC ART, Ahmed Maher, *Cairo*, Eg. Is

MUSEUM OF MODERN ART, 4 Sharia Kasr El-Nil, *Cairo*, Eg.

ETHIOPA

MUSÉE ARCHEOLOGIQUE, Institut Ethiopien d'Archéologie,
Addis Ababa, Eth.

MUSEUM OF THE INSTITUTE OF ETHIOPIAN STUDIES,
Haille Sellassie 1 University, *Addis Ababa*, Eth. p, ce, coins

GHANA

GHANA NATIONAL MUSEUM, Barnes Road, P.O. Box 3343,
Accra, Ghana. Afr, CL

195

GUATEMALA

MUSEO DE SANTIAGO, Portal Municipal, Plaza Mayor de Antigua, *Antigua*, Guat. Sp, f

MUSEO NACIONAL DE HISTORIA Y BELLAS ARTES (National Museum of History and Fine Arts) Edificio No. 6, Parque Nacional La Aurora, *Guatemala City*, Guat. p, sc, pr, f

MUSEO NACIONAL DE ARQUEOLOGIA Y ETNOLOGIA DE GUATEMALA (Archaeological and Ethnographical Museum) Edificio No. 5, La Aurora, Zona 13, *Guatemala City*, Guat. pC

HONG KONG

CITY HALL MUSEUM AND ART GALLERY, Edinburgh Place, Hong Kong. Chp, pr &d; L

INDIA

ARCHAEOLOGICAL MUSEUM, Nagarjunakonda, *Andhra Pradesh*, India. An; Budsc

MUSEUM AND PICTURE GALLERY, Sayaji Park, 5, *Baroda*, India V 2

THE INDIAN MUSEUM, 27 Jawaharlal Nehru Road, 13, *Calcutta*, India V 1

MAHARAJA OF JAIPUR MUSEUM, City Palace, *Jaipur Rajasthan*, India. ill mss

GOVERNMENT MUSEUM, Pantheon Rd., Egmore, *Madras*, India. In; Budsc

NATIONAL GALLERY OF MODERN ART (Jaipur House) Dr. Zakir Husain Rd., 11, *New Delhi*, India CInp, sc & pr 5

NATIONAL MUSEUM OF INDIA, Janpath, *New Delhi*, India V 3

ISRAEL

MUSEUM OF ANCIENT ART, Municipal Building, *Haifa*, Isr. Gr & Rosc; Co; Bibl

MUSEUM OF MODERN ART, Haifa Municipality, *Haifa*, Isr. Isr; CEup; pr

BEZALEL NATIONAL ART MUSEUM, Hakirya, *Jerusalem*, Isr. Je

ISRAEL MUSEUM, *Jerusalem*, Isr. V

The Israel Museum includes:

1. The Samuel Bronfman Biblical and Archaeological Museum.
2. The Bezalel National Art Museum.
3. The Billy Rose Art Garden. Csc

196

4. The Shrine of the Book which houses the Dead Sea Scrolls.

MUSEION HA'ARETZ (Ha'aretz Museum) Museum Center, near Ramat Aviv., *Tel-Aviv*, Isr. V, Angl, ce, Je 3

TEL AVIV MUSEUM, Dizengoff House, 16, Blvd. Rothschild, *Tel-Aviv*, Isr. V, Eu & Amp

JAPAN

KYOTO KOKURITSU HAKUBUTSUKAN (Kyoto National Museum) Higashiyama Shichi-cho, Higashiyama-ku, *Kyoto*, Jap. V

KYOTO-SHI BIJUTSUKAN (Kyoto Municipal Museum of Art) Okazaki Park, Sakyo-ku, *Kyoto*, Jap. CJap p, sc & dec

KOBE MUNICIPAL NANBAN ART MUSEUM, *Kobe*, Jap. Ja; Eu

NARA KOKURITSU HAKUBUTSUKAN (Nara National Museum) Noborioji-cho 50, Nara Park, *Nara*, Jap. Bud

OSAKA MUNICIPAL MUSEUM OF FINE ARTS, Tennoji Park, Chausuyama, Tennoji-ku, *Osaka*, Jap.

BRIDGESTONE MUSEUM OF ART, 1-1, Kyobashi, Chuoku, *Tokyo*, Jap. V 4

NEZU ART MUSEUM, 6-5-36 Minami-aoyama, Minato-ku, *Tokyo*, Jap. p, ca, sc, ce

NIPPON MINGEI-KAN (Japanese Folk-craft Art Museum) 861 Komaba-machi, Meguro-ku, *Tokyo*, Jap. cr

TOKYO KOKURITSU HAKUBUTSUKAN (Tokyo National Museum) Ueno Park, Daito-ku, *Tokyo*, Jap. V, Ea

TOKYO KOKURITSU KINDAI BIJUTSUKAN (The National Museum of Modern Art, Tokyo) 3 Kitanomaru-koen, Chiyoda-ku, *Tokyo*, Jap. CJa, Eu & Am 3

TOKYOTO-BIJUTSUKAN (Tokyo Metropolitan Museum of Arts) Ueno-Park, Taito-ku, 110, *Tokyo*, Jap. Jap & ca; Wp & sc 1

KENYA

STONEHAM MUSEUM AND RESEARCH CENTRE, P.O. *Kitale*, Kenya. V, Afr

LEBANON

ARCHAEOLOGICAL MUSEUM, American University of Beirut, *Beirut*, Leb. ce, br, coins 6

MUSÉE NATIONAL (National Museum of Lebanon) rue de Damas, *Beirut*, Leb. An, Ro & Bymo

ARCHAEOLOGICAL MUSEUM, Castello, *Tripoli*, Libya.
Gr & RoAn
LEPTIS MAGNA MUSEUM OF ANTIQUITIES, *Homs*, Libya.
Gr & RoAn

MEXICO

MUSEO DEL ESTADO (National Museum) *Guadalajara*, Mex. Me
MUSEO DE ARTE MODERNO (Museum of Modern Art) Bosque
de Chapultepec, *Mexico City*, Mex. C
MUSEO NACIONAL DE ARTES E INDUSTRIAS POPULARES
(National Museum of Industrial Arts) *Mexico City*, Mex. Mecr
& ce
MUSEO NACIONAL DE HISTORIA (National Historical Muse-
um) Castillo de Chapultepec, *Mexico City*, Mex. Me & Euce &
mo; p, sc, r

NEW ZEALAND

AUCKLAND CITY ART GALLERY, Kitchener St., *Auckland* 1,
N.Z. Eup, sc, pr&d
DUNEDIN PUBLIC ART GALLERY, Logan Park, *Dunedin*, N.Z.
V 5
SARJEANT ART GALLERY, *Wanganui*, N.Z. EuO, En, L
NATIONAL ART GALLERY OF NEW ZEALAND, Buckle St.,
Wellington, N.Z. V 3

NIGERIA

NATIONAL MUSEUM, Onikan Rd., *Lagos*, Nig. V

PAKISTAN

NATIONAL MUSEUM OF PAKISTAN, Frere Hall, *Karachi*, Pak.
V, An 1
LAHORE MUSEUM, *Lahore*, Pak. Gr-Budsc
PESHAWAR MUSEUM, Grand Trunk Rd., *Peshawar*, Pak. Budsc
ARCHAEOLOGICAL MUSEUM, TAXILA, District, Rawalpindi,
Taxila, Pak. Budsc, An 5

PERU

MUSEO DE ARTE (Museum of Art) Paseo Colon 125, *Lima*,
Peru. Per
MUSEO DE LA CULTURA PERUANA (National Museum of Peru-
vian Culture) Avenida Alfonso Ugarte 650, *Lima*, Peru. V

RHODESIA

RHODES NATIONAL GALLERY (The National Gallery of Rhodesia) 20 Kings Crescent, *Salisbury*, S. Rh. Eu & Afrp & sc

REPUBLIC OF SOUTH AFRICA

MICHAELIS COLLECTION, Old Town House, Greenmarket Square, *Capetown*, Rep. S. Afr. Du & Flp; pr 5

SOUTH AFRICAN NATIONAL GALLERY, Government Avenue, *Capetown*, Rep. S. Afr. S. Afr & Eup & pr; Eusc 4

DURBAN ART GALLERY, City Hall, Smith St. *Durban*, Rep. S. Afr. V, Afr 3

JOHANNESBURG ART GALLERY, Joubert Park, *Johannesburg*, Rep. S. Afr. V 4

TATHAM ART GALLERY, City Hall, *Pietermaritzburg, Natal,* Rep. S. Afr. En & Frp & pr 6

MUNICIPAL ART GALLERY, Arcadia Park, *Pretoria*, Rep. S. Afr. L;Cpr

PRETORIA ART MUSEUM, *Pretoria, Transvaal*, Rep. S. Afr. S. Afr & Dup, pr & sc

SINGAPORE

ART MUSEUM AND EXHIBITION GALLERY, University of Singapore, *Singapore* 10 Ea;Chce, p≻ CIn

SYRIA

NATIONAL MUSEUM, Syrian University St. (4), *Damascus*, Syr. Or; Gr; Ro; By; Is; C

TAIWAN

NATIONAL MUSEUM OF HISTORY (National Art Gallery) 49 Nan Hal Road, *Taipei*, Taiwan. L;An

NATIONAL PALACE MUSEUM, Shi-lin, *Taipei*, Taiwan. Chca, p, br&sc

TANZANIA

NATIONAL MUSEUM OF TANZANIA, THE, *Dar es Salaam, Tan.* An

TUNISIA

MUSÉE NATIONAL DU BARDO (Bardo National Museum) *Le Bardo*, Tun. Gr & RoAn; Is

TURKEY

ARKEOLOJI MUZELERI MUDURLUGU (Archaeological
Museums of Istanbul) Sultanahmet, *Istanbul*, Tur. Gr & RoAn; Is
MUSEUM OF TURKISH AND ISLAMIC ART, Suleymaniye,
Istanbul, Tur. Tur; Is; illmss
TOPKAUP PALACE MUSEUM, *Istanbul*, Tur. Tur

URUGUAY

MUSEO MUNICIPAL DE BELLAS ARTES, Ave. Millan 4015,
Montevideo, Ur. p, d, sc, wc
MUSEO NACIONAL DE BELLAS ARTES (National Museum of
Fine Arts) Paraque Rodó, Casilla 271, *Montevideo*, Ur. p

VENEZUELA

MUSEO DE BELLAS ARTES, Los Caobos, *Caracas*, Ven. V 3

VIETNAM

FINE ARTS MUSEUM, *Hanoi*, Viet.

Reading List

The titles listed represent only a small fraction of the vast literature in the fine arts. No attempt has been made to cover all periods evenly, but rather to select representative authors and interesting examples of the variety of art books. Many of these contain bibliographies, leading to further source materials.

The Reading List is divided in the following nine sections:
1. Artists about Art
2. Art through the Ages
3. Art Today
4. Art Theory and Interpretation
5. Art Appreciation, Materials and Techniques
6. Museums and Art Collecting
7. Exhibition Catalogs
8. Guidebooks and Reference Works
9. Art Journals

1. **ARTISTS ABOUT ART**

A representative selection of statements written by the artists themselves. In addition to these references, similar source material about other artists can be found in the bibliographies of the *Encyclopedia of World Art and Thieme/Becker's Allgemeines Lexikon der bildenden Künstler (See under Guidebooks and Reference Works).*

Cellini, Benvenuto. *Autobiography of*, Symonds, John A., Tr. N. Y. Doubleday, 1960. (paper)

Chagall, Marc. *My Life*. (Tr. from French) New York, Orion Pr., 1960.

Chipp, Hershel Browning, comp. *Theories of Modern Art; A Source Book by Artists and Critics*. Berkeley, Cal., Univ. of Cal. Pr., 1970. (paper)

Getlein, Frank and Dorothy. *The Bite of Print; Satire and Irony in Woodcuts, Engravings, Etchings, Lithographs and Serigraphs*. N. Y., Bramhall House, 1963.

Herbert, Robert L., ed. *Modern Artists on Art*. Englewood Cliffs, N. J., Prentice Hall, 1965. (paper)

Holt, Elizabeth G., ed. *A Documentary History of Art*. 2nd ed. 2 vols. N. Y., Doubleday, 1957-58. (paper)

Holt, Elizabeth G., ed. *From Classicists to Impressionists*: *Art and Architecture in the 19th Century*. Readings. N. Y., Doubleday, 1966.

James, Philip, ed. *Henry Moore on Sculpture*. N. Y., Viking, 1966.

Klee, Paul. *The Thinking Eye*. N. Y., Wittenborn, 1961.

Kollwitz, Käthe. *Diary and Letters*. Chicago, Regnery, 1955.

Leonardo da Vinci. *The Literary Works*. J. P. Richter, ed. N. Y., Oxford Univ. Pr., 1939.

Lewis, Samella S. *Black Artist on Art*. Los Angeles, Contemporary Crafts, 1969.

Rodin, Auguste. *On Art and Artists*. Tr. from the French of Paul Gsell by Mrs. Romilly Fedden, 1958. N. Y., Dover, 1971. (paper)

Van Gogh, Vincent. *Complete Letters of*, 2nd ed., Greenwich, Conn., N. Y. Graphic, 1959.

2. ART THROUGH THE AGES

A selection of survey histories as well as monographs on periods, movements and themes. Most of these books have bibliographies.

Amaya, Mario. *Art Nouveau*. N. Y., Dutton, 1966. (paper)

Becatti, Giovanni. *The Art of Ancient Greece and Rome*: *From the Rise of Greece to the Fall of Rome*. N. Y., Abrams, 1968.

Clark, Kenneth. *Civilisation, A Personal View*. N. Y., Harper & Row, 1969.

Fleming, William. *Arts and Ideas*. 3rd ed. N. Y., Holt, Rinehart & Winston, 1968.

Francastel, P. *Medieval Painting*. N. Y., Dell, 1968. (paper)

Gombrich, E. G. *The Story of Art*. 11th ed. N. Y., Phaidon, 1966.

Hartt, Frederick. *History of Italian Renaissance Art; Painting, Sculpture, Architecture.* N. Y., Abrams, 1969.

Hauser, Arnold. *The Social History of Art.* 4 vols. N. Y., Knopf, 1965.

Hind, Arthur M. *A History of Engraving and Etching from the 15th Century to 1914.* N. Y., Crown, 1957. Dover, 1963. (paper)

Hind, Arthur M. *An Introduction to a History of Woodcut.* 2 vols. N. Y., Dover, 1935.

Jaffé, Hans L. *Nineteenth and Twentieth Century Painting.* N. Y., Dell, 1968. (paper)

Janson, H. W. *History of Art.* Englewood Cliffs, N. J., Prentice Hall, 1969.

Janson, H. W. *Library of Art History.* N. Y., Abrams, 5 vols., 3 completed.

Klingender, Francis. *Animals in Art and Thought to the End of the Middle Ages.* Cambridge, M.I.T. Pr., 1971.

Mayor, A. Hyatt. *Prints and People: A Social History of Printed Pictures.* N. Y., Metropolitan Museum of Art, Dist. by N. Y. Graphic, 1971.

Mendelowitz, Daniel M. *A History of American Art.* N. Y., Holt, Rinehart & Winston, 1971.

Miner, Dorothy E. *The Development of Medieval Illumination as Related to the Evolution of Book Design.* Baltimore, Walters Art Gallery, 1958.

Pevsner, Nicholaus. *Studies in Art, Architecture and Design.* 2 vols. N. Y., Walker, 1968.

Rewald, John. *The History of Impressionism.* Rev. ed. N. Y., Museum of Modern Art, 1961.

Shikes, Ralph E. *The Indignant Eye: The Artist as Social Critic in Prints and Drawings from the 15th Century to Picasso.* Boston, Beacon Pr., 1969.

Schmutzler, Robert. *Art Nouveau.* N. Y., Abrams, 1964.

Vasari, Giorgio. *The Lives of the Artists.* N. Y., Farrar, Straus, Giroux, 1957.

Zerner, Henri. *The School of Fontainebleau: Etchings and Engravings.* N. Y., Abrams, 1972.

3. ART TODAY

Literature concerned with twentieth century art movements and especially with the role of art in society in the U.S.A. and other countries today.

Arnason, H. H. *History of Modern Art; Painting, Sculpture, Architecture.* N. Y., Abrams, 1968.

Barrett, Cyril. *Op Art.* N. Y., Viking, 1970.

Battcock, Gregory. *Minimal Art: A Critical Anthology.* N. Y., Dutton, 1968.

Berger, John. *Art and Revolution: Ernst Neizvestny and the Role of the Artist in the U.S.S.R.* N. Y., Pantheon, 1969.

Brett, Guy. *Kinetic Art, The Language of Movement.* N. Y., Reinhold, 1968.

Burnham, Jack. *Beyond Modern Sculpture; The Effects of Science and Technology on the Sculpture of this Century.* N. Y., Braziller, 1968.

Carrieri, Raffaele. *Futurism.* Tr. by Leslie van Rensselaer White. Milan, Edizioni del Milione, 1963.

Chamot, Mary. *Russian Painting and Sculpture.* N. Y., Macmillan, 1963.

Compton, Michael. *Optical and Kinetic Art.* N. Y., Tate Gallery – Arno Pr., 1967

Doty, Robert. *Contemporary Black Artists in America.* N. Y., Dodd, Mead, 1971.

Dover, Cedric. *American Negro Art.* Greenwich, Conn., N. Y. Graphic, 1960.

Fax, Elton C. *Seventeen Black Artists.* N. Y., Dodd, Mead, 1971.

Feder, Norman. *American Indian Art.* N. Y., Abrams, 1972.

Gayle, Addison. *The Black Aesthetic.* Garden City, N. Y., Doubleday, 1971.

Grohmann, Will, and others. *New Art Around the World.* N. Y., Abrams, 1969. (paper)

Haftmann, Werner. *Painting in the Twentieth Century.* 2 vols. N. Y., Praeger, 1965. (paper)

Hammacher, A. M. *Evolution of Modern Sculpture.* N. Y., Abrams, 1969.

Hare, Richard. *The Art and Artists of Russia.* London, Methuen & Co., 1965.

Huggins, Nathan Irvin. *Harlem Renaissance.* N. Y., Oxford Univ. Pr., 1971.

Hunter, Sam. *American Art of the Twentieth Century*. N. Y., Abrams, 1972.

Jaffé, Hans L. *The Dutch Contribution to Modern Art*. Amsterdam, Muelenhoff, 1956.

Kaprow, Allan. *Assemblage, Environments, and Happenings*. N. Y., Abrams, 1968.

Kirby, Michael. *The Art of Time; Essays on the Avant-Garde*. N. Y., Dutton, 1969.

Lippard, Lucy R. *Pop Art*. London, Thames & Hudson, 1966.

McMullen, Roy. *Art, Affluence and Alienation; The Fine Arts Today*. N. Y., Mentor, 1968. (paper)

Popper, Frank. *Origins and Development of Kinetic Art*. Tr. from the French by Stephen Bann. Greenwich, Conn., N. Y. Graphic, 1968.

Rickey, George. *Constructivism: Origins and Evolution*. N. Y., Braziller, 1967.

Rose, Barbara. *American Art Since 1900*. N. Y., Praeger, 1967.

Rosenberg, Harold. *The De-definition of Art: Action Art to Pop to Earthworks*. N. Y., Horizon Pr., 1972.

Rosenblum, Robert. *Cubism and Twentieth Century Art*. N. Y., Abrams, 1966.

Sandler, Irving. *Triumph of American Painting; A History of Abstract Expressionism*. N. Y., Praeger, 1970.

Tuchman, Maurice, ed. *New York School, The First Generation; Paintings of the 1940s and 1950s*. Los Angeles, L. A. County Calif. Mus. of Art, 1965.

4. ART THEORY AND INTERPRETATION

Some representative texts of twentieth century art historians and philosophers.

Arnheim, Rudolf. *Art and Visual Perception: A Psychology of the Visual Eye*. Berkeley, Univ. of Cal. Pr., 1964.

Arnheim, Rudolf. *Visual Thinking*. Berkeley, Univ. of Cal. Pr., 1969.

Canaday, John. *Keys to Art*. N. Y., Tudor, 1962.

Collingwood, Robin G. *Principles of Art*. N. Y., Oxford Univ. Pr., 1958. (paper)

Gombrich, Ernst Hans Josef. *Art and Illusion; A Study in the Psychology of Pictorial Representation*. 2nd ed. Rev. N. Y., Pantheon, 1961. (paper)

Kahler, Erich. *The Disintegration of Form in the Arts.* N. Y., Braziller, 1968. (paper)

Kepes, Gyorgy. *Education of Vision.* N. Y., Braziller, 1965.

Kepes, Gyorgy. *The Language of Vision.* N. Y., Braziller, 1945.

Kepes, Gyorgy. *Sign, Image, Symbol.* N. Y., Braziller, 1966.

Malraux, André. *Museum Without Walls (The Voices of Silence).* Tr. from the French by Stuart Gilbert and Francis Price. N. Y., Doubleday, 1967.

Panofsky, Erwin. *Meaning in the Visual Arts.* N. Y., Doubleday, 1955.

Panofsky, Erwin. *Studies in Iconology; Humanistic Themes in the Art of the Renaissance.* N. Y., Harper Torchbooks, 1962.

Read, Sir Herbert. *The Philosophy of Modern Art.* N. Y., Horizon, 1952. (paper)

Saxl, Fritz. *Heritage of Images.* London, (Peregrine) Penguin, 1970. (paper)

Vander Leeuw, Gerardus. *Sacred and Profane Beauty: The Holy in Art.* N. Y., Holt, Rinehart and Winston, 1963.

Venturi, Lionello. *History of Art Criticism.* N. Y., Dutton, 1964. (paper)

Wölfflin, Heinrich. *Principles of Art History.* N. Y., Dover, 1963. (originally published in German in 1915)

Worringer, William. *Abstraction and Empathy.* N. Y., World, 1967. (paper)

5. ART APPRECIATION, MATERIALS and TECHNIQUES

Introductory texts on methods and media in the fine arts.

Cennini, Cennino D'Andrea. *The Craftsman's Handbook.* N. Y., Dover, 1954. (paper)

Guptill, Arthur L. *Oil Painting Step by Step.* 3rd ed. N. Y., Watson-Guptill, 1965.

Gutierréz, José and Nicholas Roukes. *Painting with Acrylics.* N. Y., Watson-Guptill, 1965.

Herberts, Kurt. *Complete Book of Artist's Techniques.* N. Y., Praeger, 1969.

Kruiningen, H. Van. *The Techniques of Graphic Art.* N. Y., Praeger, 1969.

Laning, Edward. *The Act of Drawing.* N. Y., McGraw-Hill, 1971.

Massey, R. *Formulas for Painters.* N. Y., Watson-Guptill, 1967.

Mayer, R. *The Artist's Handbook of Methods and Materials*. N. Y., Dover, 1967. (paper)

Rich, Jack C. *The Materials and Methods of Sculpture*. N. Y., Oxford Univ. Pr., 1947.

Roukes, Nicholas. *Sculpture in Plastics*. N. Y., Watson-Guptill, 1968.

Sears, Elinor L. *Pastel Painting Step by Step*. N. Y., Watson-Guptill, 1947.

Taylor, Joshua C. *Learning to Look; A Handbook for the Visual Arts*. Chicago, Univ. of Chicago Pr., 1957. (paper)

Thompson, Daniel V. *The Materials of Medieval Painting*. N. Y., Dover, 1958.

Torche, Judith, ed. *Acrylic and other Water-Base Paints for the Artist*. N. Y., Sterling, 1967.

Tovey, John. *The Technique of Kinetic Art*. N. Y., Van Nostrand Reinhold, 1971.

Woody, Russell O., Jr. *Painting with Synthetic Media*. N. Y., Reinhold, 1965.

6. ## MUSEUMS AND ART COLLECTING

A small selection of a wealth of material introducing those who are interested in art collecting to the various aspects of this vocation, and to museum development.

Keck, Caroline. *A Handbook on the Care of Paintings*. Nashville, Tenn., Association for State and Local History, 1967.

Kurt, Otto. *Fakes; A Handbook for Collectors and Students*. 2nd ed. N. Y., Dover, 1967. (paper)

Loria, Jeffrey H. *Collecting Original Art*. N. Y., Harper and Row, 1965.

Rheims, Maurice. *Art on the Market*. London, Weidenfeld and Nicolson, 1961.

Savage, George. *Forgeries, Fakes, and Reproductions*. N. Y., Praeger, 1964.

UNESCO. *The Organization of Museums*. Paris, UNESCO, 1960. (paper)

Wittlin, Alma S. *Museums in Search of a Usable Future*. Cambridge, Mass., M.I.T. Pr., 1970.

7. EXHIBITION CATALOGS

In addition to books and journals, exhibition catalogs are increasing in number and importance as source material. Anybody interested in studying the work of a contemporary artist or movement may find that no pertinent book has as yet been published, but exhibition catalogs provide fine illustrations and rich documentary information. In addition, these catalogs are especially interesting because an increasing number of exhibitions are designed around an era or a theme, for example: *The Age of Charlemagne* and *The Victorian Age*, or *Anxiety in the Twentieth Century*, or *Man and Machine in Art*. These topical exhibitions and their catalogs often open new perspectives of art by bringing together art from various countries and various media.

The following titles are indicative of the wide range of museum publications:

Alloway, Lawrence. *Systemic Painting.* N. Y., Guggenheim Museum, 1966.

Aspects of a New Realism. Milwaukee Center, 1969.

Arts Council of Great Britain. *The Age of Neo-Classicism.* London, Victoria and Albert Museum, 1972.

Documenta. v. 1-5. (Catalogs of international exhibitions of contemporary art) Kassel, 1955 - 1972.

Doty, Robert. *Human Concern/Personal Torment.* N. Y., Whitney Museum of American Art, 1969.

Expo 1967. *Man and His World.* Montreal, Can. 1967.

Florsheim, Lillian H. *Foundation of Fine Arts: A Selection of Abstract Art, 1917-1965.* Northampton, Mass., Museum of Art, 1966.

Geldzahler, Henry. *New York Painting and Sculpture: 1940-1970.* (Metropolitan Museum) N. Y., Dutton, 1969.

Hulten, Karl G. P. *The Machine as Seen at the End of the Mechanical Age.* (Museum of Modern Art) N. Y., Graphic Society (distributor) 1968.

Klee, Paul. *The Later Work.* Basel, Switzerland, Galerie Beyeler, 1965.

Los Angeles County, Cal. Museum of Art, Los Angeles. Tuchman, Maurice, ed. *American Sculpture of the Sixties.* Contemporary Art Council, 1967.

Metropolitan Museum of Art. *The Year 1200.* N. Y., 1970.

New York City University. *The Evolution of Afro-American Artists 1800-1950*. N. Y., 1967.

Pierpont Morgan Library and Boston Museum of Fine Arts. *Rembrandt: Experimental Etcher*. Ed. by F. Stampfle & E. Sayre, 1969.

Seiz, William C. *The Art of Assemblage*. N. Y., Doubleday, 1961.

Selections from the Guggenheim Museum Collection 1900-1970. N. Y., Guggenheim Museum, 1970.

Selz, Peter. *Funk*. Berkeley, Univ. of Cal. Pr., 1967.

8. GUIDEBOOKS AND REFERENCE WORKS

An annotated list of essential information sources.

American Art Directory. N. Y., Bowker, 1898-date.

Brief information on museums, art organizations and academic institutions in the U.S.A., Canada and abroad.

Art Index. N. Y., Wilson, 1929-

A cumulative author and subject index to articles in selected American and a few foreign journals.

Chamberlin, Mary W. *Guide to Art Reference Books*., 1959.

Over 2,500 titles of art reference works, guide books, histories, etc. Lists important art collections and libraries in the U.S.A. and western Europe.

Cummings, Paul. *Dictionary of Contemporary American Artists*. 2nd ed. N. Y., Wittenborn, 1972.

Illustrated biographies of 787 American artists with extensive bibliographies.

Encyclopedia of World Art. 15 vols. N. Y., McGraw-Hill, 1959-1968.

Most comprehensive art encyclopedia in English with extensive bibliographies.

International Directory of Arts. Berlin, 1954-date.

Lists museums, art galleries, libraries, academic institutions, dealers, restorers, auctioneers, etc.

Mayer, Ralph. *A Dictionary of Art Terms and Techniques*. N. Y., Crowell, 1969.

A dictionary for the practicing artist and student with emphasis on the nomenclature of the artists materials and procedures. Includes "hundreds of entries for pigments." Includes bibliography.

McGraw-Hill Dictionary of Art. 5 vols. N. Y., McGraw-Hill, 1969.
The most comprehensive art dictionary in English. Gives extensive, up-to-date information.

Rath, Frederick L. and Merrilyn R. O'Connell. *Guide to Historic Preservation, Historical Agencies, and Museum Practices: A Selective Bibliography.*
Cooperstown, N. Y., New York State Historical Association, 1970.
An up-to-date list of books, journals and organizations involved in the collection and preservation of historical materials, including works of art.

Thieme, Ulrich and Becker, Felix. *Allgemeines Lexikon der bildenden Künstler von der Antike bis Zur Gegenwart.* 37 vols. Leipzig, Seemann, 1907-50; suppl. 6 vols. 1953-62.
According to Gombrich "The largest and most comprehensive dictionary of artists of all times and countries."

UNESCO. *Catalogue of Color Reproductions.* v.1 paintings prior to 1860. v.2 paintings 1860-1965. Paris, 1964-1966.
Arranged alphabetically by artist, this list of prints includes small black and white reproductions. Publisher and price of the prints are included.

9. ART JOURNALS

A selective list of general art periodicals in English. In addition to these, many journals dealing with specific aspects, e.g. art and education, crafts, techniques and local or regional interests are listed in the *Art Index*. (See under Guidebooks and Reference Works)

American Artist. 1937-
Antiques. 1922-
Apollo. 1925-
Art and Artists. 1959-
Art and Auctions. 1947-
Art in America. 1913-
Art Forum. 1962-
Art International. 1956-
Art News. 1902-
Art Price Annual. 1948-
Arts in Society. 1958-
Arts Magazine. 1926-

Connoisseur. 1901-
Design. 1899-
Design Environment. 1971-
Design Quarterly. 1946-
Journal of Aesthetics and Art Criticism. 1941-
Museum Journals (examples):
 Cleveland Museum of Art
 New York, Metropolitan Museum and Museum of Modern Art
 Pittsburgh (Carnegie Institute)
 Foreign Journals
Museum News. 1952-
Studio International. 1893-
Warburg and Courtauld Institutes Journal. 1939-